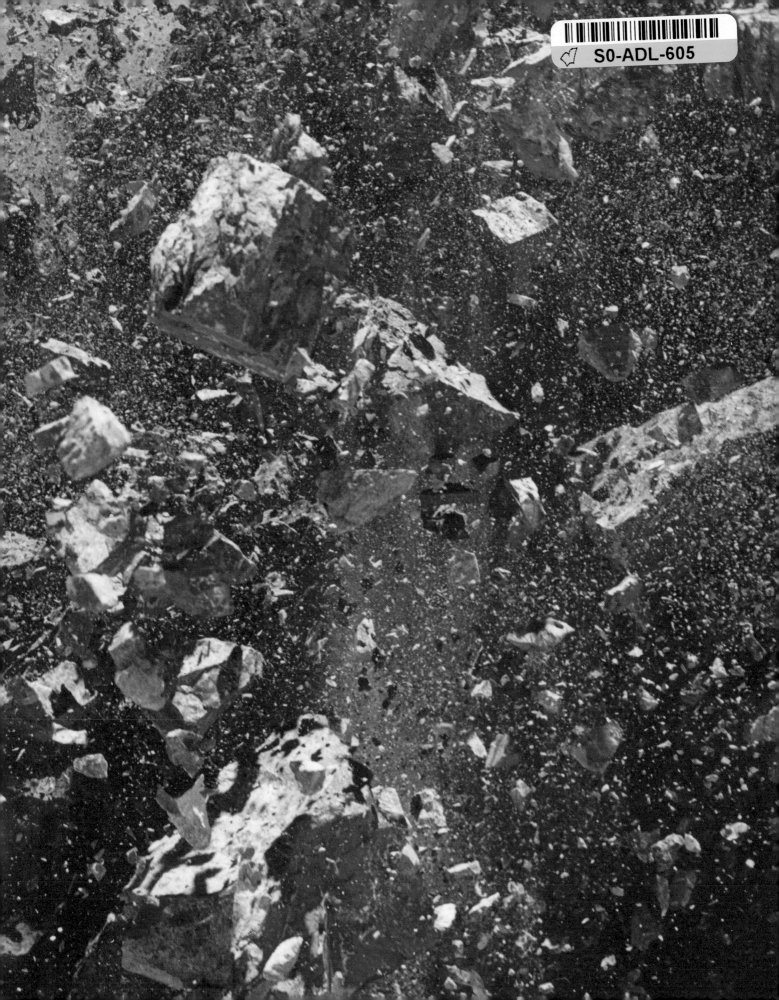

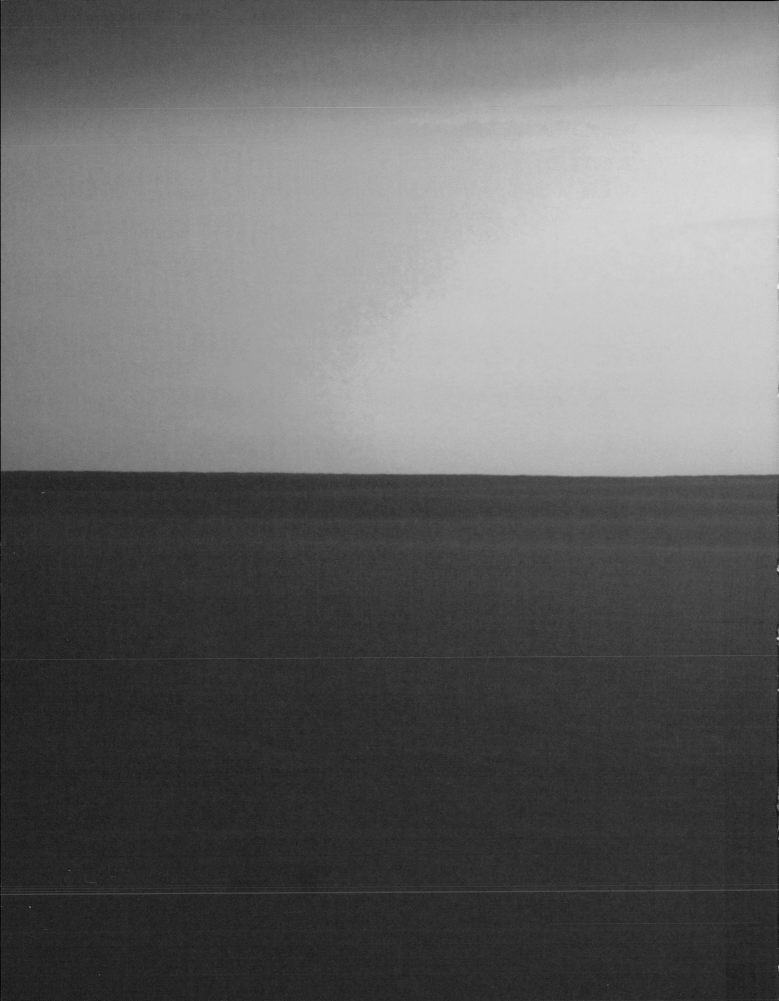

Art & Ecology Now

ART & ECO

LOGY NOW

Andrew Brown

343 illustrations, 338 in color

 Thames & Hudson

On the cover: Rúrí, *Archive – Endangered Waters*, 2003
On the front endpapers: Naoya Hatakeyama, *Blast #05416*, 1998
On the reverse front endpaper–p. 1: Erika Blumenfeld, from
Antarctica Vol. 3 (Ice Horizons), 2009
On pp. 2–3: Erika Blumenfeld, from *Antarctica Vol. 1
(Early Sea Ice)*, 2009
On pp. 4–5: Edgar Martins, *Untitled*, from the series
The Diminishing Present, 2006
On the reverse back endpaper: Alejandro Durán, *Nubes*, 2011
On the back endpapers: Tea Mäkipää, *Atlantis Wanås*, 2007

Art & Ecology Now © 2014 Andrew Brown

Designed by Studio Fernando Gutiérrez

First published in 2014 in hardcover in the United States of
America by Thames & Hudson Inc., 500 Fifth Avenue, New York,
New York 10110

thamesandhudsonusa.com

Library of Congress Catalogue Card Number
2013948271

ISBN 978-0-500-23916-2

Printed and bound in China by Toppan Leefung
Printing Limited

ABOUT THE AUTHOR

Andrew Brown is a writer, editor and publisher of art books
in London, and the former acting director of visual arts
strategy at Arts Council England.

AUTHOR'S ACKNOWLEDGMENTS

My thanks to Jacky Klein for believing in the tentative idea
for this book and for having faith that I could deliver it ...
eventually. I am also grateful to my assistant Emma Lewis
for the sterling job she did on my behalf in corresponding
with dozens of artists, studios and galleries and collating the
material included here. I also owe a big thank you to Diana
Loxley for her rigorous eye and delicate red pen. Finally,
my special thanks go to the artists who generously allowed
me to reproduce their work in these pages. I hope that they
feel I have done justice to their rich, diverse and stimulating
efforts to encourage others to reflect upon and engage with
the world around us in ever more effective ways. Likewise, I
trust that the reader goes away having discovered something
new about the challenges facing the planet and about where
we might be heading, in both art and life.

CONTENTS

'AT THE RADICAL EDGE OF LIFE'

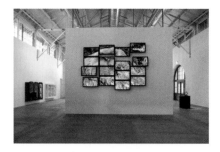

Diana Thater, *Rare*, 2008. The exhibition 'Human/ Nature: Artists Respond to a Changing Planet' at the Museum of Contemporary Art, San Diego, in 2008 involved sending eight artists to some of the planet's most biodiverse regions to investigate their changing nature. Thater travelled to iSimangaliso Wetland Park, South Africa, where she located and filmed many of the park's endangered and threatened species.

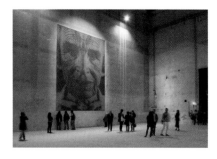

Heather Ackroyd and Dan Harvey, *Testament*, 2010 (negative 1998). Working with environmental scientists, the artists developed a technique of plant photosynthesis that allowed them to project a negative image onto grass as it grows in a darkened room. The turf is thus transformed into a photograph.

It seems almost impossible to walk into a contemporary gallery or museum these days, or to browse through an art magazine or website, without coming across work that expresses some kind of engagement with the natural world. Once an area of interest for a relatively small group of people, art that addresses environmental issues has in the last five years become part of the artistic mainstream. International exhibitions, conferences and festivals on ecological themes are announced on a more and more frequent basis; artists of all kinds are being commissioned in ever greater numbers to explore humankind's impact on the planet; and the volume of articles and papers devoted to the subject – in both the popular and specialist press – is growing rapidly. From being a peripheral activity, art that seeks to ask searching questions about the environment is now firmly centre stage, at once responding to and shaping debates in broader society.

Artists have always been inspired by the beauty and mystery of nature, of course, and have used elements of the natural world in creative ways for centuries. Painting and poetry, to name just two art forms, have long reflected the close bonds of mutual dependence that we have with our physical surroundings through landscape, still life and pastorals. In recent times, however, there has been a growing tendency in contemporary art to consider the natural world not only as a source of inspiration or subject to represent, but also as a realm to influence directly – a sphere of action to transform and improve through creative means.

As we will see, this trend has been some five decades in the making, with roots that go back to the land art and earthworks of the 1960s. Informed also by the strategies of early conceptual art, performance, institutional critique and agit-prop, artists dealing with the environment today adopt a wide range of approaches and methods: from passive commentator or enquiring researcher to visionary innovator or active interventionist seeking social and political change.

Their works reveal similar diversity. Some may, for example, take the form of photographic or video pieces documenting the effects of deforestation; others might be research studies into the effects of global warming on the spread of malaria; some may use weather formations as a source from which to create elaborate visual data maps or 'singing sculptures'; while yet others could be long-term restoration projects that seek to reclaim a tract of land from the spread of industrialization or to protect a local ecosystem. Often, the artists producing these works do so in collaboration with others, undertaking complex projects with specialists from other disciplines, such as botanists, zoologists, ecologists, geologists, meteorologists, oceanographers, architects, engineers and urban planners, as well as with community members and environmental activists. The artists in this book rarely work in isolation.

The artistic activities featured here confront some of the most urgent social, political, economic, scientific, technological and ethical issues facing humankind today. These include the creeping submission of wilderness to civilization and the consequent change in our use of the planet's resources; the impact of technology on biology; our changed relationship to the land, to our fellow creatures and to each other as a result of industrialized agriculture, mass consumption and global transportation; the redefinition of national, cultural, geographical and social divisions, and the blurring or redrawing of boundaries between what have conventionally been considered opposites, such as nature/culture, individual/community, national/international and global/local; the impact of an ever-growing flow of information on the foundations of scientific knowledge; and even our very ability to survive into the future.

This trend has developed alongside an increasing awareness of ecological matters and the rise of the environmental movement since the 1960s. What is perceived as the current crisis of climate change has thus given added impetus and urgency to many of these artists' practice. The recognition that actions on one side of the world affect people and ecosystems on the other informs much of the work in this book, acknowledging our mutual interdependence across all borders, cultures and faiths. There is also a growing awareness that the health of the environment is dependent on a set of interrelated systems (ecology, politics, technology, social practices, business and

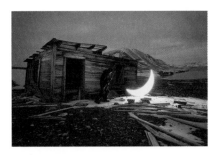

Leonid Tishkov, *Journey of the Private Moon in the Arctic*, 2010. Tishkov's project was part of Cape Farewell's expedition to the Arctic in 2010. Founded by artist David Buckland in 2001 (see p. 77), Cape Farewell brings artists, scientists and communicators together to produce art based on scientific research that addresses the urgency of global climate change.

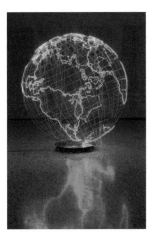

Mona Hatoum, *Hot spot III*, 2009. Hatoum's glowing 'red-hot' sculpture, an oversize globe, was a centrepiece of the 'Earth: Art of a Changing World' exhibition at London's Royal Academy of Arts in 2009.

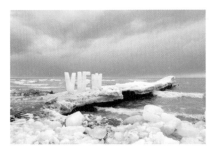

Nicole Dextras, *View*, 2007. Eco-artist Dextras created these six-foot ice letters on the shore of Lake Ontario by using wooden moulds filled with water from the lake that froze over two weeks. After removing the moulds, she left the letters in the landscape to melt naturally and be battered by strong icy winds. The work was part of a residency project that explored how we look at the landscape and turn nature into a commodity.

INTRODUCTION

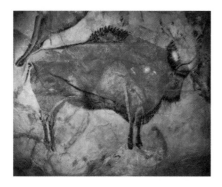

A painting of a bison in the Altamira caves in northern Spain, dating from some time between *c.* 16,000 BCE and *c.* 9,000 BCE.

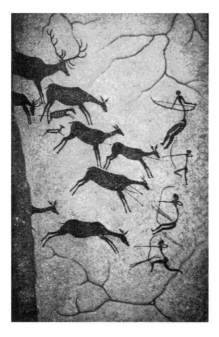

Huntsmen hunting deer, from the Lascaux cave complex in southwest France, painted around 17,000 years ago. As in the contemporaneous paintings in Altamira, these Paleolithic images show only animals and humans but no landscape, giving us an indication of what our prehistoric ancestors considered to be the most significant elements of nature.

so on), meaning that interdisciplinary approaches are needed if we are to understand and solve the problems facing the planet.

In many cases, the artist's role is not, however, to provide definitive answers to these problems. Merely asking the question is often enough. Unlike the scientist, who must follow established scientific methods, the artist is free to question and redefine anything or everything at any stage, to be wide-ranging and open to all possibilities. As Helen Mayer Harrison and Newton Harrison, two pioneering eco-artists of the past forty years, put it, the artist's function is 'to search, to discover value, to value discovery, to discover qualities of value ... to bespeak those values, to be self-critical ... to respeak the values more clearly, to be self-critical again. From this process, new metaphors emerge and old ones are tested for value.' As a result, artistic projects are able to withstand a far higher level of risk than typical scientific experiments, which often come with expectations of tangible results or even profit for their funders. They can engage local communities and garner broad support in ways that science alone can rarely do. They can offer tools for reflection, discussion, awareness and action that lead to new ways of thinking about and of being in the world. And they can bring about real change – sometimes deliberately, sometimes unintentionally – that has lasting benefit, whether to the few or to the many.

This way of working is not free of controversy, however. Environmental art raises a raft of questions, from the aesthetic to the ethical. Should art be a withdrawal or refuge from real life, or should it engage directly with the world? Should artists simply report on what they see or seek to change it for the better? Has art discovered a new sense of purpose? In what ways can an intervention be considered 'art'? Where does the line between art and propaganda lie? What is the relationship between art and science? Can art carry the weight of expectations that are being placed upon it? What responsibility does an artist – or indeed any individual – have to conserve and protect the natural environment? How can an artist balance that responsibility with the urge to leave a mark on the world? What are our obligations to each other in the face of a growing environmental threat? Are our psyches and social systems capable of comprehending and responding to the challenges confronting the planet?

These are just some of the practical and conceptual questions explored in this book. Many commentators believe that environmental issues will be the principal cause of major conflicts in the coming century. The artists who deal with these issues are thus operating not only at the vanguard of arts practice, but also, in the words of curator and critic Lucy Lippard, one of the early theorists of eco-art, 'at the radical edge of life itself'.

THE ROOTS OF AN ENGAGED PRACTICE

Depicting the physical environment and humankind's place within it has been central to art-making since the earliest cave paintings over thirty millennia ago. The anonymous prehistoric men and women who painted bisons, horses and aurochs on the ceilings and walls of caves from Europe to Australia were doing what artists have done ever since: representing their immediate surroundings in a visual language they understood.

But more than just picturing everything they could see around them, our Paleolithic ancestors were giving symbolic form to the elements of nature that were considered important, those that brought both life and death in equal measure. The tribe's survival depended on its relations with these awesome creatures – or at least with the supernatural spirits that created them in the first place. The paintings were a way of both celebrating and taming powers that were beyond their control in reality; they were also an attempt to make sense of natural forces that exceeded their limited comprehension, yet on which they owed their existence. But these images represent another form of reliance on nature, too (one that continues up to the present), for they were made with the very stuff of the physical world: pigments hewn from the earth such as ochre, haematite and charcoal, and surfaces and spaces formed by natural processes. They were thus both a visual representation of humanity's relationship with the environment and a literal enactment of that relationship.

In the centuries that followed, artists continued to represent the world around them. But it was not until the Renaissance in Europe that landscape and still-life painting proper first emerged. Coinciding with the rise of humanism, when man became the measure of all things, these two genres reflected a growing sense of ownership and entitlement in respect of the material world. Ancient faith and superstition started to fade away and in its place came a growing belief in the power of reason, science and mathematics. Nature was no longer something to be feared or revered but studied, understood, tamed, shaped to human will – and made to work. The Industrial Revolution in the eighteenth century brought with it the first attempts to harvest and harness the planet's resources on a global level.

Enormous amounts of fossil fuels were now required across the world to feed the factories and furnaces that pumped out plumes of pollution in pursuit of progress. Mechanization demanded and enabled ever greater quantities of minerals, metals and materials to be extracted, processed and dispatched. Never before had the physical heart been wrenched from the Earth on such a massive scale and returned to it in a degraded and degrading state. William Blake and others cursed the 'dark satanic mills' and their merciless machines – but there was worse to come. This was just the start of an era in which humanity saw the environment as an endless supply

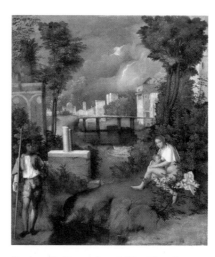

Giorgione, *The Tempest*, c. 1508. This celebrated Renaissance canvas, one of the earliest landscape paintings in Western art, has divided opinion for centuries for its mysterious symbolism and indeterminate meaning. Whatever its intended significance, the picture reveals a new understanding of the interconnected relationship between humankind and nature, one that was not only material – the built environment here is integrated with the natural – but also psychic, the storm overhead suggesting unease among the painting's human protagonists.

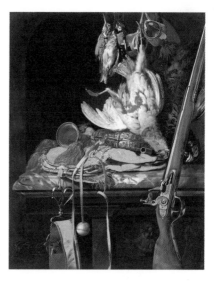

Willem van Aelst, *Game with Hunting Equipment in a Niche*, 1664. Still lifes are synonymous with the Golden Age of Dutch painting in the seventeenth century. They provided an opportunity not only to demonstrate virtuoso skill and the rendering of realistic natural forms, but also to express the growing materialism of the society of the day.

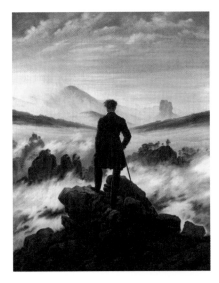

Caspar David Friedrich, *Wanderer above the Sea of Fog*, 1818. This figure by German painter Friedrich expresses the archetypal Romantic sense of awe in the face of Nature's immense and sublime splendour.

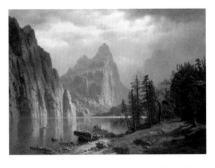

Albert Bierstadt, *Merced River, Yosemite Valley*, 1866. Bierstadt's large canvases of the American West helped create a national identity in the still young United States of the mid-nineteenth century.

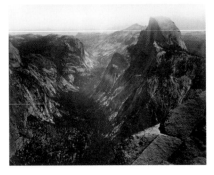

Carleton Watkins, *Half-Dome, from Glacier Point, Yosemite*, c. 1865. The new medium of photography enabled millions of Americans to see their country's magnificent landscape for the first time.

of treasures that it could plunder in search of wealth, and a bottomless pit into which it could pour its unwanted detritus afterwards. Put simply, nature was now nothing more than a commodity to be bought (or stolen) and sold.

Nonetheless, throughout all of this we retained the tendency of our ancient ancestors to find meaning in the processes and products of the natural world – and to reflect that fact in our art. *Vanitas* paintings, *memento mori*, *trompe-l'oeil* and *bodegones* were among the forms of modern still life that used metaphor and symbolism to ascribe moral significance to the growth and decomposition of natural objects. And from the Renaissance onward, representations of the land were read as allegories of everything from good government to the torments of the mind and the passions of the flesh.

In the Romantic period in Europe, which coincided with the growing industrialization of life, depictions of the natural world in both poetry and paint were emblematic of some exalted higher order beyond the physical realm – the Sublime. In the face of the horrifying onslaught of human industry, scenes from nature demonstrated its capacity to inspire awe, reverence, emotion or terror as a result of its great beauty, vast expanse or powerful force. And while contemporary philosophers and poets each had a different interpretation of the Sublime, all believed that it was a symbol of inner realities, thoughts and conflicts. According to this view, Man saw his own potential in the infinity of nature, and transformed its physical grandeur into a spiritual majesty. Many of these ideas persist to this day and, consciously or not, provide a philosophical, moral and emotional underpinning to much of the artistic work in the following pages.

Meanwhile, in the United States, nineteenth-century artists such as Thomas Cole, Frederic Edwin Church and Albert Bierstadt were painting the American landscape as a visual expression of their religious conviction and as a demonstration of the principles of Manifest Destiny – the widely held belief that American settlers, guided by a divine hand, were destined to conquer the entire continent. These painters depicted the natural environment both as tangible manifestation of the existence of God and as idealized pastoral setting where humans and nature could coexist in harmony – the pictorial equivalents of Henry David Thoreau's celebrated book *Walden* (1854), which emphasized the importance of closeness to nature as an antidote to society's burgeoning materialistic attitudes. The epic scale of the artists' canvases reminded their compatriots of the swathes of magnificent untapped wilderness that stretched across the country, thereby contributing to the philosophies of both expansionist attempts to settle the West and conservationist efforts to create national and city parks. Photography, too, played its part. Abraham Lincoln is said to have been persuaded to name Yosemite Valley the first US national park in 1864 after seeing photos of its beautiful carved landscape.

The nascent conservationism that developed in the United States, Britain, Germany and other European countries in the second half of the nineteenth century helped foster an awareness that steadily grew in the next. The images of photographers such as Ansel Adams helped spread knowledge of environmental issues more widely and encouraged the recruitment of new members to the cause.

By the mid-1960s, a new eco-consciousness had firmly taken root in sections of Western society. But if one single event can claim credit for giving a wider voice to the environmentalist movement it is the publication in 1962 of *Silent Spring* by biologist Rachel Carson. This book, which highlighted the impact on the environment of the indiscriminate use of pesticides, put ecological issues before the American public as never before. It galvanized a younger generation in the United States and beyond, prompted grassroots activism on an unprecedented scale, resulted in the formation of numerous pressure groups, and ultimately led to the establishment of the US Environment Protection Agency in 1970. Its influence continues: several of the artists featured in this book cite it as a key inspiration.

FROM 'EARTH WORKS' TO EARTH'S WORKERS

The somewhat rarefied realm of late 1960s' vanguard art was not immune from these developments. Indeed, some of the most radical artists of the day saw engagement with the natural world as a defining tenet of their practice. In October 1968, the group exhibition 'Earth Works' at the Dwan Gallery in New York was the first manifestation of a loose trend that soon became known by one of various monikers: the eponymous 'earthworks', or 'earth art' or 'land art'. This seminal show included many of the figures now identified with the defiantly groundbreaking mode of making art, such as Robert Smithson, Walter De Maria, Dennis Oppenheim and Michael Heizer, who presented work alongside that of the former Bauhaus artist Herbert Bayer, creator of some of the earliest environmental sculptures and a father-figure for some in the group. These and other individuals, notably Nancy Holt and James Turrell, went on to produce some of the best-known works of land art, shifting enormous quantities of earth, rock, minerals and human-made objects to fashion monumental site-specific forms in the deserts of New Mexico, Arizona, Utah, Nevada and elsewhere. While the primary impulse for many was to flee the 'white cube' of modernism, both literally and figuratively, it was also a desire to 'get back to nature' that drove these artists out of doors and into the landscape, often in response to the environmental concerns of the day.

From our perspective today, we may question the ecological ethics of these artists and their use of heavy earth-moving equipment to displace tons of natural materials and permanently scar the face of the Earth in the name of art. But they were leading the charge of a new avant-garde that would alter radically the way artists viewed and engaged with natural

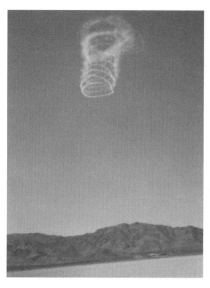

Dennis Oppenheim, *Whirlpool (Eye of the Storm)*, 1973, El Mirage Dry Lake, Southern California. One of the early American artists to move out of the gallery and into the landscape, Oppenheim took a subtle, fleeting and ephemeral approach to creating earth art, as with this piece in which an aeroplane discharged white smoke over the California desert.

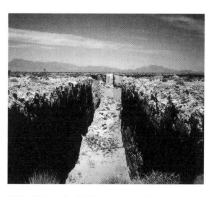

Michael Heizer, *Double Negative*, 1969, Overton, Nevada. In contrast to Dennis Oppenheim's *Whirlpool*, Heizer's celebrated work involved displacing 240,000 tons of rock and earth to leave a 1,500-foot-long, 30-foot-wide and 50-foot-deep trench in the Moapa Valley, Nevada.

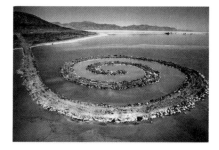

Robert Smithson, *Spiral Jetty*, 1970, Great Salt Lake, Utah. One of the iconic works of land art, Smithson's jetty is a 1,500-foot-long counterclockwise spiral of mud, salt crystals, basalt rocks and water. The level of the lake varies over time, concealing and revealing the structure as the water rises and falls.

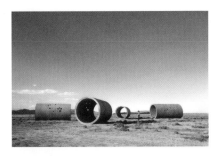

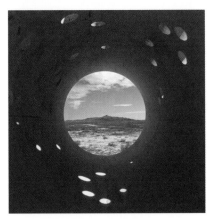

Nancy Holt, *Sun Tunnels*, 1973–6, Great Basin Desert, Utah. Holt's four concrete tunnels frame the sunrises and sunsets on the solstices.

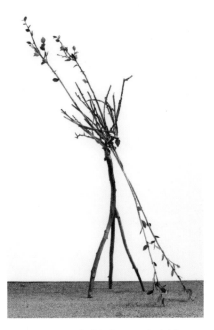

Giuseppe Penone, *Pelle di foglie – sguardo al cielo*, 2005. One of the younger figures of Arte Povera, Penone has since the late 1960s produced sculptures that explore the connections and different ascribed values between natural and cultural forms. The tree is a central element in his work.

objects and processes. These pioneers showed not only that art could be placed within the environment and be made from it, but also that the art could change that environment for ever.

The year 1968 was an intoxicating time. Revolution was in the air across the globe and these artists were not alone in wanting to shake up the art world. Postminimalist and process artists such as Carl Andre, Eva Hesse, Lynda Benglis, Robert Morris and Richard Serra, some of whom featured in the 'Earth Works' show, all shared an interest in employing natural forces – growth and decay, gravity and weather, energy and entropy, chance and serendipity – in the fabrication (or often the enactment) of their works. In Italy at the same time, the Arte Povera artists were also exploring and exploiting the properties of organic and inorganic matter and tracing the dynamism of nature through its physical and chemical transformation.

At the other end of the material spectrum, early performance, Fluxus and conceptual artists were creating art from, well, nothing (that is, no thing). They were, in Lucy Lippard's words, 'dematerializing the art object', divorcing the creative act from any lasting physical trace, at least in the conventional sense. Instead, they based their respective forms of art on the organization and experience of actions; the establishment and observance of rules or 'event scores'; and the expression and realization of ideas. Conceptualists in particular employed documenting, analysing and archiving as essential modes of practice. Systems, structures and signs of all kinds – not least language – were among their favourite objects of study. In more ways than one, they crossed over from pure art into the realms of literary theory, philosophy and the social sciences.

It was perhaps inevitable that their investigative methods would be turned inward and focused on the art world itself. By the 1970s, institutional critique had emerged as a distinct strand within conceptual art. Key figures such as Michael Asher, Marcel Broodthaers, Hans Haacke and Daniel Buren now used the tools of systematic enquiry to investigate, map and reveal the hidden workings and assumptions of cultural institutions. It was a small conceptual step from their critique and disarticulation of the institution of art to the claim of Joseph Beuys that 'everyone is an artist'. This statement developed from Beuys's own highly influential idea of 'social sculpture', in which society as a whole was seen to be one great work of art to which everyone could contribute creatively. At the heart of his project was the desire to effect both social and environmental change.

The early eco-works of the late 1960s and 1970s emerged out of this heady artistic and theoretical mix and combined with the concerns of an increasingly powerful environmentalist movement. Younger artists extended radical art's newfound interest in the land as material and site towards a deeper engagement with ecological and social issues. One of the

youngest to do so was the American Alan Sonfist. In 1965 he proposed a large-scale environmental sculpture in lower Manhattan consisting of plants that were native to the area in pre-colonial times. This forest not only presented a living vision of what existed before the urbanization of the city, but also stood as a constant reminder of the value of the land's historical past and the fragility of our environment. The work, *Time Landscape*, was eventually commissioned and, after ten years of planning, was unveiled on the corner of La Guardia Place and West Houston Street in 1978.

In the intervening decade, nature-focused work had become a fixture of the international scene. The Argentinian artist Nicolás García Uriburu was the first to announce its arrival on the world stage in 1968 when for the prestigious Venice Biennale of that year he dyed the Grand Canal using fluorescein, a pigment that turns bright green when synthesized by microorganisms in the water. Since that initial manifestation, he has repeated the action in cities across the world. He has also allowed unlimited photographic reproduction of the works to raise awareness of the problem of water pollution. Thirty years later, in an echo of Uriburu's intervention, Olafur Eliasson turned the river in the German city of Bremen green with synthetic dye (he, too, has repeated the work in several locations since).

A couple of years after Uriburu's comment on our use of the Earth's resources, the Harrisons initiated the first of what became a lifelong series of works proposing alternatives to conventional methods of agriculture, aquaculture and horticulture. *Portable Fish Farm: Survival Piece #3* is one example that was produced for an exhibition at London's Hayward Gallery in 1971. The part installation/part performance involved the creation of a catfish farm in the gallery and the ritualistic electrocution, skinning and filleting of the fish. The controversial work created outrage across Britain, with the government threatening to cut the gallery's public funding as a result. Undeterred, the artist couple continue to this day to produce imaginative and elaborate proposals to solve environmental problems, while also creating work that researches and highlights the impact of global warming and other ecological phenomena.

How we make use of the planet's resources and process the resulting waste also lay behind Mierle Laderman Ukeles's eleven-month action *Touch Sanitation* (1979–80), in which she crisscrossed New York City to shake hands with and thank each one of more than 8,500 sanitation workers for keeping the city 'alive'. She documented her activities on a map, meticulously recording her conversations with the workers. The work not only adopted the methods and objectives of conceptualists such as Douglas Huebler, who proposed photographing everyone alive, but also paralleled the contemporaneous duration pieces of performance artists such as Tehching Hsieh. It did so, however,

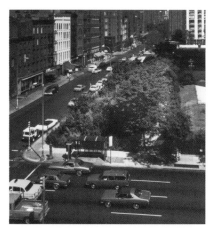

Alan Sonfist, *Time Landscape*, 1965, New York City

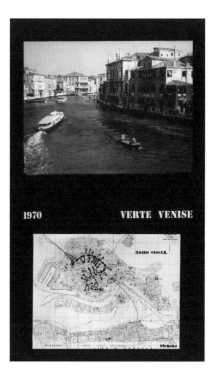

Nicolás García Uriburu, *Verte Venise*, 1970

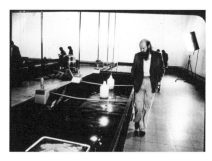

Helen Mayer Harrison and Newton Harrison, *Portable Fish Farm: Survival Piece #3*, 1971

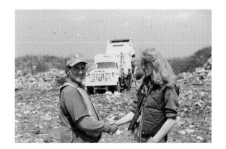

Mierle Laderman Ukeles, *Touch Sanitation Performance: Fresh Kills Landfill*, 1977–80

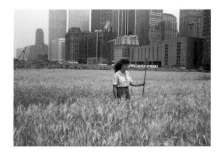

Agnes Denes, *Wheatfield – A Confrontation: Battery Park Landfill, Downtown Manhattan* (with Denes standing in the field), 1982

herman de vries, *Perlgras*, 2005

with a clear environmentalist agenda that the art of these other practitioners lacked, and which Ukeles continued in subsequent works such as *Flow City* (1983–present), an early example of eco-art that links social, political and environmental issues, involves scientists, ecologists, artists and others in its creation, and engages community members to educate them about the consequences of their lifestyle on creating a healthy environment in the future.

A magnet for pioneering artists of all kinds, New York continued to host many seminal environmental-art projects into the early 1980s. In May 1982, after months of preparation, Agnes Denes planted *Wheatfield – A Confrontation*, a two-acre field of golden wheat on rubble-strewn landfill near Wall Street and the World Trade Center in lower Manhattan, 'confronting' some of the most expensive real estate in the world with one of the Earth's most basic crops. According to the artist, the work 'represented food, energy, commerce, world trade, and economics. It referred to mismanagement, waste, world hunger, and ecological concerns. It called attention to our misplaced priorities. The harvested grain traveled to twenty-eight cities around the world in an exhibition called "The International Art Show for the End of World Hunger", organized by the Minnesota Museum of Art (1987–90). The seeds were carried away by people who planted them in many parts of the globe.'

Meanwhile in Europe, there was a growing trend of artists utilizing natural objects in their work – and to a variety of ends. Practitioners such as herman de vries, Richard Long and Andy Goldsworthy all engaged directly with the environment, either by building structures from organic and inorganic matter as traces of human intervention in the landscape or by collecting materials from nature – leaves and branches, mud and stone – in order to fashion sculptures or collages or to catalogue the Earth's natural forms. In many respects, the work of these individuals represented a sort of retreat from modern life, an embrace of nature as refuge from society and its ills.

Other environmental artists of the 1980s, however, wished to tackle the growing ecological and social problems caused by global capitalism and mass consumerism head on. They did so in a way that reflected the influence of contemporary agit-prop collectives such as Gran Fury and the Guerrilla Girls, who used artistic means to further political ends in the realms of AIDS prevention and women's rights, respectively. The direct action of these and other activist groups provided a template for later eco-artists who wished to have a real, tangible impact, either on human behaviour or on the environment itself.

For example, when Patricia Johanson was commissioned to redesign Fair Park Lagoon (an abandoned swamp in Dallas, Texas) in 1981, she decided to create an entirely new functioning ecosystem and thereby return plant, animal and

human life back to the environmentally degraded location. Johanson, along with Mel Chin, Lynne Hull and Kathryn Miller, was one of the first so-called 'remediationist' artists, who set out to 'heal' the planet through projects that cure polluted areas, eliminate invasive species, or dismantle sites that endanger the environment or public health. They share a belief that art is more than an object to look at or to think about – that it can also extend into the realm of public service and have a positive remedial impact on the Earth. As Hull puts it, 'I believe that the creativity of artists can be applied to real-world problems and can have an effect on urgent social and environmental issues. My sculpture and installations provide shelter, food, water or space for wildlife, as eco-atonement for their loss of habitat to human encroachment.'

A SPECTRUM OF ENGAGEMENT

We may discern from the few examples of early nature-related art mentioned above a range of approaches that stretch from objective observer to active interventionist, a spectrum of artistic engagement with nature that forms the structure and rationale of this book. In the chapters that follow, we move from artists who use conventional aesthetic means to make us look and look again at the way we treat the planet – in the hope that we may see things differently – to those who create art that by its very enactment or experience has a positive effect on the environment and our behaviour.

This structure is not meant to imply that an artist at one end of the spectrum is any less or more committed to ecological issues than an individual at the other end of the scale, only that their mode of working represents a particular level of engagement with the physical world itself. I could have taken any number of other ways of organizing the material in these pages: chronological, alphabetical, by medium, by place, by natural element, and so on. All of these means of organization and others were considered. By focusing on the artist's approach, I hope to have provided a clear taxonomy – a conceptual system created so that we can classify and understand the natural world – that helps the reader make sense of the rich diversity of practices and works that one can encounter today. At the same time, I do not intend to pigeonhole any single artist in any one category. Many of the individuals included in the book have produced other works that would have meant they appeared in a different chapter or chapters had I selected those projects. The point is that artists, like all of us, are complex, shifting and often contradictory. Several of the featured practitioners have moved backwards and forwards along this spectrum of engagement over the course of their careers.

The field of environmental art has grown rapidly over the last few decades and is now vast. Many more individuals and projects were worthy of inclusion, but sadly space limitations have dictated otherwise. Let us think of the trees.

Patricia Johanson, *Fair Park Lagoon*, Dallas, Texas, 1981–6

Mel Chin, *Revival Field*, 1991–ongoing. This conceptual art work by eco-artist and activist Chin is a collaborative project that had the explicit intention of reclaiming and reviving a hazardous landfill site in St Paul, Minnesota.

Kathryn Miller, *Seed Bombing Raytheon back lot, Goleta, California*, 1992. As a small-scale, guerrilla act of urban intervention, Miller designed portable seed bombs that could be thrown into degraded areas that were in need of vegetation.

RE / VIEW

1

The artists in this opening chapter are motivated by an impulse that has driven poets and painters for millennia: to represent the world as they see it, in all its splendour and horror. They consciously adopt the role of witness, observing the processes of nature and the activities of humankind from a position of relative detachment in order to provide testimony or evidence of their effects. In many ways, these individuals resemble war artists sent to record the terrors of conflict, or photographers and illustrators dispatched on assignments by newspapers and magazines. Like investigative reporters, they document, reflect and comment on the myriad changes, both global and local, that are affecting the environment in which we live and on which we depend. While some seek merely to depict the natural world dispassionately, others aim to shine an accusatory light on humanity's most damaging behaviours; yet all of these artists enhance our awareness of nature's power and fragility, forcing us to reconsider our view of the planet and the way we live with it.

Some artists offer lyrical, idealized or nostalgic visions of a lost or disappearing world in the spirit of Romantic landscape painters and pastoral poets; others hold up an objective mirror that makes us see the harsh realities of life, and forces us to acknowledge what we might otherwise overlook or choose to ignore. Some seek to jolt us out of complacency by showing the brutality of our actions; others aim to seduce with images of exquisite beauty. Some visualize complex data or information in more concrete and legible terms, while others abstract forms from nature to create alternative views of the world.

Film, digital media, sculpture, installation and public interventions are among the various mediums and techniques found in this section. But it is no coincidence that many of the artists here use photography, considered by some to be the most objective of all the art forms and thus the most appropriate with which to document the external world truthfully and honestly. The early American modernist Paul Strand, writing in 1917, even declared that 'objectivity is of the very essence of photography'. Relatively speaking, that may be so. But the camera's claim to impartial truth has long been exposed as a myth. Most photographers today – including all of those featured here – understand that photography is, in fact, a fundamentally objective medium in the hands of entirely subjective beings. Strand went on to say, 'The decision as to when to photograph, the actual click of the shutter, is partly controlled from the outside, by the flow of life, but it also comes from the mind and the heart of the artist. The photograph is his vision of the world and expresses, however subtly, his values and convictions.' Photographers never, therefore, blindly capture a two-dimensional facsimile of their surroundings. They always put something of themselves – their hopes, their fears and those of their time – into the image. Strand's French contemporary Robert Demachy expressed it in clear terms: 'There is not a particle of art in the most beautiful scene of nature. The art is man's alone, it is subjective and not objective.'

What makes the works in these pages distinct from reportage or propaganda, then, is that there is no question of their status as art. All of the artists featured here, whether they work with the photographic medium or not, employ a variety of aesthetic means at their disposal – including framing, composition, narrative, montage, colour and lighting effects, symbolism, abstraction, and so on – in order to make us look at the world with new eyes.

Although the artists in this section adopt the most detached mode of art-making in the book, this does not mean that they are disengaged from their subjects. Nor do they believe that art is separate from other realms of life. On the contrary, as the quotes throughout the chapter make clear, each one is motivated by a profound commitment to the social and environmental issues on which they focus their sight; and each one believes strongly in the power of art to communicate urgent concerns in new ways and to different audiences – to reframe the debates – and ultimately to effect change. What distinguishes these practitioners from their activist counterparts in later chapters is that they believe that simply showing something in a different way is often enough; that a powerful image or artistic statement can be sufficient to make others stop, rethink their behaviour and assumptions, and take action.

As Susannah Sayler and Edward Morris, founders of the campaigning group The Canary Project and two of the most actively engaged artists in this chapter, have stated: 'In every project, we're combating this prejudice that feels ancient, but is actually a relatively recent development – where art is regarded as being autonomous, where art is in its own sphere: "Art for art's sake." If it's thought to have any kind of rhetorical purpose, then it can't possibly be expansive in the way that art is supposed to be.... These notions are, frankly, bourgeois in a historical sense.... The problem with a lot of activism is that it's necessarily reductive. It's about consolidation of power. It's about reducing the message so that many people can get behind it, and there's a certain level of untruth in that reduction. With art you want to respect complexity, you want to be truthful, and art has to have a "ricochet effect". It has to keep bouncing around in your head. It has to not close anything off. How you keep that ricochet going while still being productive in the discourse – that's the thing we've been trying to figure out. And we're still figuring it out.'

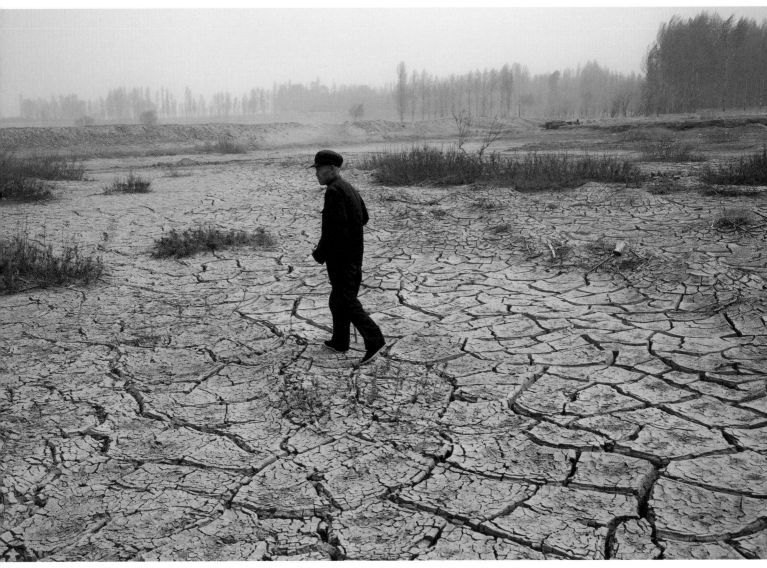

Berger à Wuwei, Gansu, Chine, 2006

'The Chinese "Dust Bowl" is a fascinating subject. It is a compelling environmental manmade disaster and photographically an interesting journey. When I embarked on this trip I was convinced that I could make surreal images and at the same time raise awareness. This is about scarce water resources, desertification and ecological refugees in China. My series shows just what happens when we mismanage the environment. These issues should not just be seen in the context of one country; they are global issues. They affect us all. And as a global population, we must solve them.'

BENOIT AQUIN

BENOIT AQUIN

Canadian, b. 1963

Benoit Aquin explores the perils of our contemporary world. From photographing the effects of the 2004 tsunami on Indonesia and Sri Lanka to recording the drastic implications of climate change in northern Quebec or overpopulation in Egypt, his work has long been characterized by a deep concern with the environment and humankind's increasingly devastating impact on it. He believes that photography can motivate people to take action on social and environmental issues and thereby effect change in the world.

One of the largest deserts in the world can be found in northern China and southern Mongolia. It is also human-made: damaging farming practices such as overgrazing and deep drilling for water have transformed vast swathes of arable land and grasslands into desert. Once the protective grass has gone, the exposed soil is swept up by high-speed surface winds into enormous dust clouds that are carried southeast across China to Korea and Japan and even as far as North America. It is estimated that these dust storms affect three hundred million people in China alone. In an effort to reverse the situation, the Chinese government has embarked on the largest environmental restoration programme ever seen, creating new cities to relocate 'ecological refugees' displaced by the advancing sands.

To raise awareness of the environmental disaster, Aquin produced this series of troubling images of a terrain homogenized and shaded by the storms. The dust gives the photographs a consistent, almost monochrome palette that makes the landscape seem magical and otherworldly. Although confronted with scenes of devastation, we are drawn into these desperate situations through Aquin's subdued, almost soothing pictures. As photography scholar William A. Ewing puts it, 'There is a great beauty to these images – a kind of Turneresque swirl of form in which people have little more substance than insects – but this beauty is held in check by the reality of what we're looking at: catastrophe, in fact, as a ballooning Chinese population squeezes (or is squeezed) onto land surfaces that can't support it.'

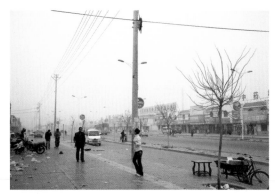

Tempête à Hongsibao, Ningxia, Chine, 2007

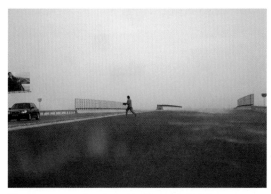

Homme rouge sur la voie rapide, Mongolie-Intérieure, Chine, 2006

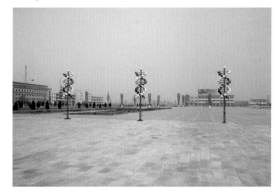

Tempête à Hongsibao No. 1, Ningxia, Chine, 2007

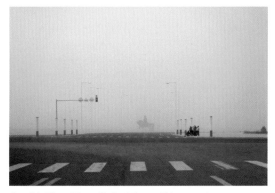

Genghis Khan, Mongolie-Intérieure, Chine, 2006

YAO LU

Chinese, b. 1967

At first glance these photographs by Yao Lu appear to be exquisitely poetic painted representations of the Chinese landscape from the Song Dynasty. But the shapes resembling waterfalls, cliffs and mountains are in fact landfills and mounds of construction rubble covered with the netting used to prevent dust from blowing away or to discourage thefts from building sites. These green drapes can be seen everywhere in today's Beijing – indeed they have become a symbol of contemporary China, a by-product of the extraordinary urbanization that is transforming the country. While to some they may seem like an ugly intrusion on the natural landscape, to many they are a welcome sign of a place 'under construction'. If a Chinese city does not have such green hills and piles covered by dustproof mesh, it may indicate that it lacks vigour and confidence and is not favoured by capital and power – that it has not entered the modernization process; in other words, that it has no future.

Yao Lu's pictures, made from photographs taken by the artist and assembled using digital technology, seem idyllic from a distance, a paradise of lush greenness and hazy mist, but get closer and one can make out the harsh actuality poking through the gaps: rubbish-strewn riverbanks, factories pumping out toxic fumes and discharge, workers making their way across contaminated areas. The images thus both reveal and conceal their truth, appearing to be one thing but in reality being another, just as the actual dustcloths both reveal and conceal the dirty consequences of modernization.

'I chose traditional Chinese painting because there is an aesthetic and poetic sense, while garbage is destructive and undesirable. The undesirable comes from what once was good, so I wanted to restore their beauty and poetic sense, to express my memory of the past. I myself don't like works full of blood and nonsense. I hope there is a concept of beauty in it. Even if it is criticism, it should be expressed in a language of praise.... Photography can be understood in traditional ways: it can "record" many histories long before our own time, and it can take people back to times and situations many years ago. But photography is also very contemporary. It can reassemble and re-edit the things that we see in order to produce illusions that people see when they are in front of such photographic works. In these works, you see images that are both real and fictional.'

YAO LU

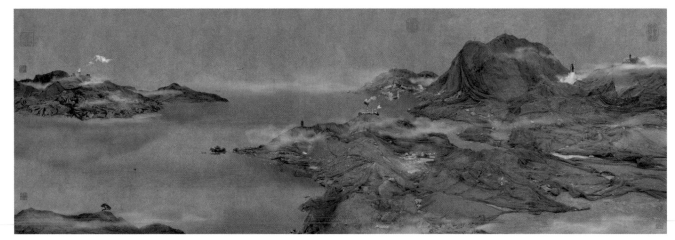

Dwelling in the Mount Fuchun, 2008

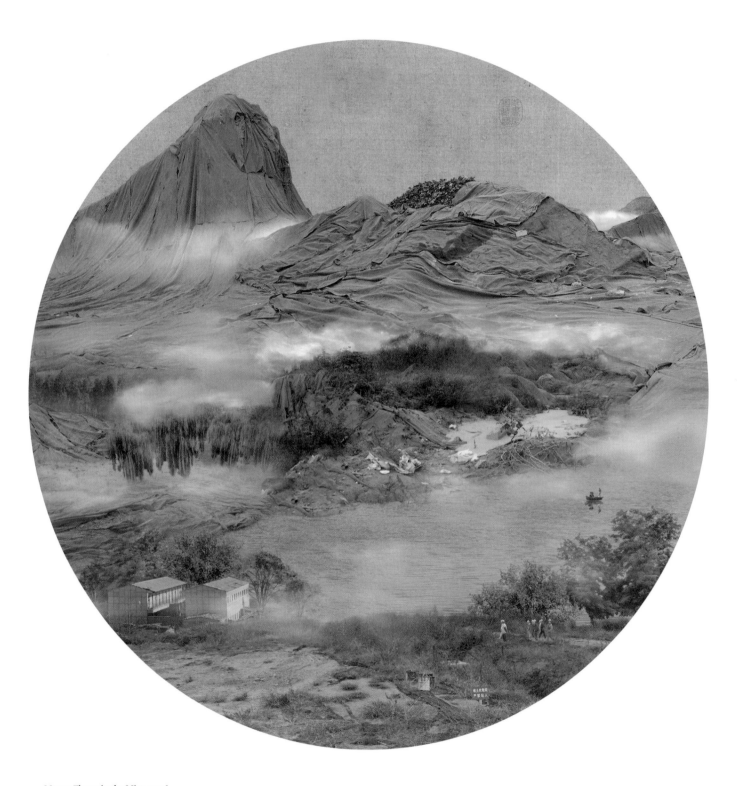

Mount Zhong in the Mist, 2006

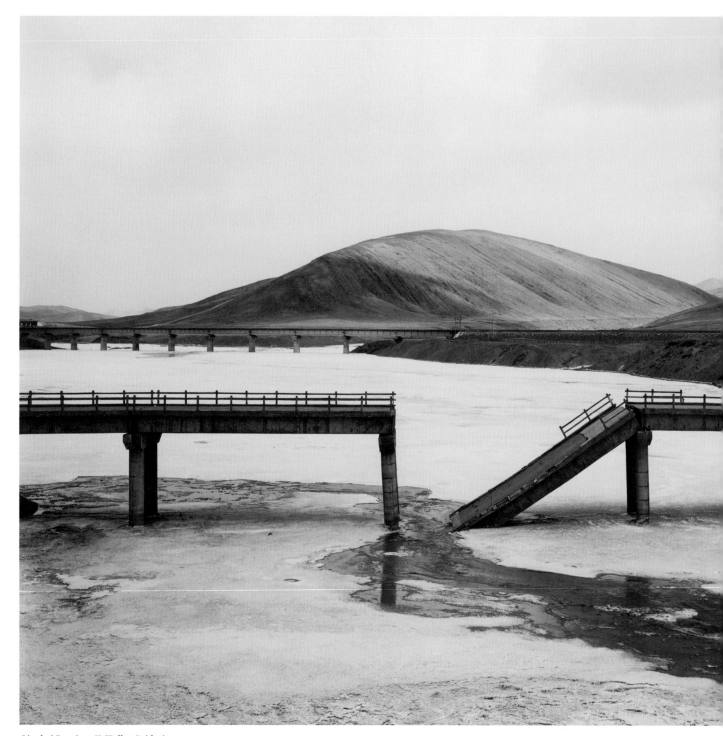

Qinghai Province II (Fallen Bridge), 2007

NADAV KANDER

Israeli, b. 1961

Nadav Kander was born in Israel but brought up in South Africa. He has won numerous international awards for his restrained yet striking photographs in a variety of genres, from nudes and portraits to still lifes and landscapes. In 2009, he won the prestigious Prix Pictet for his series *Yangtze, The Long River*. The works capture the landscape and people along the banks of the Yangtze River, the principal waterway across China, flowing some four thousand miles from Qinghai Province to Shanghai. 'The river is embedded in the consciousness of the Chinese,' Kander says, 'even for those who live thousands of miles from the river. It plays a significant role in both the spiritual and physical life of the people.'

The Yangtze is also for Kander a metaphor for the rapid change sweeping away China's past: 'It became clear that what I was responding to and how I felt whilst being in China was permeating into my pictures; a formalness and unease, a country that feels both at the beginning of a new era and at odds with itself. China is a nation that appears to be severing its roots by destroying its past in the wake of the sheer force of its moving "forward" at such an astounding and unnatural pace: a people scarring their country and a country scarring its people.'

His images, with their carefully arranged compositions and muted tones, capture an empty stillness amid all the activity taking place, creating a tangible sense of unease and anxiety. In an understated and detached aesthetic, the pictures show an ongoing battle between the forces of 'progress' on the one hand and everyday human and natural life on the other. Families picnic among the debris beneath a vast bridge cutting a swathe through the landscape. Mounds of rubble and half-built skyscrapers suggest future human-made vistas that will dominate what was once a rural view. Brave bathers swim in seemingly polluted waters against the backdrop of a factory spewing out fumes. Nature takes its occasional revenge, however, as when the river pulls down a section of a bridge.

All of Kander's works display a precise formal beauty that leaves a lasting impression. That is just as well, for as he explains, 'China's landscape both economically and physically is changing daily. These are photographs that can never be taken again.'

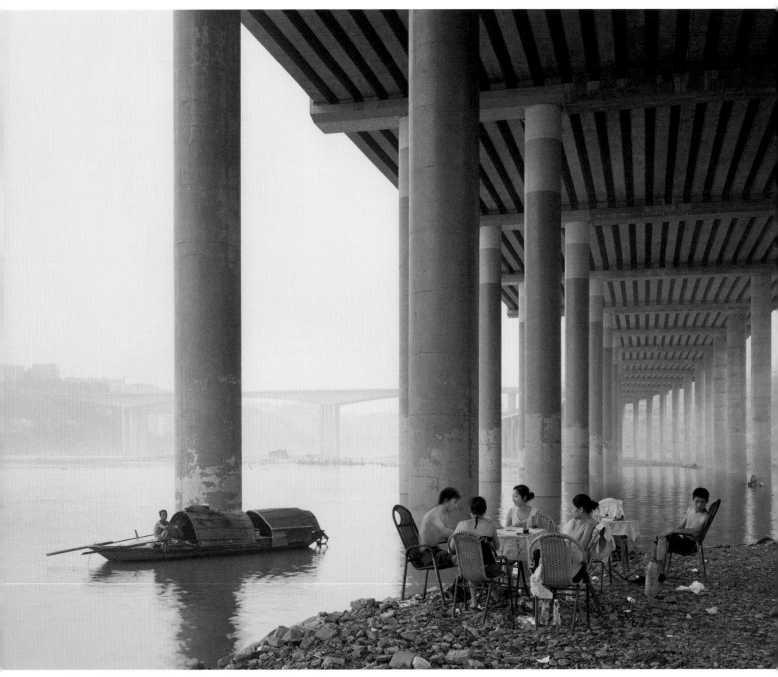

Chongqing IV (Sunday Picnic), Chongqing Municipality, 2006

'Although it was never my intention to make documentary pictures, the sociological context of this project is very important and ever present. The displacement of three million people in a 600-kilometre stretch of the river, and the effect on humanity when a country moves towards the future at pace, are themes that will inevitably be present within the work.'

NADAV KANDER

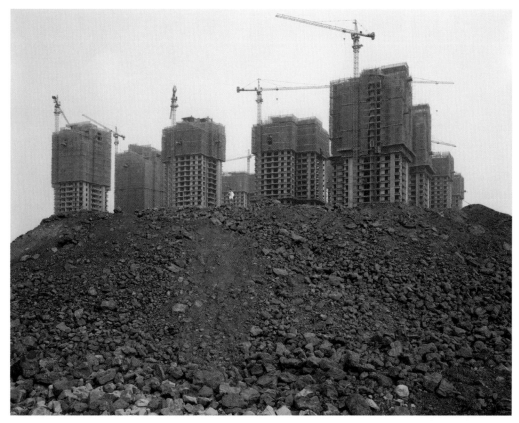

Chongqing III, Chongqing Municipality, 2006

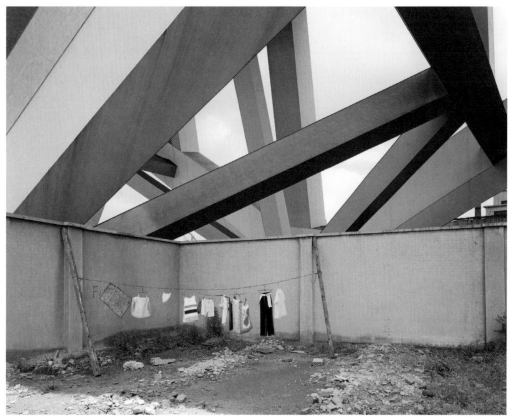

Shanghai I, 2006

DANIEL BELTRÁ

Spanish, b. 1964

Over the past two decades, Seattle-based Daniel Beltrá has photographed the Amazon rainforests, the Arctic landmass, the Southern Oceans and the Patagonian ice fields. His passion for conservation issues is evident in his striking, large-scale photographs shot from the air. This perspective gives a wider context to the human-made disasters he witnesses, as well as a delicate sense of scale and beauty.

In early May 2010, he flew over the BP Deepwater Horizon oil spill forty miles off the coast of Louisiana in the Gulf of Mexico, the largest accidental marine spill in history and the worst environmental disaster to befall the United States. The view from above revealed the immensity of the destruction and the extent of the clean-up. Five million barrels of crude oil leaked into the sea in a little over three months, covering an estimated 68,000 square miles. Two relief wells, dozens of military boats and aircraft, thousands of hired and volunteer vessels, two million gallons of toxic chemical dispersant and more than four hundred controlled burns were used to try to cap the sunken wellhead and to remove the oil that had escaped into the water. Skimmer ships, floating containment booms, anchored barriers and sand-filled barricades along the shore were all used to protect hundreds of miles of beaches, wetlands, estuaries and fishing areas from the spreading pollution. A year later, almost five hundred miles of the Louisiana, Mississippi, Alabama and Florida coastlines remained contaminated, with up to three-quarters of the spilt oil still in the local environment.

Beltrá photographed the scene on behalf of the environmental organization Greenpeace. He was 'blown away by the insane colours' on the surface of the sea, a kaleidoscope of fluorescent orange, red, turquoise, green and burgundy as waves created curves of thick oil and boats left paths of clean water through the vast expanses of blackness. The sheer beauty of the sights below contrasted with the utter devastation caused by the spill. As he put it, 'The oil-stained, blue waters of the Gulf of Mexico swirl in my mind's eye like a grotesque painting.'

Opposite: *May 6, 2010*

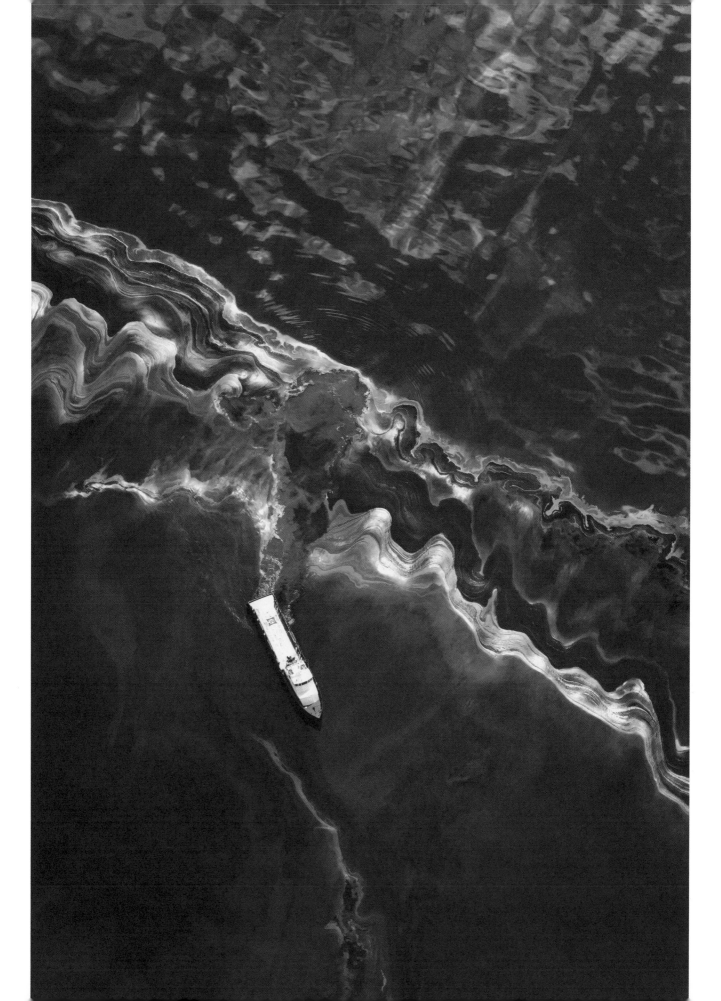

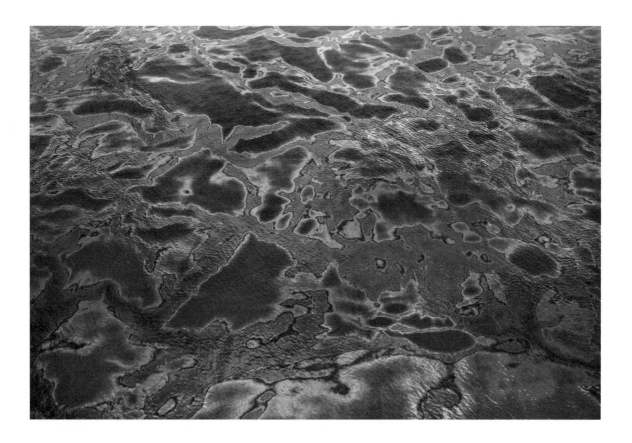

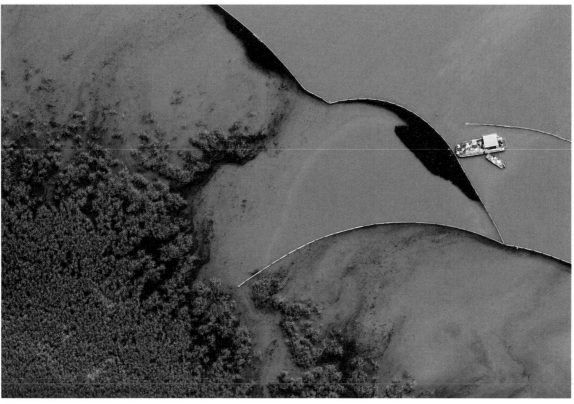

All images *May 6, 2010*

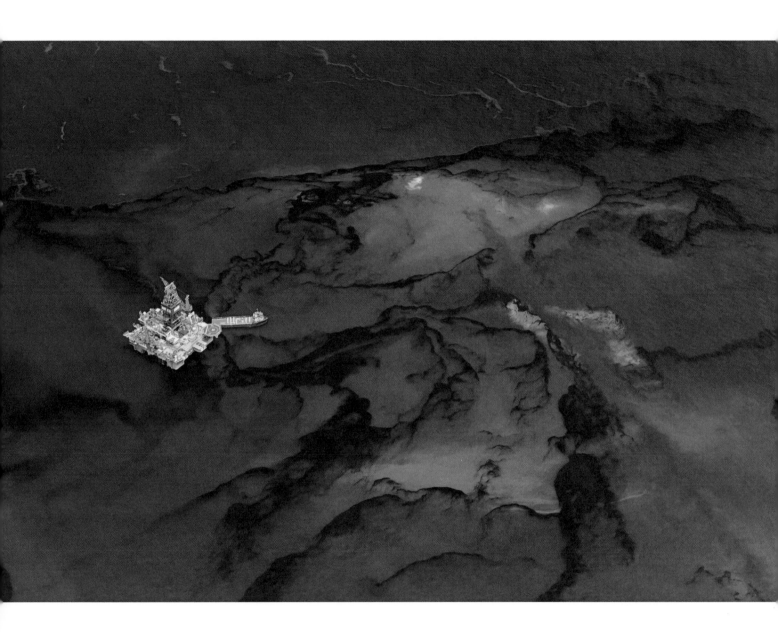

'The fragility of our ecosystems is a continuous thread through my work....
My photographs show the vast scale of transformation our world is experiencing
from man-made stresses. To capture this ... it is often best to work from the
air, which reveals the juxtaposition of nature with the destruction wrought by
unsustainable development.... By taking viewers to remote locations where man
and nature are at odds, I hope to instill a deeper appreciation for the precarious
balance we are imposing on the planet.'

DANIEL BELTRÁ

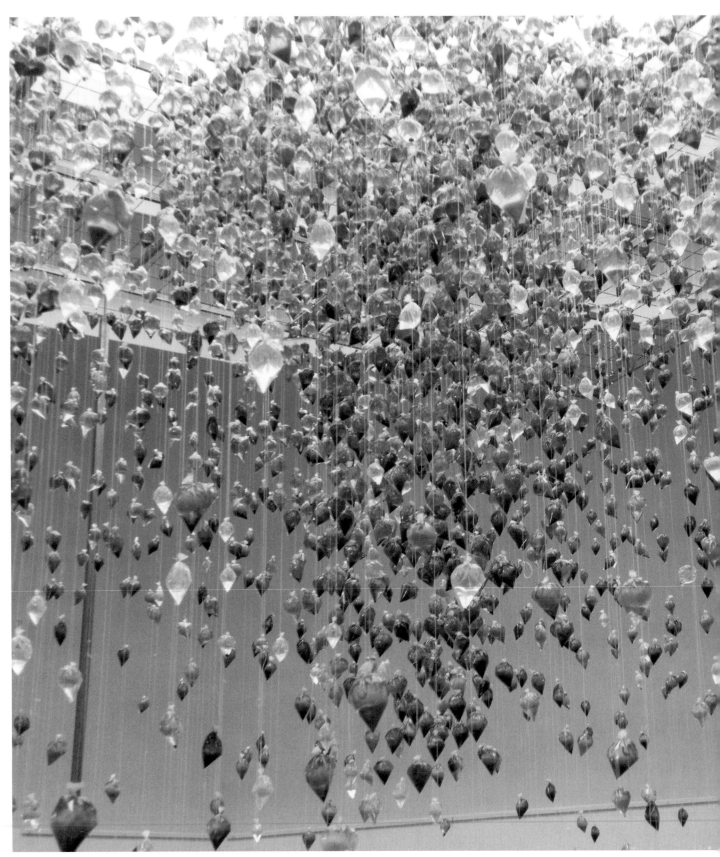

Acid Rain, 2009

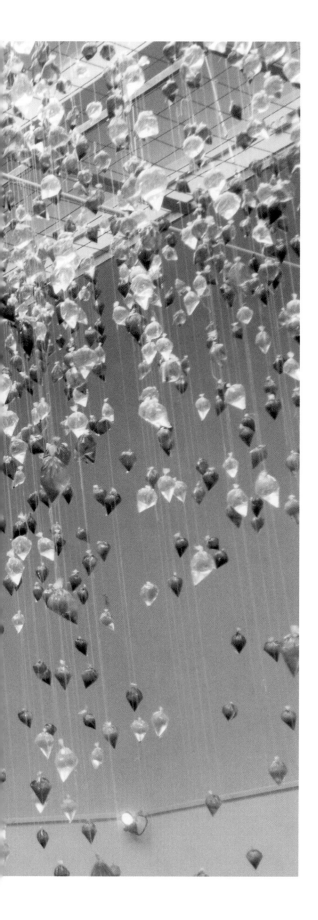

BRIGHT UGOCHUKWU EKE

Nigerian, b. 1976

Los Angeles-based Nigerian artist Bright Ugochukwu Eke focuses on the widespread disregard for the environment by polluting authorities and powerful corporations, but also on the damage caused by individuals who litter indiscriminately. In particular, he comments on how industrialization in developing countries – especially the oil-producing areas of Nigeria – has decimated the natural world and climate. A recurring theme in his work is a fascination with water and its crucial importance to our existence.

Acid Rain, which featured in the exhibition 'RETHINK: Contemporary Art and Climate Change' in Copenhagen in 2009, consists of thousands of teardrop-shaped plastic bags filled with water and hanging from the ceiling. These sparkling droplets shimmer in the light, like Christmas decorations, but closer inspection reveals that they contain charcoal-coloured carbon dust, a reference to the blackish acid rain that blights industrialized countries. The installation reflects Eke's own experience of working outside in the delta region of Nigeria, where after just two days the toxic rainfall had caused burns to his skin.

'From afar you begin to see it as rain falling, though you sense something scary. But the work is not just about looking from a distance: you have to go inside it to experience what it is like to be under acid rain. And when you are inside the work, you imagine yourself in such a situation. As an artist I don't know if I have a duty to provide a solution to the problems of climate change, but I can use my art to talk about the ills that have been caused by our interference with the environment.'

BRIGHT UGOCHUKWU EKE

HEHE

Helen Evans, British, b. 1972
Heiko Hansen, German, b. 1970

HeHe is a Paris-based partnership that defines itself as a 'platform for art, design and research, exploring new ways to integrate "binary media" in a physical environment'. Using a language based on light, sound and image, their art explores the relationship between the individual and their architectural and urban environment. Many of the duo's projects explore the possibilities of correlating physical, chemical and environmental phenomena.

Champs d'Ozone was typical in this respect. It overlaid projected live images of the Paris skyline with colours representing the unseen pollutants contained within the atmosphere. The work was connected via the internet to sensors located across the city by Airparif (an independent association for monitoring the air in the Paris region), which provided real-time analytical data on the quality of air. The colours hanging over the city changed according to the current levels of pollution. This computer-generated cloud of saturated but always changing colour reflected the concentrations of nitrogen dioxide, sulphur dioxide, ozone and particle dust suspended in the air. The work was responding to growing fears about the level of air pollution in the French capital. As Airparif states, 'One can choose the quality of our water or food, but not the quality of the 15,000 litres of air that each of us breathes in one day and which is transported into our body, the oxygen as well as the dust and gas pollutants.' *Champs d'Ozone* also pays homage to the memory of the four hundred people who died because of ozone in nine French cities, including Paris, during the record-breaking heatwave of 2003.

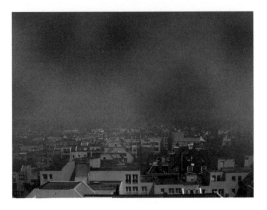

But the work also raised questions about how scientific data – in this case statistics measuring environmental change – are mediated and presented to us. The reading of the cloud code was left entirely up to the viewer to decipher. Is a red cloud more toxic than an orange one? Might there be such a thing as zero pollution and what colour would that be? And since colour is a continuous spectrum, with one end resembling another, how can we distinguish between maximum and minimum levels of pollution at all? Isn't such a coding system in fact meaningless?

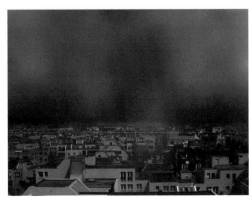

All images *Champs d'Ozone*, 2007

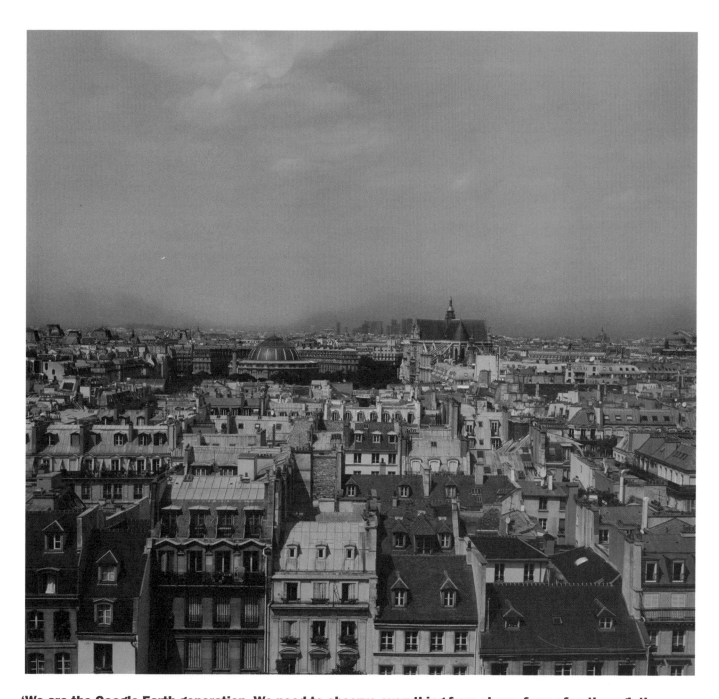

'We are the Google Earth generation. We need to observe everything from above, from afar, through the glasses of a scientific model. Perhaps one day we will have to install a machine on the moon to measure nanopollution on Earth? Maybe it is a design approach, to cut through layers of representation and to project the pollution back onto the air of Paris, to the place in which it exists and where it concerns us. All these models pose questions. Do the models just complete our imagination and reinforce the fact that we are doomed to live in the disaster we have conjured? We already live in the reality evoked in *Champs d'Ozone*. In Paris, a chemical microclimate repeats itself in a daily tidal routine: as the ozone rises and falls with traffic peaks. On the other hand, are we not measuring what we know already? The new hi-tech materials burnt in incinerators will release pollutants for which we haven't yet developed the sensors to monitor.'

HEHE

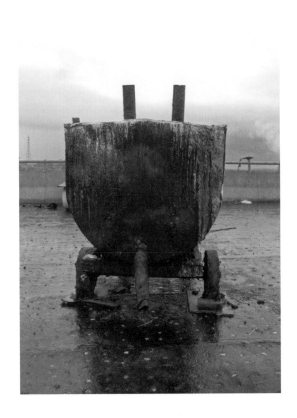

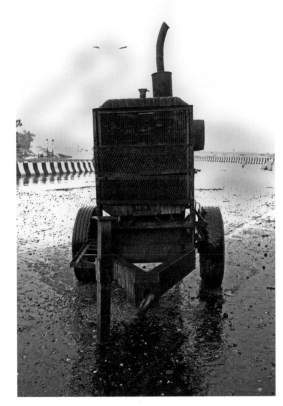

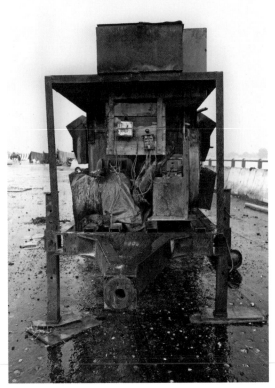

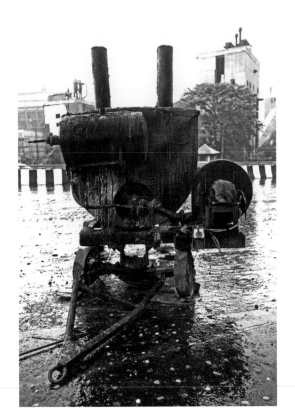

All images from the *Tar Machines* series, 2011

RAVI AGARWAL

Indian, b. 1958

Originally trained as an engineer, Ravi Agarwal is an artist, activist, writer and curator. He is also the founder of the leading Indian non-governmental organization Toxics Link, which campaigns on global waste and ecology matters. He first came to international attention in 2002, when he was invited to show his photographs at that year's 'Documenta' exhibition in Kassel, Germany.

Agarwal's photographic and video art often takes the form of social documentary and reflects a deep concern with issues of nature, work, urban development and ecological sustainability, as well as the cultural traditions of his native land. In particular, he charts the landscape of the New Delhi area, most often focused on the Yamuna River. It is an area undergoing rapid change, with urbanization destroying the centuries-old environment. 'There is no breathing space left around me any more,' says Agarwal. 'Everything is fluid and in flux. The city is in transition and I seek spaces for keeping myself intact, which is what the work is about. At one time, for instance, one could see a coin thrown into the Yamuna; now that is impossible.'

For his photographs of iron tar-boiling machines, used to lay new roads across the countryside, he took 'straight, frontal and deadpan-like' shots of the machines, presenting them as 'sculptural forms' in a way that is similar to the German couple Bernd and Hilla Becher, whose serial images of industrial structures Agarwal acknowledges as an influence. 'Old machines fascinate me, the whole idea of decay and productivity. In the rain, they looked real and alive.' Indeed, these rusty, hulking machines seem almost to be advancing stealthily up a slick new road blackened with their own power.

'I am not suggesting that we go back to paradise, go back to nature. The challenge is what sustainability means. It's not only about the challenge of technology, of production or consumption, but challenges of self in relation to the environment around us. Social power and politics and ideas of self start influencing how we can imagine something, how we change something.'

RAVI AGARWAL

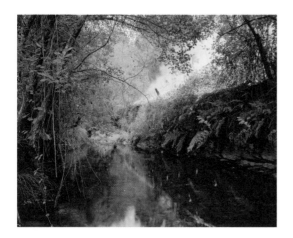

EDGAR MARTINS

Portuguese, b. 1977

In 2005 and 2006, Edgar Martins photographed the forest fires then raging across Portugal, creating images that are rich in seductive, painterly, atmospheric effects. Like many parts of southern Europe, the country often suffers from wild fires caused by long periods of drought and high summer temperatures. In recent years, these conflagrations have become more frequent and more damaging, wiping out huge areas of woodland and leaving death and destruction in their wake. For many, they are a sure sign of global climate change. But they are also the product of gross mismanagement of the land. Many of the forests destroyed in 2005 and 2006 had only recently been planted with eucalyptus, a fast-growing but highly flammable tree that is often used in reforestation projects. Martins's works tell the story of this self-inflicted 'natural' disaster while creating images of intense beauty that belie the devastation wreaked by the flames.

Martins organized his project with the assistance of the National Fire Protection Unit and trained with firefighters before being allowed to operate alongside them. He worked as close to the flames as he could, employing a wide-angled lens to create panoramic shots that give the viewer the sense of being on the spot. But working so close to the fire had some unintended results: the photographic film was affected by the intense heat and became 'foggy', which added to the smoky atmosphere of the scenes.

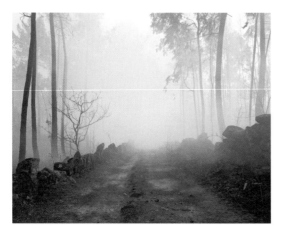

All images *Untitled*, from the series
The Diminishing Present, 2006

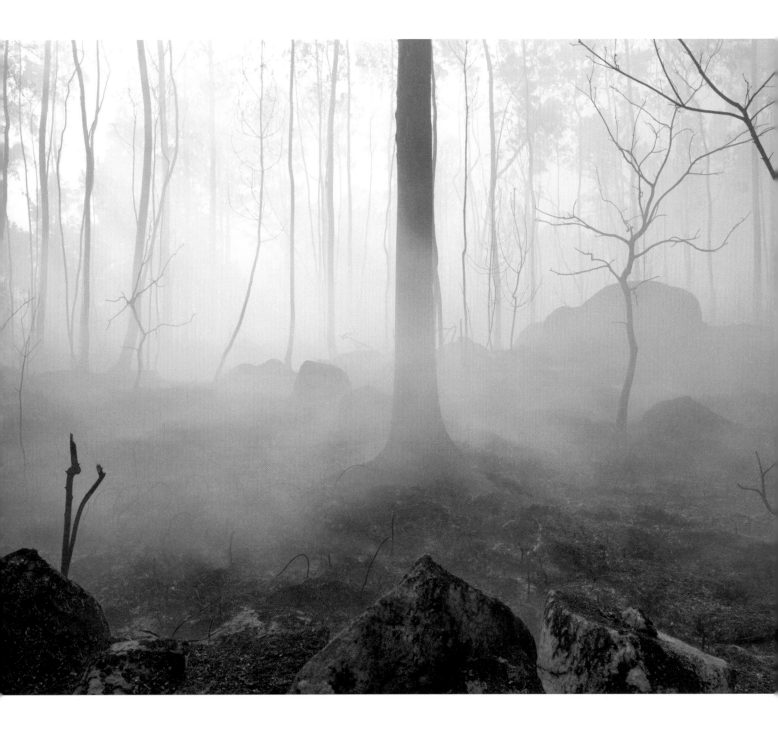

'I approached *The Diminishing Present* within the pictorial traditions of Arcadian and romantic painting. However, despite all its historical evocation and appeal to the sublime, these images reflect on something rather more sinister: the death of the physical landscape as well as the death of landscape as a pictorial theme.'

EDGAR MARTINS

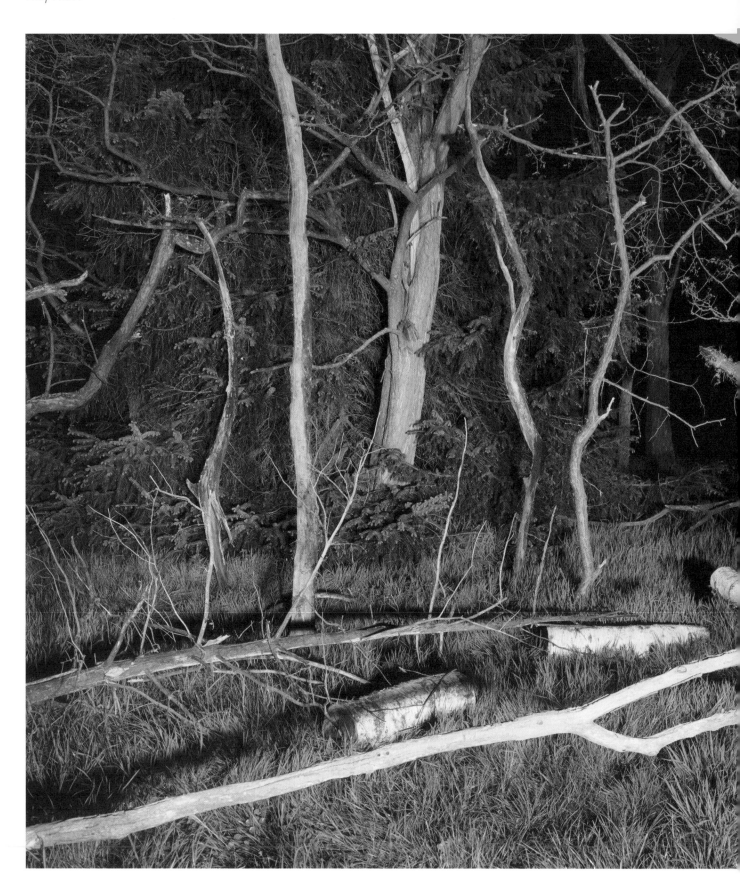

MARJOLIJN DIJKMAN

Dutch, b. 1978

Through her diverse work, Marjolijn Dijkman considers the foundations of how we perceive and experience our environment – the conventions and categories that underlie the comprehension of the world around us. She is interested in how we create a sense of place, and how traces of the human – both deliberate and accidental – can be seen everywhere in the landscape. Many of her works question or rethink existing forms of representation or organization, and explore alternative ways of relating to our surroundings.

For *Forest*, Dijkman examined the authenticity of the Dutch wooded landscape. In the Netherlands, nearly all of 'nature' is made or designed in some way, whether in the form of reclaimed land, landscaped parks or managed woodlands. What may appear to be natural is almost entirely human-made. In order to shine a light, literally, on this fact, the artist selected a number of forest sites, constructed arrangements of trees for the camera, and then illuminated the settings at night with two strong, gas-powered lights. The intense, constant light creates a sublime, accentuated appearance that brings out the detail of every leaf and branch with precise clarity. But this heightened visual information serves only to render the scenes more artificial and otherworldly. After Dijkman had taken the photographs, she left these set-ups behind in the forest for unsuspecting passers-by to encounter.

Forest, 2001

KATIE HOLTEN

Irish, b. 1975

'I'm concerned with environmental issues. I think there are fundamental misunderstandings of the "environment" and "landscape" (the environment is our surroundings and that can be apartment buildings and offices in Manhattan, not only meadows, forests and whatever else people tend to think of as "nature"). I don't want to preach or be didactic with my work, but I want to make people curious and maybe think a bit more about these fundamental issues.'

KATIE HOLTEN

Katie Holten makes drawings, sculptures and books; she also organizes events that often have an environmental message. At the root of her practice is an understanding that the environment is not somewhere else. In her words, 'Nature is not far away on an abandoned island or in a prairie; it is everything around us, including unforgiving city streets and inherently urban communities.'

In December 2007, Holten was commissioned to create a public art work to celebrate the centenary of the four-and-a-half-mile stretch of the Grand Concourse, the historic boulevard connecting Manhattan to the parks of the north Bronx. She decided to work with street trees, as they are the most palpable connection most city dwellers have with nature. She walked the Grand Concourse countless times for months, photographing the entire length and documenting the street through drawings of its trees, some of which date back to before the Concourse was constructed. Along the way, she also met hundreds of people and gathered their stories.

The resulting *Tree Museum* was vast, ten miles in length, and yet the project was almost invisible and launched with little fanfare in June 2009. One hundred street trees, from 138th Street at the southern tip of the Grand Concourse to Mosholu Parkway at the north, became the entrances into a kind of urban 'museum-without-walls'. Holten installed sidewalk markers to identify each of the trees by species and location number. By keying the number into a mobile phone, the walking 'museum-goer' could listen as a local resident, gardener, musician, student, activist or someone with a connection to the area shared information about the place.

The recording for Tree #69, situated outside the 1929 landmark Loew's Paradise, detailed the rise of that opulent movie palace via the lively commentary of an architectural historian; while the one for Tree #1, at the southern end of the Concourse, featured a poet reading a haiku about the neighbourhood. Stories included the way that weather affects tree growth, the glory days of the street in the 1920s, invitations to visit nearby community gardens, and descriptions of the pre-Concourse Bronx with farmland as far as the eye could see. Other segments introduced the sounds of the borough's trees, animals and insects. The audio guide thus linked the natural and social ecosystems in an art work that resembled its subject. Its roots reached down into the history of the place, while its branches spread out and offered insights into the resilient communities, fragile ecologies and vibrant daily scenes to be found along the street. The work sought to make the hidden elements of the street visible so that pedestrians could experience the city in unexpected ways and appreciate their natural environment anew.

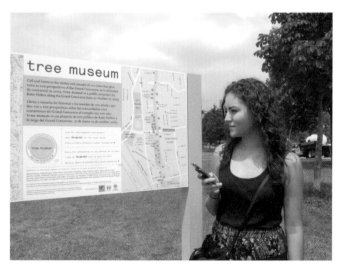

All images from *Tree Museum*, 2009

43

SPECIES
Red Squirrel, *Sciurus vulgaris*

LOCATION
Westbourne Park, 2005

RARITY
Extinct in London, last seen Hainault Forest, 1950s. Catastrophic decline and threatened in UK. IUCN RDB3.

SPECIMEN
Courtesy of Horniman Museum

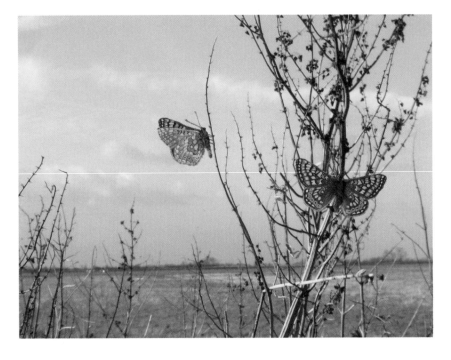

SPECIES
Marsh Fritillary, *Eurodryas aurinia*

LOCATION
Tydd St Giles Fen, 2005

RARITY
Priority species protected under Annex II of the EC Habitats Directive; lost from Fens, pre-1940s. Restricted to West UK.

SPECIMEN
Courtesy of Bedford Museum

SUKY BEST

British, b. 1962

In 2005, London-based agency Film and Video Umbrella commissioned Suky Best to create *The Return of the Native* as part of 'Silicon Fen', a long-running visual arts project that took place across the east of England between 2004 and 2007, and which considered how landscape in general (and the East Anglian Fens in particular) has been affected and reflected by technology. The Fens have long been a constructed and managed landscape, but recent use of the land has exacerbated the loss of flora and fauna: over the last fifty years, the volume and variety of birds and insects have declined dramatically.

In *The Return of the Native*, Best highlights a number of species that were once commonplace in the East Anglian Fenland and whose numbers have diminished to such an extent that they are now considered rare, endangered or extinct in the region. She brings the creatures back to life by photographing specimens from local museum collections and reintegrating them digitally into contemporary settings. Across a series of still images and video animations, she 'reintroduces' several indigenous species into places they were once commonly found. Best subsequently extended the project to include threatened species in urban London.

All the scenes depicted in *The Return of the Native* appear constructed, a blend of fact and fiction (like 'faked' or hoax Victorian composite photographs) – a deliberate attempt to make clear that the images do not represent reality. Best wanted them to look 'convincing but not too real' in order to emphasize that they depict something that has been lost and can never be recovered.

'The title of the piece described the work, referencing Thomas Hardy's novel *The Return of the Native*, which is about doomed relationships after a man returns to his village after a successful career abroad. I wanted there to be some impossibility of success in returning the species to their native places.'

SUKY BEST

SPECIES
Bombadier Beetle, *Brachinus crepitans*

LOCATION
Queens Park, 2005

RARITY
Notable species, rare and in decline in London; scarce in the UK. Wasteland species, threatened by loss of wasteland areas to development

ORIGINAL IMAGE
Courtesy of Roger Key

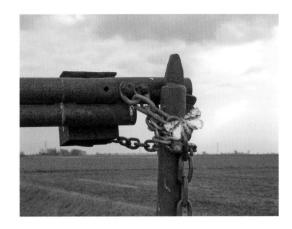

SPECIES
Marsh Dagger Moth, *Acronicta strigosa*

LOCATION
Tydd St Giles Fen, 2005

RARITY
RDB3 Rare

LAST SEEN
Fens, 1939

LAST SIGHTING
Rye, 1996

SPECIMEN
Courtesy of Bedford Museum

ANDREJ ZDRAVIČ

Slovenian, b. 1952

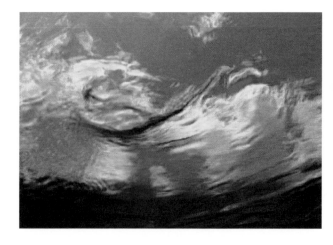

For more than three decades, film and sound artist Andrej Zdravič has captured the elemental poetry that can be found in running water, rolling cloud and bubbling lava. In the mesmerizing *Riverglass: A River Ballet in Four Seasons* he immerses the viewer into the emerald-turquoise streams of the Soča River, which flows from the peaks of the Julian Alps in Slovenia down to the Adriatic Sea. Over four years, he placed his camera beneath the surface and recorded the living drama of the river – the pulsating blue-green volumes of water, surging bubbles, flashing sunlight, dancing stones, rushing fish – presenting the images alongside a soundtrack of abstracted noises such as slowed-down birdsong. We see just enough of the surrounding mountainous terrain to establish that the film begins in winter and moves through the four seasons of the work's title.

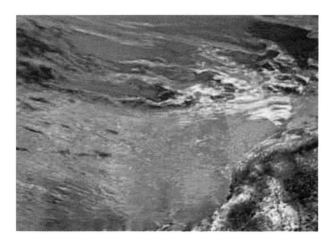

A lyrical, hypnotic river dance set to the music of environmental sounds, *Riverglass* is a work of breathtaking beauty, confounding expectations that environmentally engaged art must be polemical and deal directly with some kind of ecological or political issue. It contains no human presence, no story of political injustice or destruction. It offers nothing but the images and sounds of a flowing river – from within the river – through the course of a year. And yet it is a deeply ideological work, for it transforms our awareness and perceptions of the natural environment. By placing us firmly 'in nature', by slowing down the passage of time and by focusing on seemingly insignificant details of the landscape and the changing seasons, it enables us to meditate on our relations with the non-human world. It subtly declares that our environment is not merely a backdrop against which we act out our lives, but a place that is deserving of our sustained attention and commitment.

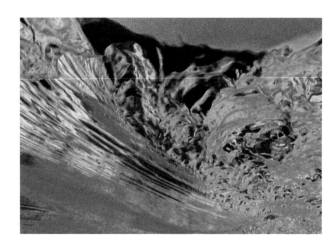

'The vivid colours and rhythms of the river become a source of philosophical and spiritual insight. *Riverglass* is a reflection of my endless fascination with the forces of nature, forces that contain universal principles of life and the seeds for a new kind of narrative cinema.... It is educational, it is therapeutic. I don't think you can change people by telling them what to do. It just has to happen inside and you've got to have an experience. And when I make films like this, it's not that I have a plan to make a statement, but it just happens. It's creating experience, it's a vehicle.'

ANDREJ ZDRAVIČ

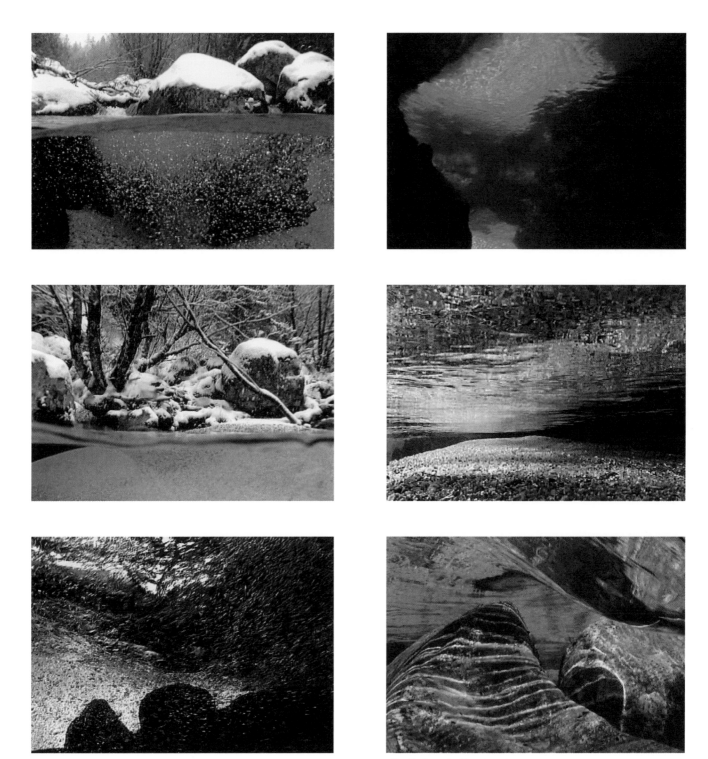

All stills from the film *Riverglass*, 1997

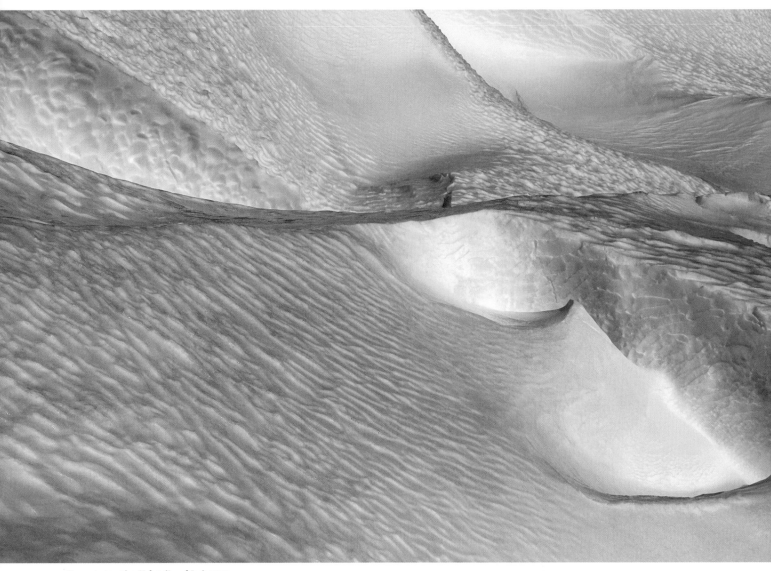

From *Antarctica Vol. 2 (Land Ice)*, 2009

'We live on a rare and magnificent planet of profound beauty. Though human beings hold the wisdom for remarkable and benevolent creativity and innovation, lingering in the shadows [are] the devastating consequences of our avarice. This "beauty and the beast" conundrum presents a compelling place for me as an artist to begin witnessing our relationship to Earth. The visible consequences of humanity's footprint upon the natural world [have] ignited within me a desire to document these impacts more directly.... *The Polar Project*'s mission is to capture the natural environment of these precious regions to preserve their image and voice for future generations and to inspire awareness and change now.'

ERIKA BLUMENFELD

ERIKA BLUMENFELD

American, b. 1971

In 2009, American artist and photojournalist Erika Blumenfeld was invited to join an expedition to Antarctica as a team member of the Interpolar Transnational Art Science Constellation (ITASC) and guest of the South African National Antarctic Program. As official artist-in-residence, she lived for six weeks amid the vast icy terrain.

The resulting *Antarctica* project consists of three volumes of photographs and a four-channel video piece. The 'Early Sea Ice' volume shows the Southern Ocean beginning to freeze as autumn approaches. As the temperature drops, the surface water, which contains less salt, turns to ice first. The ocean is never still, so the new pieces of ice move gently on the surface, bumping into and eroding each other, resulting in their round shape, called 'pancake ice'. The 'Land Ice' volume of photographs portrays the extraordinary ice formations that are created by the fierce winds in Antarctica, which can surpass even hurricane force. The 'Ice Horizons' volume depicts the stunning colours that occur when sunlight bounces off the ice fields. As Blumenfeld explains, with ice particulate blowing constantly across the snow- and ice-covered ground, virtually everything in this landscape is a refracting surface that scatters and bends light: 'Antarctica literally holds light within it.' The video work *Apparent Horizons: Antarctica (a vision in four parts)* documents these same aspects in real-time footage.

Blumenfeld's images are stunningly beautiful, but her intention is more than purely aesthetic. She hopes not only to share the visceral experience of being in this fragile yet vital ecosystem, but also wants her work to be a conduit for people to learn about the global and local issues of climate disruption.

From *Antarctica Vol. 1 (Early Sea Ice)*, 2009

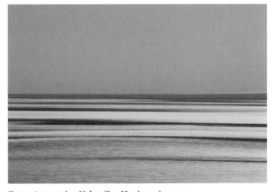

From *Antarctica Vol. 2 (Land Ice)*, 2009

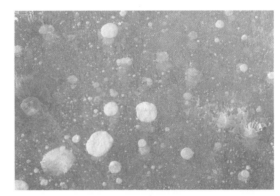

From *Antarctica Vol. 3 (Ice Horizons)*, 2009

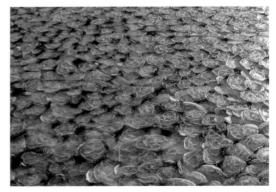

From *Antarctica Vol. 1 (Early Sea Ice)*, 2009

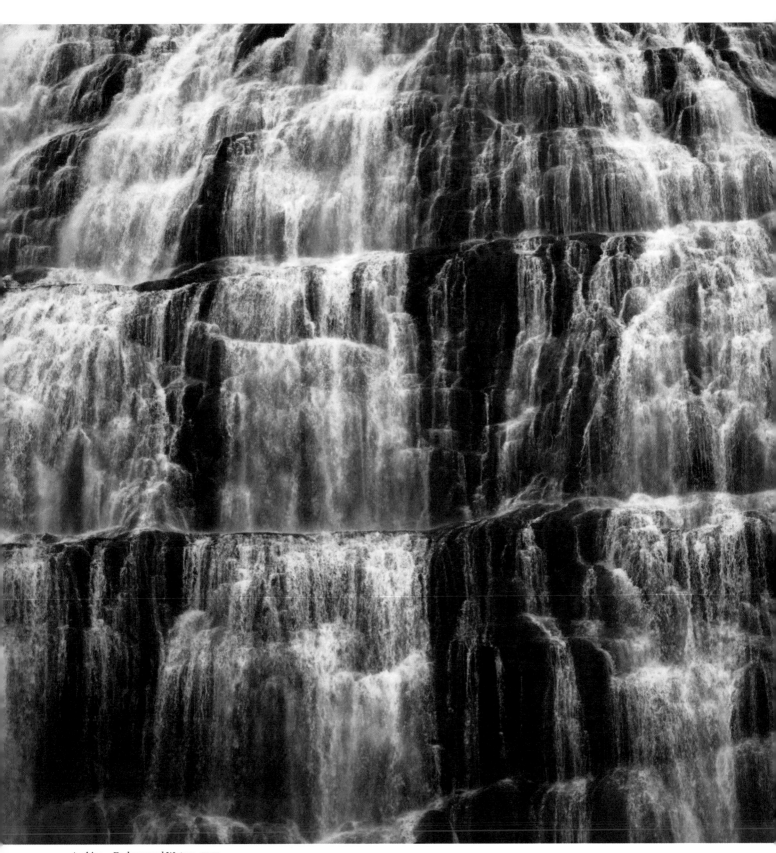

Archive – Endangered Waters, 2003

RÚRÍ

Icelandic, b. 1951

Iceland is celebrated for its hundreds of waterfalls, each one a spectacular natural beauty spot with its own unique appearance and character. However, growing demand for energy and the power companies' pursuit of profit have threatened their survival. Large-scale infrastructure projects like the recent construction of the Kárahnjúkar hydropower plant and dam in the east of the country have seen many waterfalls disappear under vast new reservoirs.

Scandalized by this exploitation of one of Europe's last remaining areas of untouched wilderness, Rúrí made several long and dangerous expeditions to Iceland's glacial rivers, photographing and recording the sound of the roaring waters. Her *Archive – Endangered Waters* installation, which was exhibited in the Icelandic Pavilion of the 2003 Venice Biennale, documents these imperilled natural treasures. It consists of fifty-two large photographs mounted between fragile glass in steel frames, which are installed in a large archiving unit and can be pulled out for inspection. When a frame is pulled out, the recorded sound from the waterfall on the photograph starts playing. Each one has its own voice, from gentle gurgling to deafening roar. When the frame is pushed back into its slot, the sound stops. Up to five photographs can be pulled out at the same time, the images blending into one another to create a visual composite, while the sounds merge to form a water symphony that changes as different frames are pulled out and reinserted. The work thus reacts to the actions of the viewer, who 'plays' the hauntingly beautiful 'music'. But when the sound stops, silence sets in – a pointed reminder of the empty void that is left when the waterfalls have gone.

Archive – Endangered Waters is both a lasting record of Iceland's natural environment and a warning of the future to come if human 'progress' continues to threaten the planet. Since it was created, almost half the waterfalls featured have been damaged or destroyed entirely. Eventually, the piece may become a monument to Iceland's lost waterfalls. Yet at the same time, it points, perhaps knowingly, to a paradox of much eco-art, for it is made from materials – glass, steel, photography, electricity – that depend on many of the industrial processes that cause environmental damage.

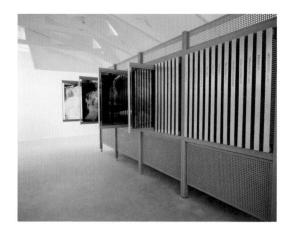

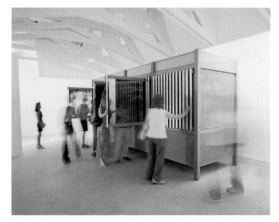

All images from an installation of
Archive – Endangered Waters, 2003

'For me art is philosophy. My works are concerned with the connections between man, the earth, and the universe; between the existence of mankind and the inestimable age of the universe; human perceptions.'

RÚRÍ

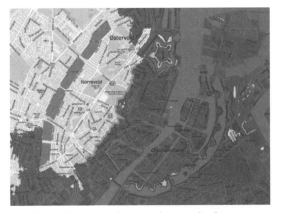

Map showing Copenhagen's potential new sea level, created by KMS

For *waterknowsnowalls*, Haubitz+Zoche applied a blue line transferring the contour line from the map to the actual space of the city.

HAUBITZ+ZOCHE

Sabine Haubitz, German, b. 1959
Stefanie Zoche, German, b. 1965

The German duo Haubitz+Zoche are two Munich-based artists who work in a variety of media, including photography, video, installation and architecture. In 2009, they painted a blue line that meandered its way through the centre of Denmark's capital, Copenhagen, marking an elevation of twenty-three feet above the current sea level. This height corresponds to the predicted average rise in the global sea levels that would occur if all the inland ice of Greenland were to melt due to climate change.

Haubitz+Zoche took this calculation as their starting point for an investigation into the environmental consequences for Copenhagen. They commissioned a map from the Danish National Survey and Cadastre (KMS) that showed which areas would be flooded as a result of rising sea levels. It demonstrated that more than half the city would be flooded, with several key neighbourhoods disappearing under water. The artists then marked out what would be the new waterfront with a line of blue paint almost two miles long, making the scientific evidence visible in a very direct and real way.

In the related *Lighthouse Project*, Haubitz+Zoche installed a revolving spotlight some two hundred feet up the bell tower of the former St Nikolaj Church, now a contemporary art centre. The white light beamed a coded signal into Copenhagen's night-time urban space, transforming the tower into a temporary lighthouse. Haubitz+Zoche also commissioned KMS to include this new landmark on a nautical map of the city's harbour. As with the blue line, this artistic intervention creates an unexpected shift in perspective and invites the observer to take an unconventional view of the consequences of climate change.

Opposite: Lighthouse Project, 2009

Atlantis Finland, 2007

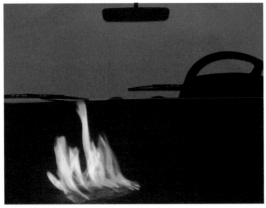

Atlantis Copenhagen, 2007

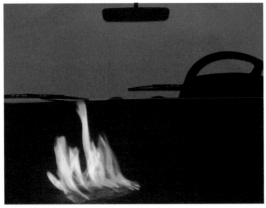

Motocalypse Now, 2007/8

TEA MÄKIPÄÄ

Finnish, b. 1973

Tea Mäkipää's sculptural installations, videos and photographs communicate a deep concern with ecological issues, in particular global consumer culture, the rapid decrease in biodiversity and humankind's coexistence with other species. In each of her works, she seeks to create an experience that equalizes our own species with others, and that allows us to see ourselves as an outsider might. Although her art expresses a profound anxiety over the sustainability of human life on Earth, it often does so with touches of humour and irony.

Her sculptural piece on the dangers of global warming, *Atlantis* (a collaboration with Icelandic artist Halldór Úlfarsson), situates a small cabin in the middle of a lake or river. The dwelling floats on the water, precariously tilted on its side as it slips beneath the surface. And yet lights shine out from the windows, and sounds of a normal family life come from within, the occupants seemingly unaware of their imminent fate.

A more catastrophic vision is expressed in *Motocalypse Now*, which points to the role of the automobile in the destruction of the planet. This disturbing piece presents passengers trapped within a burning car, their frantic screams ringing out loud. As with many of Mäkipää's works, *Motocalypse Now* conveys a bittersweet sense that we are our own worst enemy, that in striving for short-term happiness and instant gratification we sacrifice our long-term survival.

In another series, *Link*, a video and series of photographs tell the story of a half-human, half-ape character living with his mother on a small island in a remote part of Finland, far away from civilization. But their simple and idyllic life is disrupted by the arrival of a young journalist with whom Link falls in love. This work is a wry comment on humankind's refusal to adapt to its environment and our insistence that nature adapts to us instead.

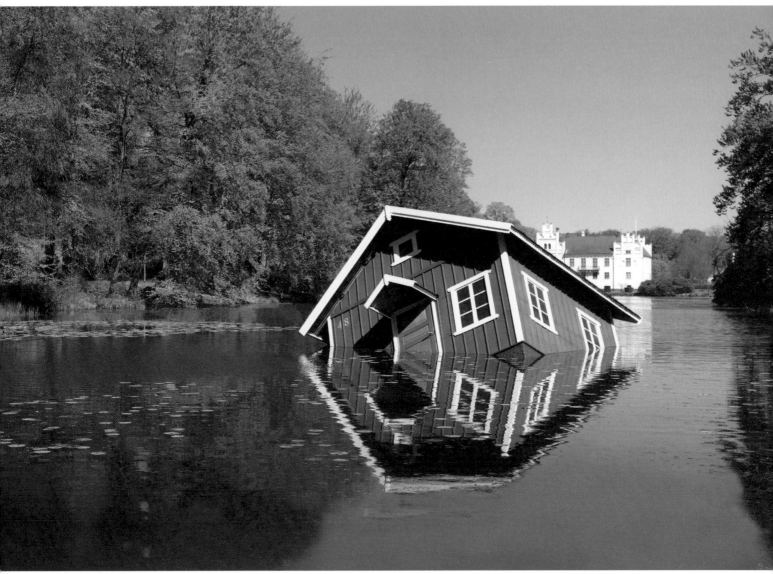

Atlantis Wanås, 2007

'The feeling of global guilt connected to frustration and powerlessness can be fought against by introducing the ecological viewpoint and integrating it in all kinds of education.... Feeling sad in front of the extinction of another species of animals or plants is the first step to new consciousness. Feeling sorry is the least we can do, but of course it must lead to action in daily life.'

TEA MÄKIPÄÄ

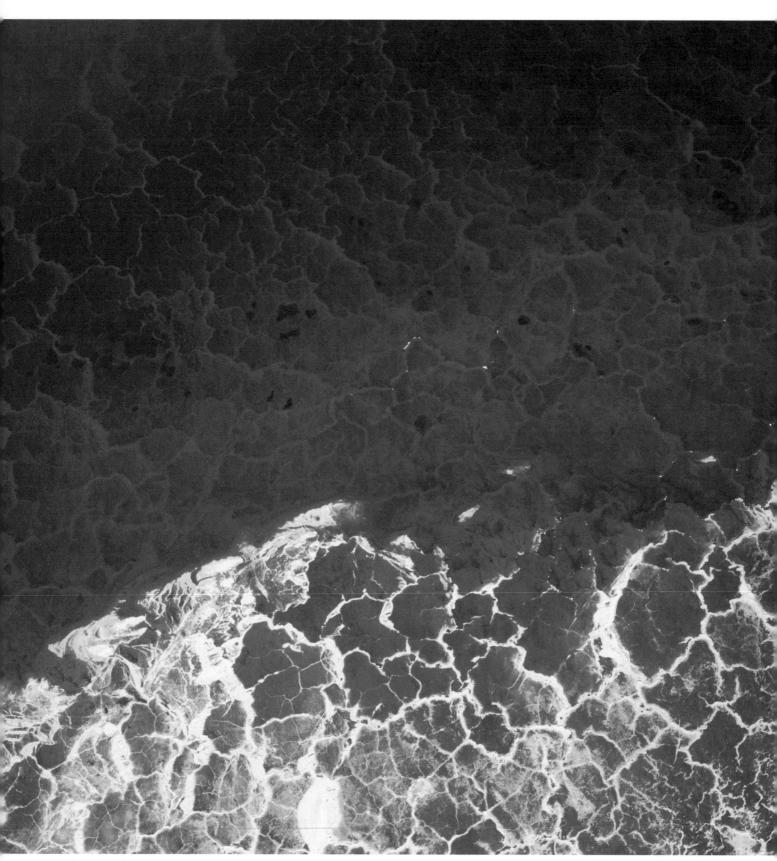

The Lake Project 20, 2002

DAVID MAISEL

American, b. 1961

David Maisel's large-scale photographs show the physical impact on the land from industrial efforts such as mining, logging, water reclamation and military testing. Because these sites are often remote and inaccessible, he frequently works from an aerial perspective, thereby permitting images and uncovering photographic evidence that would be otherwise unattainable. His otherworldly images chronicle the relationships between natural systems and human intervention, framing the issues of contemporary landscape with equal measures of documentation and metaphor. As art critic Leah Ollman has stated, 'Maisel's work over the past two decades has argued for an expanded definition of beauty, one that bypasses glamour to encompass the damaged, the transmuted, the decomposed.'

The Lake Project comprises images of Owens Lake, the site of what was a two-hundred-square-mile lake in California. Over the course of the first quarter of the twentieth century, the lake was depleted in order to bring water to Los Angeles. What was once a fertile valley became an arid landscape of vast exposed flats. Fierce winds pick up tiny carcinogenic particles from the lakebed, creating poisonous dust storms that carry tons of cadmium, chromium, arsenic and other deadly materials into the atmosphere. The high concentration of minerals in the little water that remains encourages the growth of microscopic bacteria that turns the liquid a deep red. None of this is explicit in the photographs, as Maisel explains: 'I don't caption my images or even title them in a manner meant to sway audience reaction. I want them to exist as visual images first and foremost, but their power comes from examining sites that are contested, difficult, and damaged. They are intended to offer a sense of what has been lost, what the structure and forms of our civilization are taking, and perhaps, views of the problems we face and that we've collectively created.' He considers his topographically uncertain images of the lake to be landscapes of the human psyche, eliciting a deep sense of loss and abandonment, immersion and submersion. In some, strangely human forms seem to have been etched into the surface of the Earth as if by some immense hidden hand.

The Lake Project 1, 2001

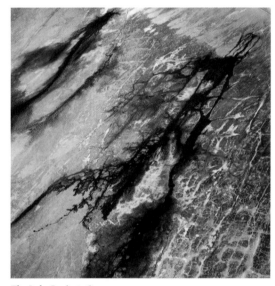

The Lake Project 38, 2002

'The lake has become the locus of water's absence, a negation of itself, a void. The images serve, in a sense, as the lake's autopsy. Viewed from the air, vestiges of the lake appear as a river of blood, a microchip, a bisected vein, or a galaxy's map. It is this contemporary version of the sublime that I find compelling – a strange beauty born of environmental degradation.'

DAVID MAISEL

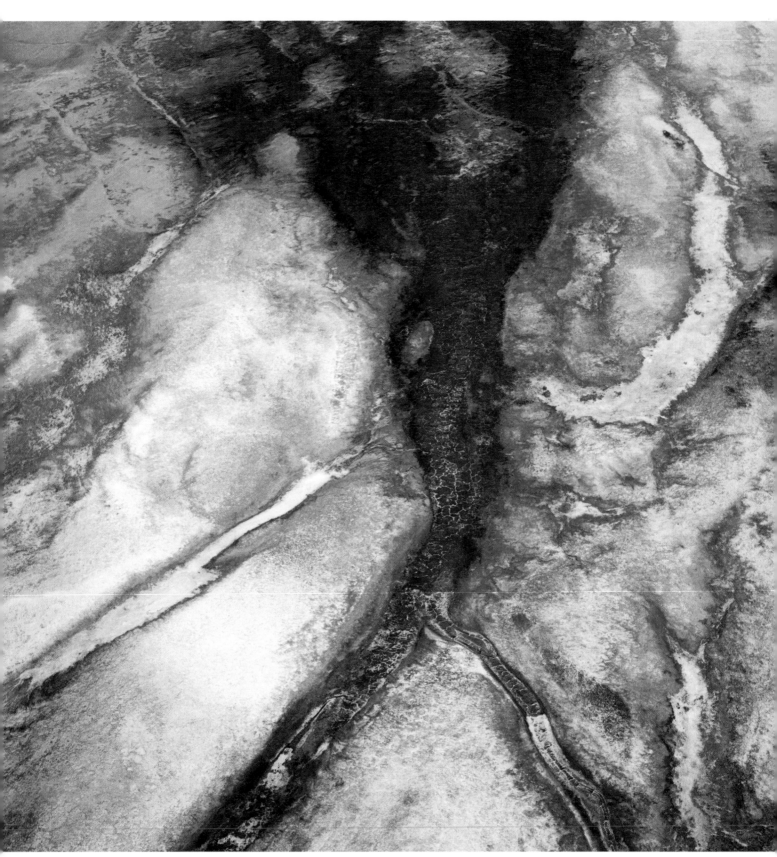

The Lake Project 11, 2001

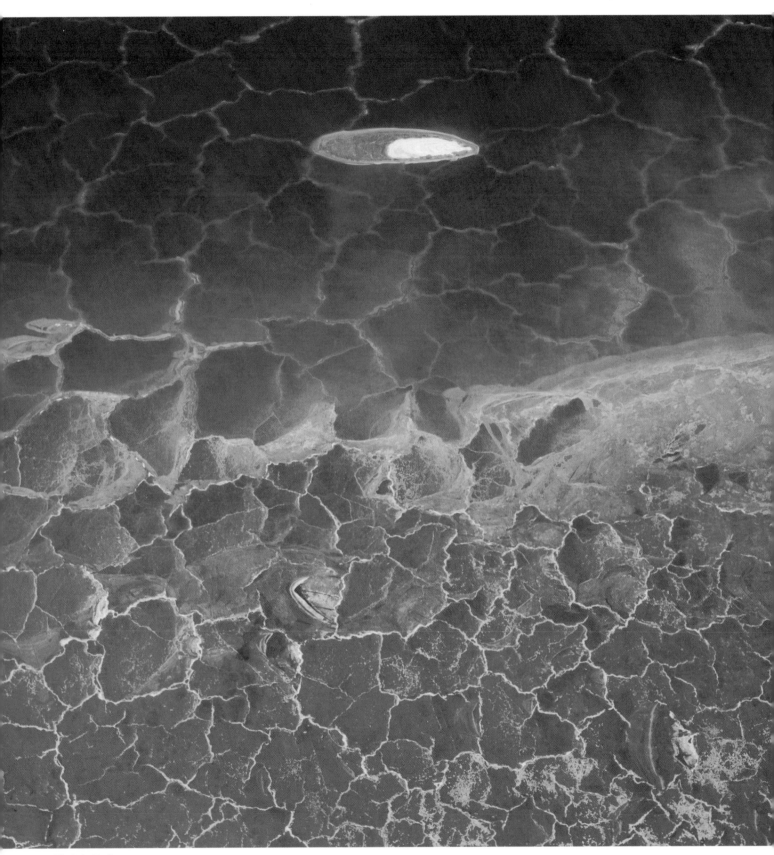

The Lake Project 3, 2001

SUSANNAH SAYLER & EDWARD MORRIS

Susannah Sayler, American, b. 1969
Edward Morris, American, b. 1971

*Glacial, Icecap and Permafrost Melting XLVII:
Cordillera Blanca, Peru, 2008*

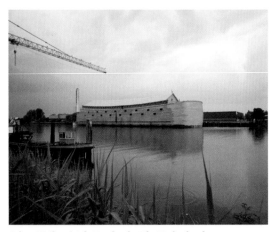

*Glacial, Icecap and Permafrost Melting XXXVI:
Bellingshause Base, King George Island, Antarctica, 2008*

Johan Huibers' Ark, Dordrecht, The Netherlands, 2010

Susannah Sayler and Edward Morris's primary concern, and the declared aim of their art, is to deepen public awareness of ecological issues. The impetus came in 2005, when the couple read 'The Climate of Man', a series of articles on climate change by Elizabeth Kolbert in the *New Yorker*. 'Those articles made us morally outraged,' they recall. 'It became an imperative: We can't just sit here!' They were moved to show the immediacy, the reality of climate change. So later that year, they began a series of photographs taken in locations where scientists were studying either the effects of climate change, the environment's vulnerability to future impacts, or different attempts to mitigate or adapt to changing weather patterns.

At the time of writing, they have photographed fourteen sites spread across several continents. In each place, they work with experts such as scientists, explorers, conservationists, academics, government officials. They started by photographing Hurricane Katrina's devastation of New Orleans and have since documented a range of disasters, from droughts and forest fires to floods and melting glaciers. They have also found instances of human response to changing conditions, including desert wind turbines near Palm Springs, California, and the anti-flood network of the Netherlands.

In keeping with their ambition to spread ecological consciousness, the couple has shown images from *A History of the Future* in diverse venues, including art galleries, science museums, universities, sides of buses, billboards and magazines. They seldom display the work the same way twice, and often incorporate objects, archival imagery, video or other installation elements that draw out different ideas or relate to the specific exhibition context. They recognize a clear distinction between the photographic series and their campaigning work, however. 'We looked at the photographs and we thought they're just not yelling. We need to yell! That's not the kind of photographs they are.... They work in a more contemplative way and also work very well with other kinds of research material. That's part of the reason we want to do things where we can just be straight-out activists.' *A History of the Future* led Sayler and Morris to establish the larger arts collaborative The Canary Project, which has involved more than thirty artists, scientists, writers, designers and educators in efforts to deepen public understanding of climate change.

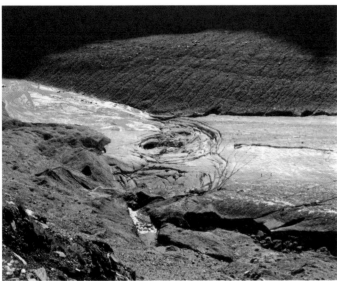

Glacial, Icecap and Permafrost Melting XIV: Pasterze Glacier, Hohe Tauern National Park, Austria, 2006

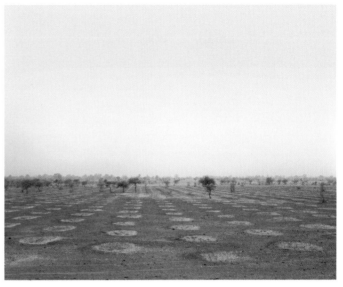

Drought and Fires LI: Niger, 2007

Double Blind – Billboards, Columbus, GA, 2010

Extreme Weather Events IV: Plaquemines Parish, Louisiana, 2005

'From the beginning, as now, we had both activist aims and artistic ambitions. These two types of motivation overlap in places and in other places feel completely distinct. In general, we feel as though we are carrying forward a torch that science cannot carry any further.'

SUSANNAH SAYLER & EDWARD MORRIS

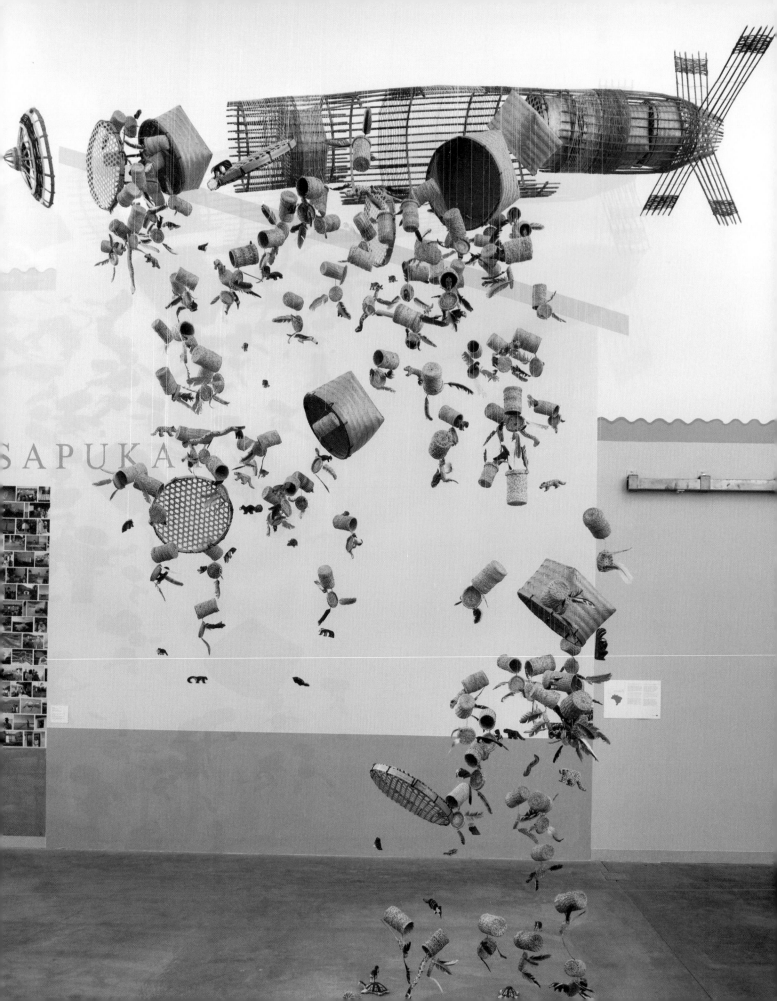

RIGO 23

Portuguese, b. 1966

Born on the Portuguese island of Madeira and now based in San Francisco, USA, Rigo 23 is an artist who is constantly on the move. Describing himself as 'an urban interventionist, a muralist, a conceptualist', he creates site-specific work that combines various artistic techniques and practices with an engaged political activism. In 2005, he visited the forests of southeast Brazil. Over the next three years, he made four additional trips to the site, forging close ties with the native people, observing their ceremonies and rituals, and learning about their integration with the cycles of nature.

Rigo 23 worked with the community artisans to build two sculptures using the traditional materials and methods that exemplify their sustainable lifestyle. Together, they built objects that were completely alien to the local culture – an American cluster bomb and a nuclear submarine. The submarine houses dozens of handmade craft objects, while similar artefacts spill out of the bomb in an explosion of wood, feather and raffia. These replicas of weapons of mass destruction draw attention to the potential violence that can come from unequal access to natural resources. They also highlight the fact that although developed countries encourage economically disadvantaged populations to preserve the environment, they nevertheless continue to exploit the Earth to sustain their own, often destructive, lifestyle.

'Maybe a small environmental organization, some art museums, and a bunch of artists can actually contribute to a much-needed dialogue on sustainability and thus make a difference in the long run – by impacting thousands of museum-goers in the US and further alerting local authorities at the sites to the great interest the world has in the treasures they are safeguarding.'

RIGO 23

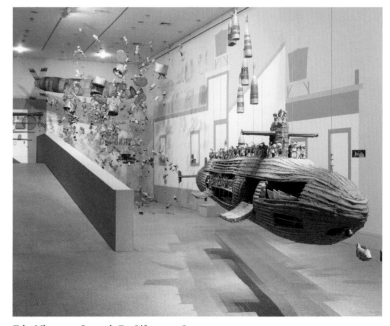

Teko Mbarate – Struggle For Life, 2005–8

Opposite: *Sapukay – Cry For Help*, 2005–8

MITCH EPSTEIN

American, b. 1952

In 2003, American photographer Mitch Epstein was working in Ohio when he came across a small community that was, in his words, 'being erased' by American Electric Power. The locals had been 'paid a lump sum to leave, never come back and never complain in the media or in court if they became sick from environmental contaminants.... I was not the same after this trip,' he remembers. 'The cost of growth, with its implicit energy demands, had become terrifyingly vivid. I had seen first-hand the grave results of fossil-fuel production on human life and our ecosystem.'

For the next five years, Epstein photographed at and around sites across the United States where fossil fuel, nuclear, hydroelectric, wind and solar power were produced. His focus was on electricity – how it is made, how it is used, and the effects of this on the environment and society. But the work is about much more than just energy. It investigates notions of power (both literal and figurative) – electrical, political, cultural, military and economic – and illuminates the often competing forces of nature, government, corporations and mass consumption in the quest for growth. The result is a radical reflection on 'the American Dream gone haywire', with moments of candid objectivity, surreal humour and chilling despair. As Epstein puts it, 'I wanted to photograph the dangerous trinity of corporate power, consumerist advertising, and citizens who believe the old American dream that improving your lot means having more and using more.... *American Power* bears witness to the cost of economic growth and asks viewers to consider the landscape they have created – and take responsibility for it.'

In an accompanying essay, Epstein wrote about how making these photographs led him to think harder about the artist's role in the twenty-first century. He not only exhibited the images and published them as a book, but also created an interactive project with his wife, the writer Susan Bell, that used billboards in Ohio and a website (whatisamericanpower.com) to encourage wider engagement with the issues raised. According to the couple, the site 'asks everyone to look harder at their daily relationship to energy. We created it to heighten awareness of the toll that energy production and consumption take on our economy, security, health, and natural resources. When we understand the realities of American power, we can make wiser choices about energy through conservation and civic action. We hope to instigate a discussion, online and off, about the direction of American power. It is an opportune, if not crucial, moment in the history of the United States to discuss what it has done and could do with its natural resources, wealth, and might, but also its brain power, power of imagination, and power of community.'

Amos Coal Power Plant, Raymond, West Virginia, 2004

Biloxi, Mississippi, 2005

BP Carson Refinery, 2007

Ocean Warwick Oil Platform, Dauphin Island, Alabama, 2005

'About a year into making this series of pictures, I realized that power was like a Russian nesting doll. Each time I opened one kind of power, I found another kind inside. When I opened electrical power, I discovered political power; when I opened political power, I discovered corporate power; within corporate was consumer; within consumer was civic; within civic was religious, and so on, one type of power enabling the next. I began making these pictures with the idea that an artist lives outside the nesting doll, and simply opens and examines it. But now – while America teeters between collapse and transformation – I see it differently: as an artist, I sit outside, but also within, exerting my own power.'

MITCH EPSTEIN

'Future generations are going to wonder about us, the inhabitants of the Earth when the climate began to change. If seas are rising and at the same time drinking water is scarce, they are going to want to know what scientific evidence was before us and what we did in response to it…. By the title [*When It Changed*], I meant to refer to the possibility of a hopeful turning point. In the past few years increasing recognition of the danger has led to many positive responses across the globe to confront humanity's greatest challenge. If these efforts are successful then this current period will be the time when the essential human–Earth relationship changed.'

JOEL STERNFELD

JOEL STERNFELD

American, b. 1944

Joel Sternfeld has produced many photographic projects that address issues of human behaviour and sustainability. But in *When It Changed*, he took an unusual approach to documenting the effects of environmental change, by photographing not the landscape but the faces of its inhabitants.

In November 2005 Sternfeld attended the 11th United Nations Conference on Climate Change, held in Montreal, Canada. Even though he considered himself to have a strong knowledge of the effect of the seasons, like most Americans at the time, he was confused about the prospect of 'global warming', the information and disinformation surrounding the subject providing little to help him formulate a concrete understanding. He recounts: 'What I heard and saw in Montreal shocked me as nothing else. I went there wondering if climate change existed but most of the twenty thousand delegates were already considering the possibility that it not only existed but was about to become irreversible.' Sternfeld decided to take photographs of the participants at moments when the horror of what they were hearing was most visible on their faces. And yet, although their expressions do seem to convey a sense of concern, we have no way of knowing in what context they were made: boredom, irritation, annoyance and tiredness – all realities of such conferences – could equally be the cause. Indeed, in one image a delegate appears to be sleeping mid-session.

Unlike other photographers working in a documentary mode whose images leave no room for uncertainty, Sternfeld's images in *When It Changed* are expressly ambiguous. He remains the detached observer, recording, capturing, documenting what he sees as truthfully as he can, but always leaving the obligation to interpret the work – and the responsibility to act upon it – entirely in the hands of the viewer.

All images from *When It Changed*, 2006

RE / FORM

For the artists in this chapter, the physical environment provides the raw matter from which to make art. Not content with simply examining their surroundings as detached observers, they prefer to engage with the stuff of nature directly. Not satisfied with representing the material world, they choose to re-present actual objects from it instead. Not happy with merely framing a view of the natural realm, they take things a step further by recontextualizing elements of the landscape in new ways and alternative settings. These artists take their inspiration from the materials and processes of nature and make creative use of them, turning natural forms into aesthetic form.

Here the influence of art of previous decades is felt particularly acutely. The vast earthworks of early American land artists such as Michael Heizer and Robert Smithson, which cut deep into the landscape to transform it for ever, left their mark on artistic practice as well. These pioneering individuals took art out of the studio and the gallery and into the wilderness, and claimed ownership of the land by carving out sculptures on a monumental scale. At the other end of the spectrum, the subtler, less invasive work of Richard Long and Hamish Fulton, who both adopted the opposite philosophy of minimal impact, was equally influential. Instead of taking heavy machinery to move tons of soil and rock, they simply walked across the countryside, leaving nothing but footprints and the occasional marker. These art works were often ephemeral, and their only trace is a photograph or text piece documenting the event, an indexical register of a passing moment rather than a static representation of the world. Other art movements from the late 1960s and 1970s also combined to prepare the ground for the contemporary artists we see here. Arte Povera's focus on the symbolism of materials; postminimalism's concern with process and entropy; and John Cage's and the Fluxus group's shared interest in randomness and chance have all informed the practice of those who work today with natural objects and phenomena.

Some of the artists in the present chapter create large-scale, often permanent art works in natural settings, making use of specific materials and processes from the locality. This intensive and potentially damaging method of working is not without its ecological and ethical ambiguities, of course, and it seems that the age of spectacular earthworks may have long passed. But contemporary work of this kind can prove provocative in other ways, too, generating huge hostility because of its use of a controversial material or contested site. For that reason, these works may be produced in consultation or even collaboration with members of the community to ensure that they reflect the interests of the local population. Disputes can still flare up, however, especially where the piece is a public commission, as the fate of Chris Drury's *Carbon Sink* demonstrates (see p. 74).

Other artists adopt a less intrusive technique, observing, collecting and manipulating nature's forms in ways that leave only temporary or imperceptible traces. They may compose symbolic interventions into the landscape – making metaphoric use of certain materials or forms with universal significance, such as circles, spirals and lines. Some even collaborate with nature itself, creating works that follow or subvert

the natural rhythms of growth and decay and utilize the dynamic cycles of life and death. Several of the featured artists have brought elements of nature inside, either by re-creating natural phenomena in a human-made setting or by deploying elements from nature – fauna and flora, living and dead, organic and inorganic – in sculptures and installations that challenge our perceptions of the relations between the human and natural worlds.

While the works presented in this chapter reflect a diverse range of practices and motivations, there are also striking similarities between them. In all cases, the different approaches reveal a desire on the part of the artists to engage directly with the stuff of the Earth as the essential source of art. But there is also recognition that our relationship with the environment has been disrupted and that we need to 'return to nature'. For many, even to speak of nature and culture as two separate realms is a false dichotomy. 'This art movement is part of a much wider understanding that we're not separate. We're a part of nature', argues Drury. 'As soon as you say "art and nature", it makes some people think of fiddling about with sticks, which is really not what I'm interested in. What I *am* interested in are the underlying things: that man is nature, and the question of how we are to resolve the problem of human beings seeing themselves as separate from nature. Cities are also nature. Nature is not out there, nature is here, every moment of the day.'

Like all of the artists in this book, those in this chapter consider their decision to work with natural materials, forms and phenomena to bring serious obligations on their part – towards both the environment and the rest of humankind. The veteran Dutch environmental artist herman de vries, still active in his eighties and an inspiration to younger ecologically conscious practitioners, feels this responsibility acutely and speaks for many of his colleagues when he says: 'By presenting things from primary reality, from nature, I draw attention to these things happening, and to the poetry of it, to the astonishing things that are taking place that we've lost the ability to see, and perhaps here and there this will provide the possibility of an opening, a window for people. This is part of what I call my social participation and my social responsibilities. I have always thought about the social position of the artist. What is he doing, what is his place in society? With the work I do, I know exactly what my place is and what I am doing: it is a social contribution to a general consciousness.'

CHRIS DRURY

British, b. 1948

'My work makes connections between different phenomena in the world, specifically between nature and culture, inner and outer, and microcosm and macrocosm. To this end I collaborate with scientists and technicians from a broad spectrum of disciplines and use whatever visual means, technologies and materials best suit the situation.... My work is featured in many key land art survey books, although I would stress that it has wider implications than this. It is political in that it may draw attention to the way we abuse our environments.'

CHRIS DRURY

Chris Drury is a leading British environmental artist whose works include temporary arrangements of natural materials, permanent interventions in the landscape, drawings and prints, and indoor installations. He is particularly known for his 'cloud chambers' – circular structures made of materials from the landscape, such as stone or reed – which work on the principle of the camera obscura. Their interiors are dark; the only light inside enters through a small aperture or lens in the ceiling or wall, projecting images of the sky, branches, waves and the surrounding landscape onto white viewing surfaces. These chambers are mysterious, meditative spaces where external nature is brought inside and reversed. Clouds drift silently across the floor.

Drury's work often addresses environmental issues specific to its location. One controversial example is *Carbon Sink*, a 46-foot-wide spiral installed on the campus of the University of Wyoming, USA. The idea behind the piece was simple: the whirlpool of dead, charred and beetle-infested pine logs on a bed of coal was to show the link between global warming and the devastating effect of pine beetles, which have destroyed more than three million acres of forest across the Rockies as temperatures have risen. The aesthetic and symbolic power of the piece comes from the interplay of its two contrasting materials, both forms of wood separated by millions of years – one pale in colour, the other an intense black – as well as the shape that sucks the viewer into a vortex at its centre. Its location was provocative too: Wyoming is a state rich in fossil fuels and home to the largest coal mine in the United States.

The artist's stated intention – and that of the university – was that the sculpture would be left in place until it disintegrated back into the earth. But less than a year after its installation, the university quietly removed it. They were responding to aggressive objections from local politicians and influential voices within the coal industry, a major source of income not only for the state but also for the university itself. Drury has said the sculpture was not intended as a political statement, but he hoped that it would prompt viewers to 'have a conversation about climate change'. In that respect, it could be considered a great success, for it has focused attention on the power of the energy companies not only to damage our environment but also to shape debate about the use of fossil fuels and to silence any dissenting view.

Carbon Sink, University of Wyoming, 2011

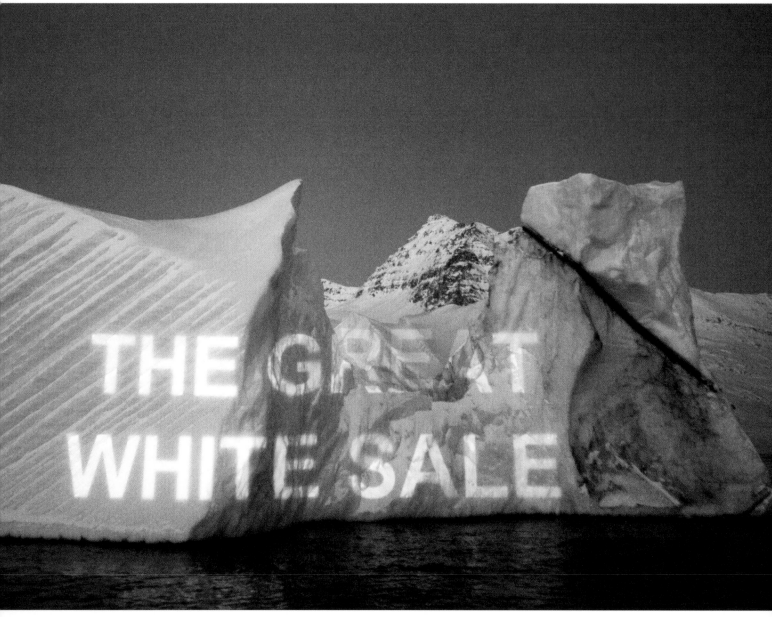

Ice Text, 2009

'The urgency isn't being communicated successfully enough to provoke the real change in our societies around the globe which is needed to reduce greenhouse gas emissions and mitigate climate change. Our resistance to engaging with change is baffling, in the face of the extreme weather events and other disturbances across our planet. Anthropogenic climate change threatens us all with an uncertain physical, social and economic future, so why are we not engaged in sorting out our future?'

DAVID BUCKLAND

DAVID BUCKLAND

British, b. 1949

David Buckland is a designer, photographer, artist, filmmaker, writer and curator who has devoted himself to raising international awareness of environmental issues. In 2001, he created the Cape Farewell project with the purpose of bringing together artists, visionaries, scientists and educators in order, in his own words, 'to stimulate the production of art founded on scientific research' and to shift cultural attitudes towards climate change. Over a decade later, more than a hundred and forty arts practitioners have taken part in a series of expeditions to the High Arctic, the Andes and the Scottish islands. They have created operas, films, art works, pop music and novels that communicate the urgency of the global challenge on the human scale and build a vision for a sustainable future. The Cape Farewell team has also organized multiple exhibitions and educational projects around the world, including taking young people to some of the most fragile ecosystems on the planet. As such, Cape Farewell is widely recognized as the most significant sustained artistic response to climate change anywhere in the world.

Buckland continues to direct the project, while producing his own art works. On the March 2005 expedition to Tempelfjorden, north of Norway, he and the rest of the crew of twenty aboard the one-hundred-year-old Norwegian schooner *Noorderlicht*, including novelist Ian McEwan, artists Antony Gormley and Rachel Whiteread and choreographer Siobhan Davies, experienced six days of extreme temperatures as low as −30°C. Buckland's own response to this and later expeditions was to project a series of texts from the ship onto the foot of a crumbling glacier, almost a hundred and fifty feet high. All of these 'ice texts' have a haunting effect, compounded by the low light in which they were projected and photographed, and encourage us to engage with the climate emotionally. Some of the short, emotive slogans bring potential risks into clear focus as the glacial ice melts away. Others have a more ethereal quality, their significance not immediately palpable: their meaning melts into water and evaporates into air like the ice itself. As Buckland says, 'Ice is alive. The wall of ice we engaged with is in the process of dying – 100,000 years of know-ledge going, going, gone.... It has a language that is as clear as words, and understanding it is like dealing with poetry and raw emotion.... Filming the demise of an iceberg is both exhilarating and sad. As we watch it sink lower and lower, and finally collapse, our reflections turn towards the implication of the loss of ice.'

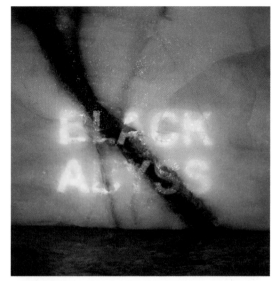

Ice Text, 2006

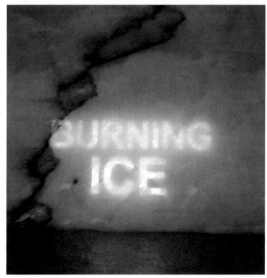

Ice Text, 2006

Vatnajökull (the sound of), 2007/8

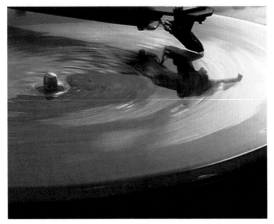

Vatnajökull (the sound of), 2007/8

Langjökull, Snæfellsjökull, Solheimajökull, 2007

KATIE PATERSON

British, b. 1981

In her short career, Katie Paterson has established a reputation for creating laconic and yet highly suggestive works that bring aspects of the planetary or even cosmic realms to a tangible human level.

Vatnajökull (the sound of) was Paterson's graduation piece in her final year at art school. On the wall was a mobile phone number – 07757001122 – traced in white neon, the only presence in the gallery; the number connected the caller to a microphone submerged beneath a glacier in the Jökulsárlón lagoon in Iceland. The glacier, Europe's largest, has been gradually eroding since 1930. Callers could hear the slow trickles and quick rushes of melting water and the creak of the ice as it sheared off and crashed into the lagoon. Around ten thousand people from forty-seven countries called the live phone line throughout the course of the project. Only one person could get through at a time.

The related work *Langjökull, Snæfellsjökull, Solheimajökull* involved pressing the soundscape of three other melting glaciers onto LPs made from refrozen meltwater from each glacier. The records were then played on turntables until they returned to their liquid state. As the artist explains: 'The turntables begin playing together, and for the first ten minutes as the needles trace their way around, the sounds from each glacier merge in and out with the sounds the ice itself creates. The needle catches on the last loop, and the records play for nearly two hours until completely melted.'

With such a poetic economy of means, Paterson manages to compress space and time in a complex, moving and sublime tale of creation and destruction, connection and alienation, intimacy and distance, power and helplessness. Through these diverse technologies of sound – one old, one new – she takes us to the ends of the Earth, transforming us into silent and impotent witnesses as the polar ice cap recedes before our very ears.

Opposite: *Vatnajökull (the sound of)*, 2007/8

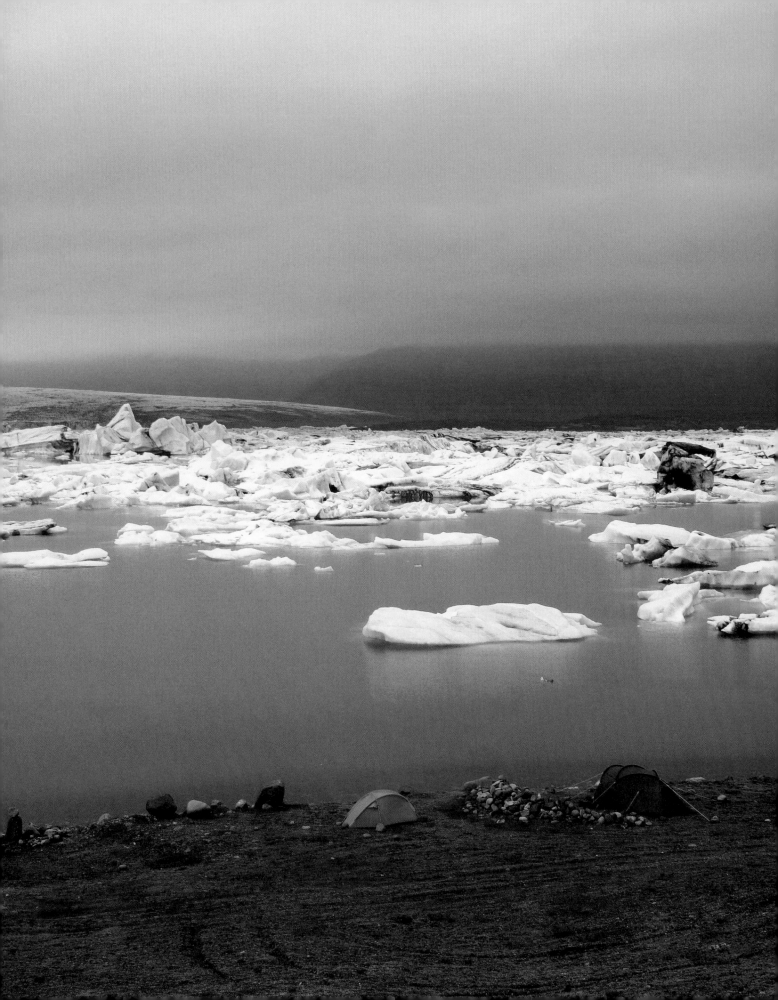

The River Taw, 22 January 1998

The River Taw (Rowan), 22 July 1997

The River Taw (Willow), 3 May 1998

SUSAN DERGES

British, b. 1955

Trained as a painter, Susan Derges has become celebrated for her use of cameraless photography, a process that allows the artist to fix shadows onto light-sensitive paper. Much of her work has been made out of doors at night, using torches, moonlight and flash to capture forms from nature directly onto photographic paper. She therefore uses the natural world as her own vast personal darkroom, creating new techniques as necessary for each situation. In *The River Taw* series, for example, she used the river near her home in Devon, England, as a lens, with fragments of ice, trailing ivy, leaves and other bits of debris reflected or passing through the water becoming part of the two-foot by five-foot images. They are direct indexes of the moving waters, a trace of the actual thing itself, or, in the artist's words, 'prints of the flow of the river'.

Distinguished art critic and exhibition organizer Mel Gooding has written about the series: 'These beautiful images of Susan Derges's, taken from the heart of a landscape, and revealing to the eye what no eye has seen, are yet strangely familiar. We see, with surprise and delight of recognition, things we have seen before; the variable currents of the river's "watery transparency", and the flow and drag of shoreline wave, have the look of fire, their elemental opposite; the river's surface, seen against light, tessellates, lace-like, as ice upon a pane; the edge of a wave, seen from below, seems to imitate the sweep and curve of the coastline upon which it breaks, as it might be seen from the sky above.'

'I was fed up with being the wrong side of the camera. The lens was in the way. I was stuck behind it and the subject was in front. I wanted to get closer to the subject. I had long liked the idea of the river as a metaphor for memory. The river being a conscious thing containing memories – all the things it carries with it such as rocks, pebbles, shale. It is nature's circulatory system.... Walking along the river I realized that if I worked outside in the dark with something that was real, if I worked at night, then the whole night became my dark room and the river was my long transparency. I was able to work directly with the subject – no intermediaries – no lens between us.'

SUSAN DERGES

Host Analog, 1991

Host Analog, 2000

BUSTER SIMPSON
American, b. 1942

Buster Simpson has been a pioneer environmental artist since the 1970s. He has undertaken numerous temporary interventions, community projects and large-scale public art works that highlight the interdependence between humans and nature, often by using recycled materials or by providing creative solutions to real-world problems. One of his best-known pieces is the ongoing 'living' installation *Host Analog* at the Oregon Convention Center in Portland, which reflects the artist's concern with ecological systems and natural processes. It makes use of an eighty-foot-long section of a decomposing, thousand-year-old Douglas fir tree left on the ground of a nearby forest by loggers in the 1950s, which provides a fertile breeding ground to 'host' the growth of fresh vegetation. Simpson cut this rotting 'nursing log', as it is known, into eight segments, arranged them into an arc, and installed a misting system to encourage the optimum growing conditions.

At first, Simpson intended the log to nurture only seedlings from the forest, once indigenous to the area, thereby making a connection between the city (and the citizens) of Portland and the surrounding wilderness. But it soon became enveloped by urban plants that had seeded themselves around this alien 'host' suddenly introduced into their human-made habitat. Although this turn of events ran counter to his original plan, Simpson decided not to intervene but to allow the vegetation to grow unimpeded. In this way, the installation evolved to become not only an exploration of death and rebirth in nature and a demonstration of mutualistic ecologies, but also an interplay of different forms of invasion and hospitality, where the line between host and parasite is blurred beyond all recognition.

Host Analog, 1991–2000

'I prefer working in public domains. The complexity of any site is its asset, to build upon, to distill, to reveal its layers of meaning. Process becomes part and parcel. Site conditions, social and political realities, history and existing phenomena, and ecology are the armature. The challenge is to navigate along the edge between provocateur and pedestrian, art as gift and poetic utility.'

BUSTER SIMPSON

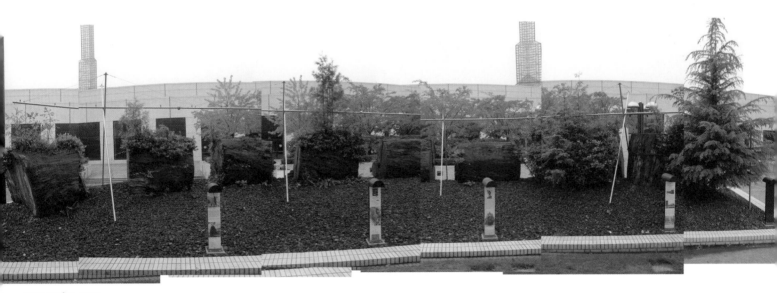

Host Analog, 2003

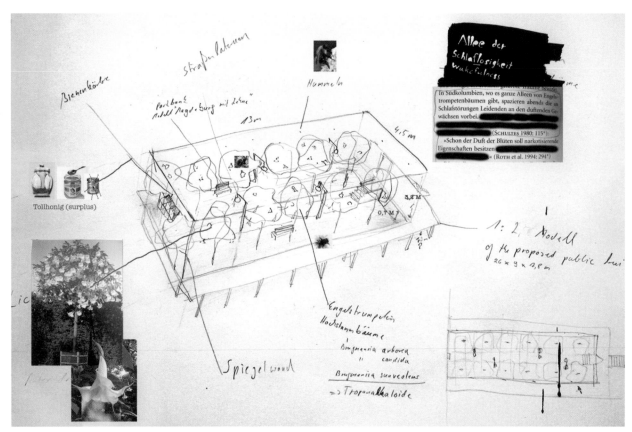

Avenue of Wakefulness, 2005 (artist's drawing)

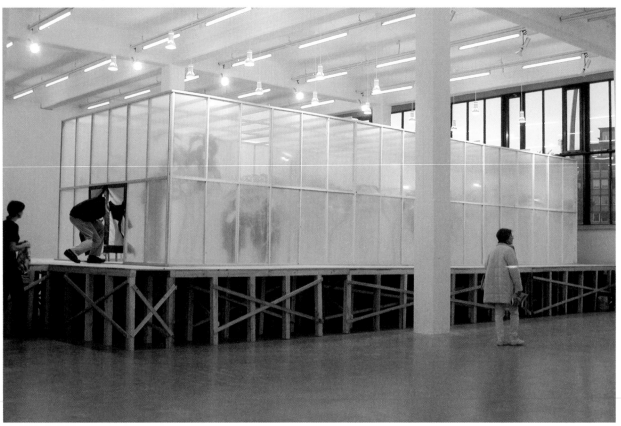

Avenue of Wakefulness, 2005 (installation)

KLAUS WEBER

German, b. 1967

Klaus Weber has frequently employed the random forces and forms of nature in his work – in particular working with live bees, as well as narcotic substances that disrupt our sense of reality – as a way of highlighting our relative inability to control our environment as opposed to being controlled by it.

Installed in the Kunstverein in Hamburg, the *Avenue of Wakefulness* was an accessible 1:2.45 scale model for a public building. The proposed structure was to be built beneath street level and house a glass pavilion for an avenue of angel's trumpets, a highly hallucinogenic subtropical tree that has shamanic use in many cultures. The plant contains tropane alkaloids and is valued for its power to induce visionary dreams and to reveal causes of disease and misfortune. According to the artist, 'Its gorgeous tubular, trumpet-like flowers give off an intense sweet and heavy smell that strengthens as the sun goes down and continues through the night. In scientific books, this odour is described as narcotic and psycho-active. Avenues of angel's trumpets already exist in Colombia, where people stroll at night if they cannot sleep. There are also folk tales of people who became shamans after sleeping under one of these trees. In some parts of South America, people are told to avoid avenues of the trees, as they are areas where prostitutes allegedly work (angel's trumpets can also function as an aphrodisiac).'

With this installation, Weber imagined such an avenue as a public space in the centre of a Western city – a generous and unlikely offer on the part of the civic authorities. His model contained fourteen real, blooming angel's-trumpet trees, approximately three hundred living bumble bees and a large mirror. It also included mock-ups of street lamps and park benches. Weber placed the mirror at the end of the avenue, reflecting the length of the walkway back on itself to compound the disorienting effect of the trees' fragrance. In the centre of the mirror, he hung three beehives. Throughout the course of the exhibition, bees collected nectar from the trees and produced pure angel's-trumpet honey – the first time psycho-active honey had ever been made. At the end of the show, the honey was harvested and given away as a metaphor of the work's concept of giving, transformation and transgression.

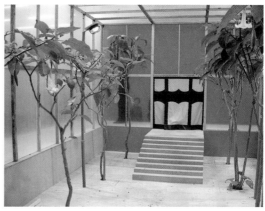

Avenue of Wakefulness, 2005 (installation exit)

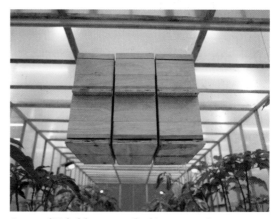

Avenue of Wakefulness, 2005 (beehives mounted on a large mirror)

Tree Drawing – Dragon Spruce, 2012 (installation view)

Tree Drawing – Dragon Spruce, 2012 (detail)

TIM KNOWLES

British, b. 1969

Like Klaus Weber (see p. 85), Tim Knowles rebalances the power relationship between humans and nature, handing over control of the creation of his art to natural forces. Working in a range of media, from photography and video to drawing and light installation, he produces works that rely on chance environmental elements and processes. In 2009 he wore a kite-like weathervane on a helmet and went wherever the wind led him, recording his journey in a series of photographs entitled *Wanderlust*. He has also created long-exposure photographs of the flight of insects and reflections of the moon in moving waters, as well as drawings of wind patterns created by hanging pens from helium-filled balloons that move in the air.

Between 2005 and 2006, Knowles produced a similar series of drawings created by trees. He attached ink pens to the tips of branches and allowed the wind's effects on the tree to determine the marks recorded on paper. Like signatures, the drawings reveal the different qualities, characteristics and aesthetics of each tree. For *Oak on Easel #1*, the oak tree in question seems to be drawing the scene before it, rather like a traditional landscape artist might do. For *Circular Weeping Willow, Victoria Park, London*, Knowles suspended one hundred pens to the branches of a willow tree and allowed it to draw on a circular disc more than six foot wide and made up of ten segments in a twist on Abstract Expressionism or a Damien Hirst spin painting.

Opposite: *Tree Drawing – Dragon Spruce*, 2012 (detail)

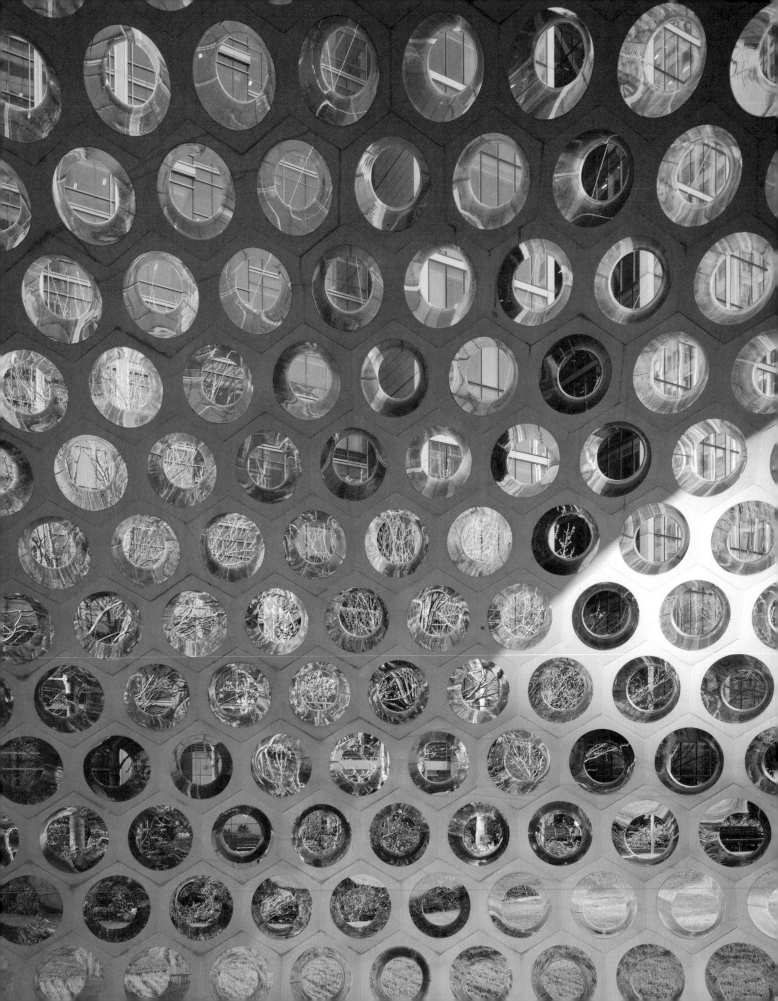

LUKE JERRAM

British, b. 1974

Luke Jerram's multi-disciplinary practice involves the creation of sculptures, installations, live art and gifts. Named after the ruler of the four winds in Greek mythology, *Aeolus* is one of his largest projects to date. Despite appearances, the arch-shaped piece is in fact a giant stringed instrument – an aeolian harp – that resonates as wind passes over and through it. In this way, it 'sings' without any electrical power or amplification. The shiny structure – which the artist describes as 'an acoustic and optical pavilion' – also reflects the moving clouds and shifting light of the changing sky.

Using a web of strings attached to some of its three hundred and ten stainless-steel tubes, *Aeolus* creates a three-dimensional sound map of the winds reverberating around it. Ultra-sensitive, the strings register the slightest movement of air, and its vibrations are then projected down the tubes towards anyone standing beneath the arch. It thus acts as an acoustic lens, focusing any sounds made on the tubes to a point at the centre of the arch. At the same time, someone standing beneath the structure can look out through its highly polished tubes, which draw in light, inverting and magnifying the surrounding landscape and presenting a constantly evolving vista.

Jerram developed the idea after undertaking a research trip to Iran, where he heard about a series of desert wells that 'sang in the wind'. This led him to investigate the acoustics of architecture and sculptural forms. The art work was the result of a collaboration between the artist and the Institute of Sound and Vibration Research at the University of Southampton and the Acoustics Research Centre at the University of Salford. Dozens of other people were brought together to provide expertise, from art managers, sound engineers, structural engineers and designers to steel manufacturers, fabricators, welders and installation crew. To communicate his ideas to his colleagues, Jerram created more than four hundred drawings of the proposed piece. Many prototypes were made, and hours of testing were carried out on a hill local to Jerram in Bristol. The sculpture took three years to build.

Opposite and above: *Aeolus*, 2011

Aeolus, 2011

Aeolus, 2011 (computer-generated mock-up)

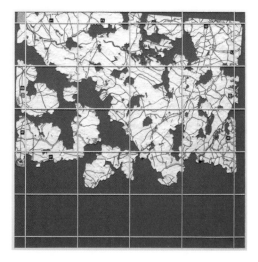

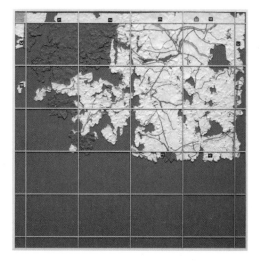

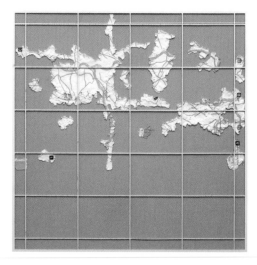

RIVANE NEUENSCHWANDER

Brazilian, b. 1967

Conceptual artist Rivane Neuenschwander creates playful, sometimes ephemeral art works in a variety of mediums, often with more than a hint of melancholy. The chaotic, random and sometimes hidden processes of the natural world have always been at the heart of her practice. Neuenschwander is another artist who creates art with 'partners' over which she has little or no control, including the weather, gravity and ants. In particular, she references the heavy and sudden rainfall that is typical in her homeland during the wet season, which can cause major devastation and change the land dramatically in the space of a few hours.

Rain Maps is a series of fourteen maps of Brazil that Neuenschwander exposed to the elements during the country's rainy season. The rain diluted and washed away the inks used on the charts, smudging natural and political boundaries, erasing entire landmasses and creating wholly new territories. In this way, the maps enact the kind of damage that takes place in reality when torrential downpours leave a familiar terrain unrecognizable after a violent storm. The artist then fills the 'rivers' and 'valleys' between the landforms with painted colour and applies a grid in an attempt to plot and bring order to the new lands, just like a real cartographer might do. Neuenschwander's *Rain Maps* point to the futility of trying to master the forces of nature, for their power is ultimately beyond our control.

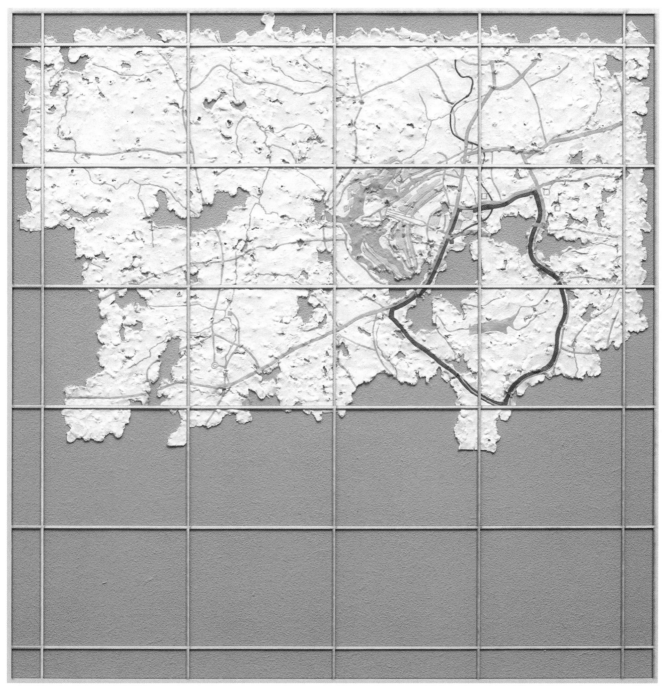

All images *Rain Maps*, 2008

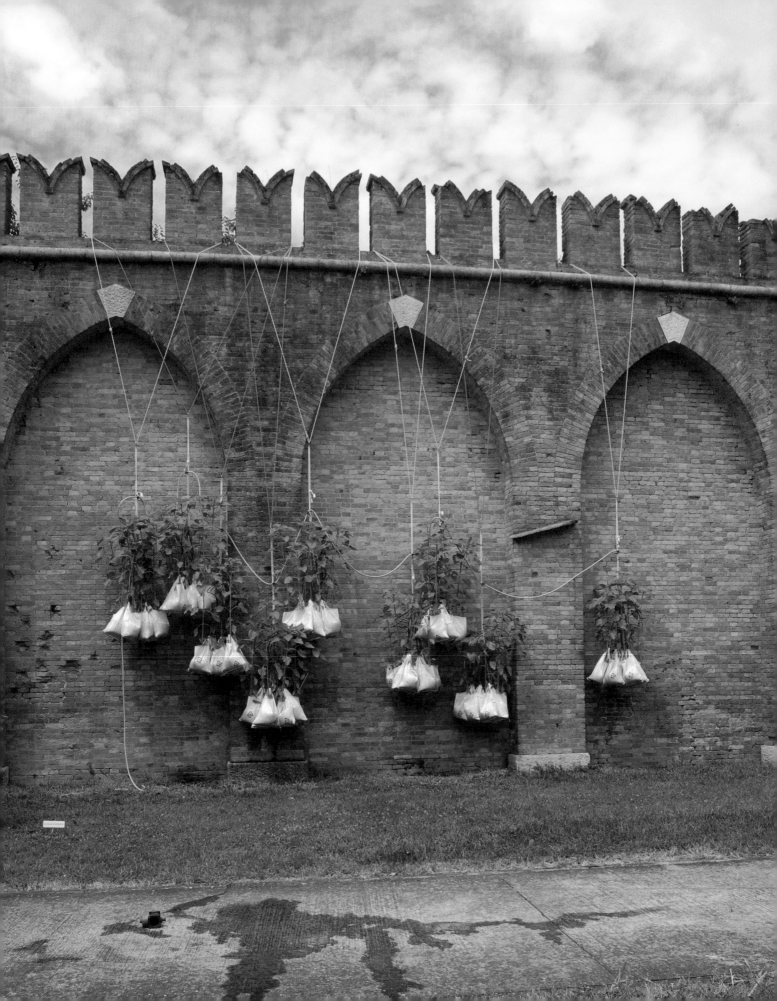

WILHELM SCHERUEBL

Austrian, b. 1961

Wilhelm Scheruebl examines the experience of time and the contribution it can bring to the practice of sculpture. Consequently, he has used living forms in his work for a number of years. He is particularly interested in the structures and processes found in nature, such as the cell network of a plant, and the way that these systems are finely balanced between order and chaos. He often focuses, too, on the transformation of matter over time and the constant natural cycles of life, death and renewal, such as the development of a flower over the seasons, from seed, to seedling, to full bloom, to seed-production, to dead and decaying organic material, and to the growth of a new seed and the repeat of the whole process.

For the 'Round the Clock' exhibition held in the Spazio Thetis in Venice's Arsenale in 2011, Scheruebl created a remarkable array of sunflowers in soil-filled bags suspended from the walls of the space's gardens, which rose up and sank down as the plants grew, bloomed, withered and declined over the course of the exhibition. The artist was acting as an initiator, beginning a process for which he had formulated the conditions but that, in the end, escaped his control.

The work was typical for its element of tension coming from the contrast between controlled artistic placing and the uncontrollable influence of time. This transient quality of these perpetually changing sculptures contradicted the aspiration of art to create something for eternity. The sculptures also referred to the constant confrontation between nature and culture, while at the same time recognizing the similarities between organic life and society; they demonstrated the continuous transformation to which every form is subjected, and encouraged the viewer to reflect on the eternal processes of becoming and of passing away.

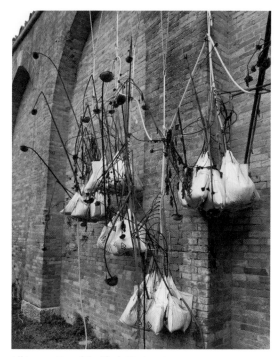

All images *Round the Clock, Venice*, 2011

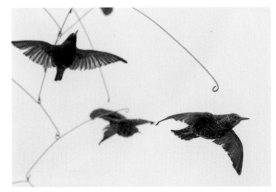

'A Forest Divided', 2012 (installation view)

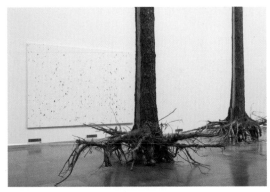

Vertical Swarm (Sturnus Vulgaris) #01, 2010 (detail)

'A Forest Divided', 2012 (installation view)

HENRIK HÅKANSSON

Swedish, b. 1968

Henrik Håkansson is one of the most renowned Swedish artists of his generation. Over more than twenty years, he has established an international reputation for his unique relationship with the natural world. He has employed live animals, trees and plants, as well as other organic materials, in his extended, almost obsessive investigation into the various ways the observation of nature can result in the production of culture. Among his many idiosyncratic projects, he has arranged a 'duet' by a Swedish and an Italian nightingale; organized a solo performance of an English songbird in a concert hall; enticed stick insects to cross a tightrope to reach pieces of lettuce; allowed frogs to relax to ambient techno music; sought to express the psychic state of plants; created a miniature jungle for a colony of beetles; and grown plants and bred exotic animals in his studio, turning it into a florist's-cum-pet shop. For the group show 'Radical Nature' held at London's Barbican in 2009, he exhibited *Fallen Forest* (2006), which comprised a 172-square-foot section of lush forest flipped on its side to grow – or perhaps die – horizontally. This work is perhaps a reference to the vogue in some architecture and interior design for 'living walls', but it is also a reminder of the tremendous fragility of the Earth's ecosystem.

For the exhibition 'A Forest Divided' at the Konsthall in Lund in his native country, Håkansson brought together many of these interrelated works alongside newer pieces in an installation that filled the exhibition spaces. The most prominent features of the display were tall spruces that had been uprooted and cut in half – 'divided' as the title of the exhibition suggests. The trees came from a forested area outside Lund that was being cut down to restore the original and more open landscape. Around this divided forest hovered dark-brown starlings that once lived near an airport in northern Italy but had been shot to prevent accidents and disruptions to aeroplanes. In an explicit reference to the American modernist sculptor Alexander Calder, these birds are mounted as hanging mobiles – one of the many ways in which Håkansson has connected the realms of culture and art with those of nature and the environment.

In all of his works, Håkansson assumes the role of a biologist and discoverer. By doing so, he not only uses natural forms and processes but also tries to understand them and make the viewer receptive to them. He thus adopts a mode of art-making similar to that of the artists in the next chapter.

Opposite: 'A Forest Divided', 2012 (installation view)

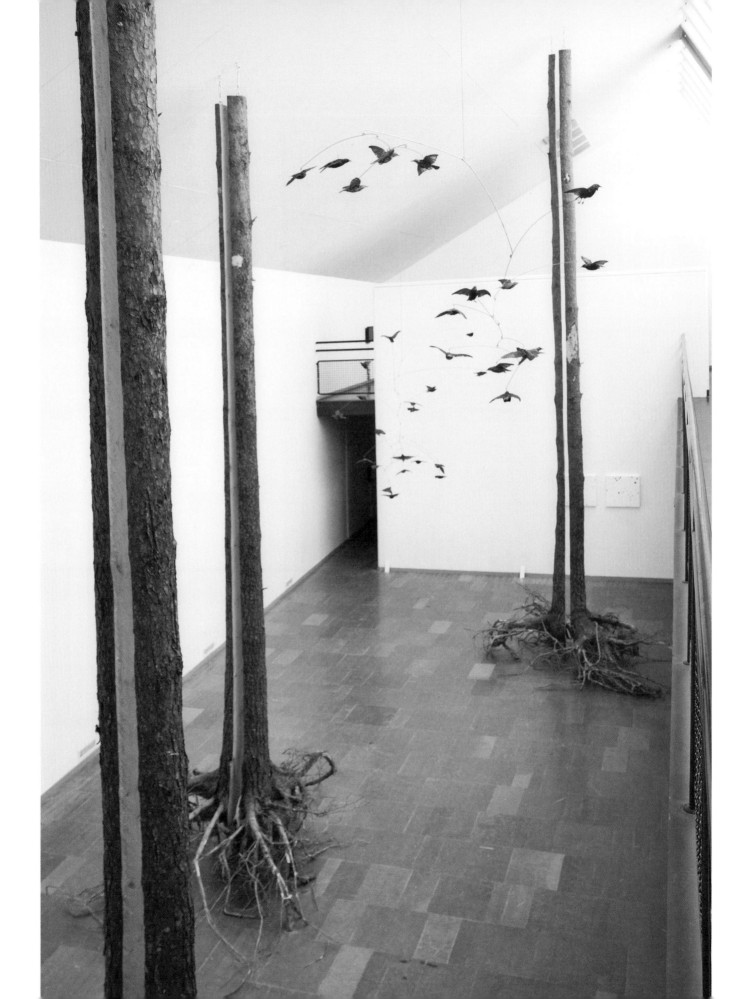

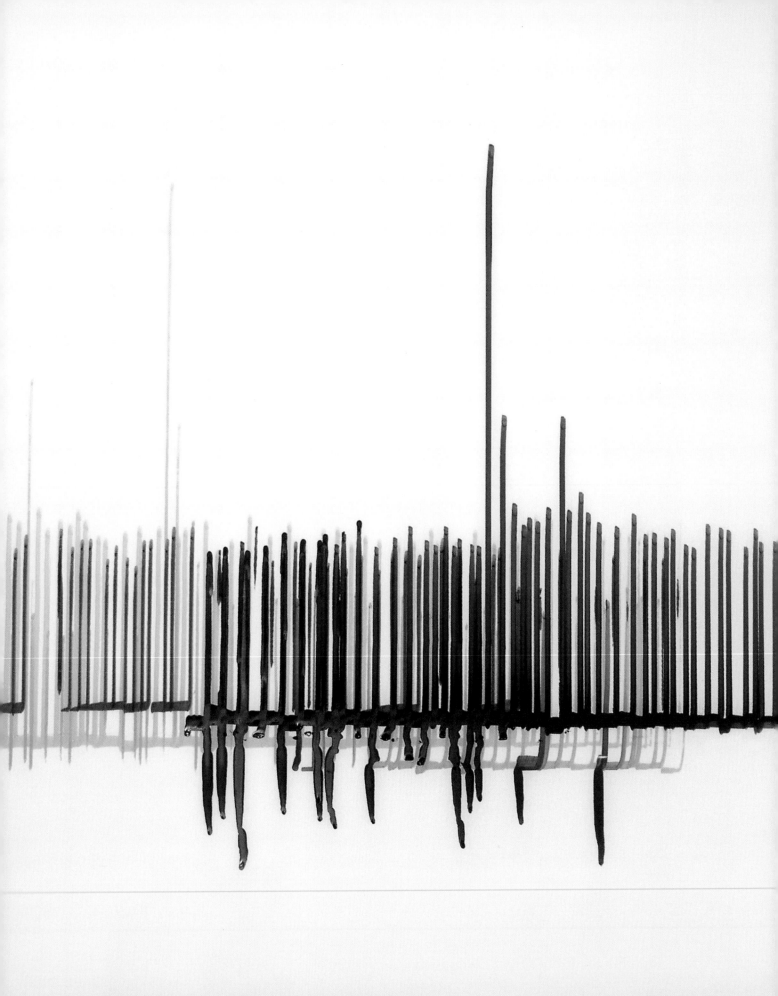

SABRINA RAAF

American, b. 1968

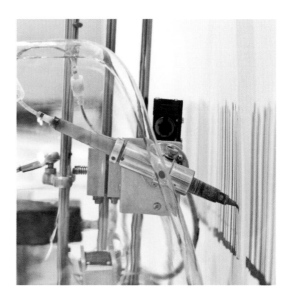

Chicago-based artist Sabrina Raaf produces mechanized sculptures and designs responsive environments and spaces for social interaction. Her research as an artist focuses on making explicit the interdependent relationships of human to machine as one vital entity to another. *Translator II: Grower* is a small 'rover' vehicle that moves its way around the edge of a room, responding to the level of carbon dioxide in the air by drawing varying heights of 'grass'. Any change in the level – which may be caused by a change in the number of people breathing in the room – is picked up immediately by a sensor and transmitted to the robot. The more carbon dioxide there is in the room, the higher the line that is drawn. Once the *Grower* robot has completed a line, it moves forward slightly and starts again. By the end of the exhibition, the bases of all the walls in the space are covered with this cross-section of 'a field of grass'. As the artist explains: 'The metaphor is based on the fact that grass needs carbon dioxide in nature to grow. Here, the simulated grass needs the breath of human visitors in order to thrive. The more people in the space, the more amenable it is to "grow" the grass.'

But the metaphoric relationship between *Translator II: Grower*, the space and the visiting public does not end there. Raaf continues: 'The piece also makes visible the extent to which art institutions depend on their visitors to make them "healthy" spaces for new art to evolve and flourish. The machine's grass-growing is a dynamic, emergent behaviour in which humans participate involuntarily. This behaviour allows the *Grower* to "nest" the space – meaning, make the space into one where you find evidence of natural, organic change. The drawings of grass are not organic in a strict sense, but they may be read cognitively, the way we read plants or gardens outside. Is the grass thriving? Has there been much activity? Watching the artistic output of a machine that is so sensitive to its surroundings makes the people in the space more attuned to the conditions of their own environment.'

All images *Grower*, 2004–6

CHIARA LECCA

Italian, b. 1977

Chiara Lecca's work charts the boundary between the natural and the artificial. In some respects, her sculptural 'still lifes' continue the legacy of this most ancient of art forms: to depict inanimate natural or human-made objects, to pause time, and to encourage the viewer to reflect either on the processes of nature or on some religious or philosophical concept. In particular, they resemble Dutch flower paintings of the mid-seventeenth century. But Lecca's sculptures also remind us of the inherent contradiction between the different names used to describe this artistic genre. In northern Europe and in the English-speaking world, its name is, as we have seen, 'still life', after the Dutch *stilleven* – that is, 'life stilled'; but in the Romance languages of the Mediterranean (and in Greek and Russian), a very different term is used: 'dead nature'. With the former, the suggestion is that the work of art preserves and celebrates the beauty of life; death is denied by preventing the onset of decay for ever. With the latter, however, it is the already dead natural world that has been frozen for eternity; life has gone with no prospect of return.

Lecca's works combine both of these meanings in a single piece. They contain not only life stilled in the form of the cut flowers, but also dead nature (*nature morte*) in the form of taxidermied animal parts. They also demonstrate two of the aesthetic conventions that were common to virtually all forms of still life/*nature morte* in the seventeenth and eighteenth centuries: illusionism and symbolism. At first, her clever *trompe-l'oeil* arrangements seem to be bunches of real flowers placed artfully on display on tables and plinths. It is only on closer inspection that we realize that what appear to be attractive lilies or tulips are in fact rabbits' ears and tails. And like earlier *vanitas* paintings, Lecca's sculptures are replete with symbolic references to mortality, not least the dichotomy between organic and inorganic materials, between once-living flesh that has now become dead matter. Lecca thus takes elements from the animal and plant worlds and subverts them in uncanny presentations that beguile and almost seduce, only to unsettle and even repel once their hidden, grotesque secret becomes apparent.

Black Still Life, 2010

Black Still Life, 2010 (detail)

Still Life, 2007 (detail)

'I consider my work an attempt to establish a relationship between the natural world and the human world, experienced outside conventional patterns. I use organic materials as a ploy to arouse atavistic impulses belonging to our collective unconscious, to the oldest part of our brain.... I try to investigate how social reality refers to the natural world, with the desire to create doubts, imagine new structures. Whoever benefits from my works is obliged to reflect on their position with the natural realm. I find the human–animal connection full of paradoxes, but the attempt to understand animals is necessary to truly understand ourselves. Indeed it's this kind of relationship I'm interested in, and man tends to divide it into categories – pets, barnyard animals, animals to be eaten, to be used for clothing or furnishings – and doesn't consider it in its complexity.'

CHIARA LECCA

Still Life, 2007 (foreground) and
Domestic Economy, 2001 (background)

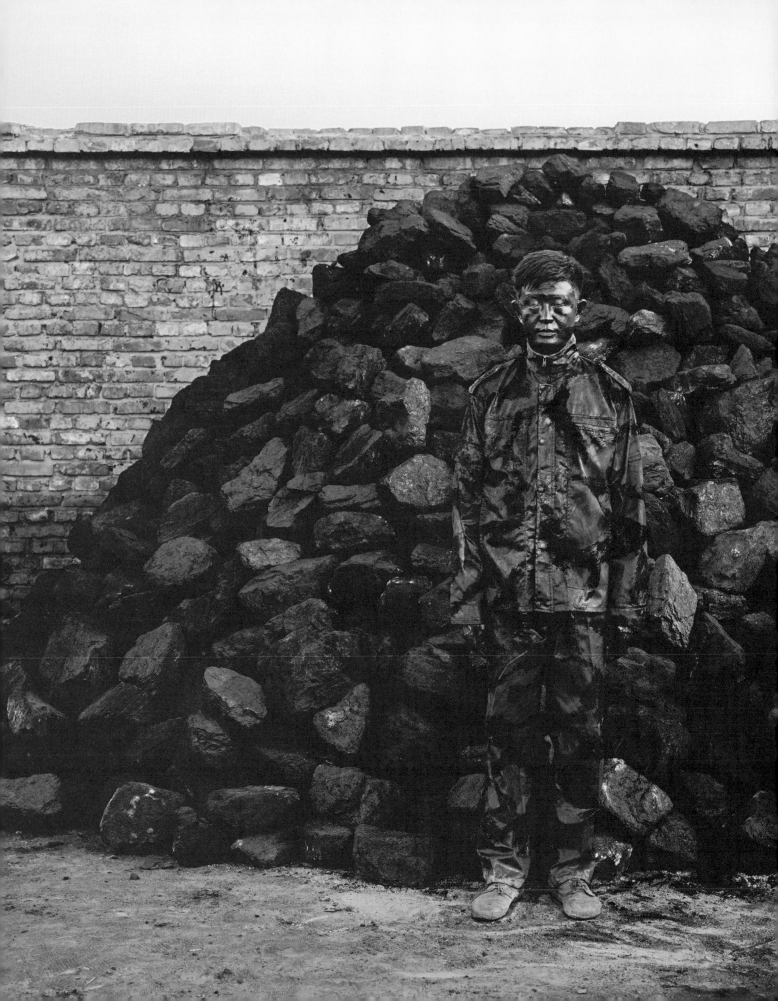

LIU BOLIN

Chinese, b. 1973

Known as the 'Invisible Man', Liu Bolin is known for his stunning photographs in which he paints his entire body to match his surroundings so that he disappears into the background. Liu uses two assistants to paint the camouflage onto him, and each photograph can take up to ten hours to set up. His most popular series of works is *Hiding in the City*, which he began in 2005 and shows him in almost one hundred situations in his home city of Beijing. While this diverse set of images makes reference to a host of political and social issues current in contemporary China, the artist himself claims that his principal ambition was to comment on the way the rapid urban development of the country is damaging the individual. He states that, 'My intention was not to disappear in the environment but instead to let the environment take possession of me.'

Many of the photographs comment on the effects of the mass consumerism that is taking over Chinese society, as well as the widespread modernization that goes hand in hand with that situation. But none more than *Hiding in the City No. 95 – Coal Pile* reflects on the damaging effects of industrialization on both the landscape and the population. Liu seems smothered by the black mound of fossil fuel that towers over him. And yet it is his fellow humans who have wrenched this natural form from the centre of the Earth, men who no doubt resemble the painted artist when they emerge from the underground mines. The devastation of the planet is both caused by and causing the unimpeded march towards the future. In such a scenario, the question of who are the victims and who are the perpetrators of the environmental damage is never black or white.

Hiding in the City No. 95 – Coal Pile, 2010

BERNDNAUT SMILDE

Dutch, b. 1978

'I imagined walking into a classical museum hall with just empty walls. There was nothing to see except for a rain cloud hanging around in the room. You could see the cloud as a sign of misfortune. You could also read it as an element out of the Dutch landscape paintings.... I wanted to make a very clear image, an almost cliché and cartoon-like visualization of bad luck.'

BERNDNAUT SMILDE

Berndnaut Smilde is an artist who tries to trap the transitory and the ephemeral. He is interested in the fleeting moment – the fine line between presence and dissipation – and his works explore both impermanent states and transitional spaces. For his remarkable series *Nimbus*, he manipulates elements from his surroundings in order to create 'artificial' natural forms in human-made interiors. Carefully regulating the temperature and humidity of a chosen setting, he uses a smoke machine to create a cottony nimbus cloud that hovers in the centre of the empty room for a few seconds before evaporating for ever. He fills the scene with dramatic lighting and then captures the moment on camera, the photograph being the only lasting record of the event.

By bringing the outdoors inside in this way, the works allude to our futile efforts to shape the environment according to our own desires and needs, only for it to resist and ultimately escape from our control. This allusion is heightened by the choice of traditional locations from the past (abandoned chapel, historic castle, ornate neoclassical gallery), which serve to emphasize the forced encounter between nature and culture. The resulting images are uncanny, eerie, almost ominous, Smilde's floating clouds acting as portents of the trouble that may lie ahead.

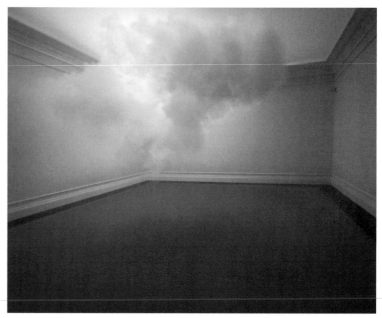

Nimbus, 2010

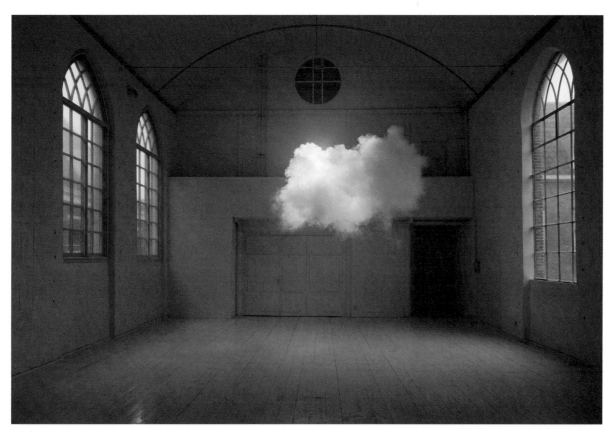

Nimbus II, 2012

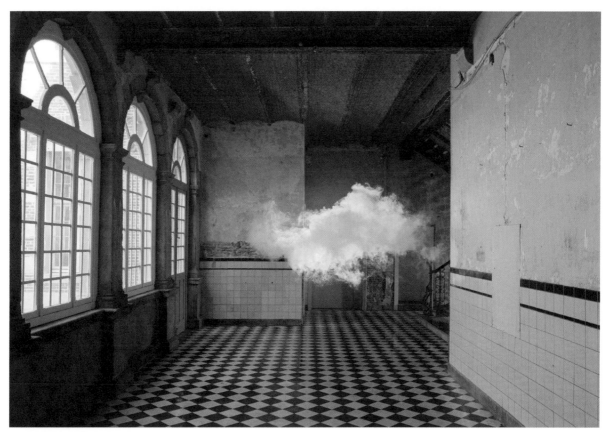

Nimbus D'Aspremont, 2012

RE / SEARCH

The artists in this chapter take their engagement with the Earth one stage further. Not satisfied merely to *use* the environment as a source of raw material, as those in the previous section did, the individuals and groups here wish to go deeper to *understand* the elements of nature. They want to get beneath the surface of things and explore the inner workings of the natural world to learn how it functions and how we interact with it. To do so, they assume the mantle of the researcher, gathering and interpreting data and other forms of information. Like enquiring scientists on a quest for a groundbreaking solution or intrepid explorers in search of new lands, they are driven by a desire to discover life's hidden mysteries and to present what they find to others.

To a certain extent, of course, all creative practice is a kind of research. Drawing a tree in fine detail or sketching a fleeting cloud as it passes overhead are both ways of investigating natural phenomena – indeed they are often described as such: 'studies of a...'. They require a certain level of exploration and scrutiny on the part of the artist and can lead to a profound understanding of how the elements of nature work. The same applies to other approaches to art that are less conventional than landscape. The analytical cubist paintings of Picasso and Braque were neither the first nor the last works by vanguard artists seeking to explore the mysteries of the visible and invisible realms through art. Once again, we find ourselves drawn to the words of the early modernist Paul Strand, who one hundred years ago asserted that, 'It has always been my belief that the true artist, like the true scientist, is a researcher using materials and techniques to dig into the truth and meaning of the world in which he himself lives; and what he creates, or better perhaps, brings back, are the objective results of his explorations. The measure of his talent – of his genius, if you will – is the richness he finds in such a life's voyage of discovery and the effectiveness with which he is able to embody it through his chosen medium.' But what marks out the artists in this section is that their work foregrounds the methods and objectives of investigation as its primary defining characteristic. For them, research is both the modus operandi and the means of engaging an audience – the very medium itself, in other words.

Sometimes the artists in this chapter are helping to solve some of the planet's most urgent challenges; at other times, they are simply wanting an answer to something that puzzles or troubles them personally. Many of the projects take the form of meteorological, geographical or botanical surveys. Each is a committed attempt to increase our knowledge of nature's forces and the effect we are having on the ecosystem. Some of the artists here venture to the ends of the Earth – in several cases quite literally – or delve into the most inaccessible of its reaches to unlock hidden knowledge. In doing so, they often collaborate with professional scientists or experts from other disciplines, and work as much in the field or in the laboratory as in the studio to advance understanding through creative means. For that reason, a number of the works in this section are the result of extended collaborative projects involving teams of participants. Whether they are taking part in an existing research project as an active member or invited guest or have devised the study themselves, they provide a critical complement and iconoclastic foil to

more established approaches to scientific investigation, focusing on an aspect that mainstream 'serious' science might consider insignificant, or bringing an alternative social or ethical view or just a broader cultural perspective to bear on the enquiry.

Without the responsibility of needing to find answers, the artist can fulfil a vital role simply by looking at a problem from an innovative angle, or by posing a difficult or unexpected question that might otherwise go unasked. And unlike the scientist, who may be led by institutional or commercial imperatives, not to mention the rigorous assessment of peers, the artist can apply his or her own criteria of success to a study, prioritizing such things as creativity, wonder and beauty, and thereby opening up areas of research to entirely new approaches and discoveries. Moreover, art's ability to communicate in imaginative ways brings with it the potential of engaging the public's interest in issues that otherwise might not enter the general consciousness. The American artist and academic researcher Stephen Wilson, who has written widely on the subject of creative practice as research, set out in 1996 the important role that art has to play in scientific advances: 'Skeptics sometimes wonder what possible contribution artists can make to serious research and development. Artists can augment the research process in several ways. They can define new kinds of research questions, provide unorthodox interpretations of results, point out missed opportunities for development, explore and articulate wide-ranging implications of the research, represent potential user perspectives, and help communicate research findings in effective and provocative ways. They can bring centuries of artistic experience to bear on the technological future.'

For these and other reasons, in recent years, there has been a marked rise in the number of artists working at the heart of scientific and scholarly environments, especially in northern Europe. In countries such as the United Kingdom, the Netherlands, Germany and the Scandinavian nations, academic institutions, government agencies, funding bodies and private corporations have all embraced the concept of artist as researcher and now recognize the importance of art practice as a valid and valuable form of research.

That said, for some artists in these pages, it is not the end result of the research itself that is the attraction so much as the unfamiliar processes and practices undertaken by counterparts in other fields. These creative practitioners knowingly choose to appropriate archaeological and other scientific methods of collecting, ordering and exhibiting objects in order to explore the distinction between 'objective' ('rational') methods and 'subjective' ('irrational') influences. They 'play the role' of scientific researcher either to celebrate or to challenge the authoritative status that science enjoys in contemporary society.

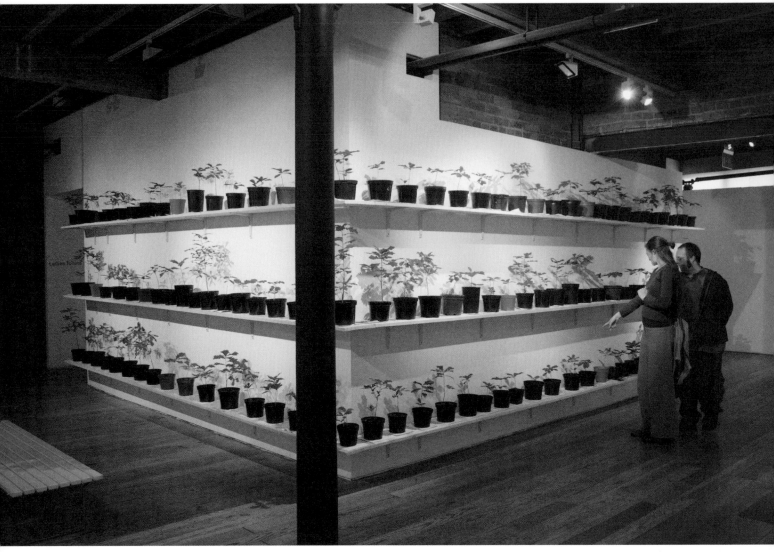

Beuys's Acorns, 2009 (installation view)

'[Beuys] created a level playing field between art, ecology, aesthetics, politics, economics and education. At the heart of his vision was a transformation of consciousness, where the biosphere, as a healthy, biological and essential atmosphere, would be consistent with human and species needs.... Two decades later, Beuys's vision may seem idealistic given the deeply troubling world picture, but scientific evidence is firmly pointing to the importance of mass planting of trees in our cities to mitigate the "heat island effect" and rising temperatures.'

HEATHER ACKROYD & DAN HARVEY

HEATHER ACKROYD & DAN HARVEY

Heather Ackroyd, British, b. 1959
Dan Harvey, British, b. 1959

Artist couple Heather Ackroyd and Dan Harvey have been producing award-winning art using living materials and processes from nature for more than twenty years. Many of their projects have been in collaboration with scientific institutions and have involved pioneering research. Some of their best-known works have used a new technique to manipulate the process of plant photosynthesis to create different tints of yellows and greens. Working with scientists from the UK Institute of Grassland and Environmental Research, the pair developed a strain of 'stay-green' grass seed and specialized drying methods. The process allows them to project a negative image onto the grass as it grows in a darkened room, effectively transforming a piece of turf into a variety of photographic paper. From close up the grass pictures look like an ordinary stretch of lawn, but from a distance they resemble vintage photographs (see p. 6). The couple's work contributed to the establishment of the UK's National Plant Phenomics Centre at Aberystwyth University in Wales in 2012.

Ackroyd and Harvey's *Beuys's Acorns* explores the currency of ideas associated with trees and their cultural impact, and provokes questions about our relationship with nature and the climate. The project began in 2007 when the pair went to Kassel in Germany to gather fallen acorns from Joseph Beuys's seminal art work *7000 Oaks*. Beuys was a passionate advocate of environmental biodiversity and a founding member of the German Green Party. *7000 Oaks* was perhaps his grandest expression of his belief in art's ability to effect radical social change. Beuys planted the first tree in 1982; his son planted the last in 1987, a year after the artist's death.

Ackroyd and Harvey collected over seven hundred acorns from Beuys's trees and potted them at their studio in England. Around three hundred saplings survived and continue to grow. Like Beuys's original project, *Beuys's Acorns* is a time-based work: it can take eighty years for an oak to reach maturity. If the trees survive, they may spawn thousands of other oaks. As well as nurturing the saplings, the artists have sought to raise awareness of the importance of trees by initiating ongoing research into their cultural, biological and climatic significance in partnership with the Department of Life Sciences at the University of Manchester and the UCL Environmental Institute in London. The educational and ecological value of *Beuys's Acorns* will be felt by others for years to come.

Beuys's Acorns (single germination), 2007

*The Highway Traveller Native Seed Dispersal
Program* poster, 2007

The Highway Expedition Project poster, 2007

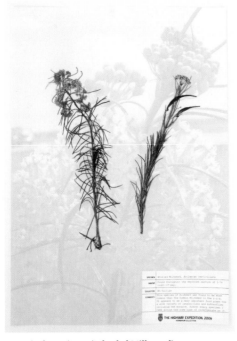

Botanical Specimen (Whorled Milkweed), 2007

BRIAN COLLIER

American, b. 1970

Brian Collier describes himself as an 'artist, educator and re-naturalist'. His work spans a variety of media and disciplines and includes photography, video, performance, drawing and website design. He focuses on the ways in which the natural world survives in human-altered landscapes.

From August 2004 to May 2007, Collier commuted between Bloomington, Illinois, where he lives, and the University of Illinois at Urbana-Champaign, fifty miles away, where he was teaching. Much of the journey was along Interstate Highway 74 (I-74) through a region dominated by large-scale agriculture. Illinois has one of the lowest levels of remaining natural areas in the United States; only a fraction of its original prairies, forests, savannas and wetlands survive. Large swathes of its territory have been given over to road-building, and now its highway network is the third largest in the nation. The section of I-74 that Collier travelled each day was completed in 1965. Since then, the right-of-way alongside the road has been left, for the most part, to return to a relatively wild state. After more than forty years, it has developed into a unique ecosystem of its own.

Collier decided to undertake an expedition of the route to discover for himself some of the specific qualities of this roadside habitat. His first challenge was to gain access to the right-of-way, which is, paradoxically, prohibited to pedestrians. After numerous letters and emails, he finally received permission from the Illinois Department of Transportation, and over the course of twenty-seven trips he explored a little more than 115 miles of the highway, documenting the entire expedition through photography and video. He discovered a strange world of native and non-native plants and animals, all living in the shadow of constant traffic noise and heightened pollution levels.

The images and videos Collier produced from his excursions offer a small window into this remarkable marginal habitat, where nature attempts to reestablish itself between speeding cars, human litter and the huge expanses of industrial farming. He exhibits these works alongside a map of the complete expedition, several dioramas, a handmade and bound journal of his trips, and botanical specimens of plants collected along the way. The project also incorporated a proposed 'Highway Traveller Native Seed Dispersal Program', which enabled individuals travelling along the I-74 to throw native plant seeds from the windows of their moving vehicles. *The Highway Expedition* is thus a multi-layered, interactive diaristic work combining research, performance, memoir and film that attempts to broaden the understanding of our effects on and relationship to the natural world and challenge our perceptions of purity in nature.

Trip 13 Journal, page 28, 2007

'Is it possible to consider the unbridled offspring of human-introduced plants and animals wild? If not, how should we define these familiar but ill-defined cousins of what is conventionally called nature? This everyday version of nature, which I define as "The Re-Natural Environment", is a conglomerate of alien and native species that have managed to remain, or reinsert themselves, in the interstitial spaces of the human-dominated landscape. Through my work, I provide opportunities for people to notice, find value in, and develop positive relationships with everyday fragments of wild nature.... Of particular interest are examples of our direct effect on the non-human natural world, how non-human nature is evolving to respond to our domineering presence, and ways to shift away from destructive models of interaction with the plants and animals that we encounter in our everyday lives.'

BRIAN COLLIER

Fertile Ground, 2002

Fertile Ground, 2002

ALEXANDRA REGAN TOLAND

American, b. 1975

Alexandra Regan Toland is an American visual artist and an environmental planner based in Germany. She has been a research fellow in the Department of Soil Protection at the Technical University of Berlin since 2009. Her research covers sustainable art, environmental ethics, urban ecosystems, plant population ecology, soil conservation, ethnobotany, landscape architecture and urban planning.

Toland has conducted numerous research-based art projects, many of which investigate diverse plant ecologies in the urban setting. She took as her inspiration for *Fertile Ground* the science of invasive ecology – the environmental impact of species translocated from one region to another by human activity. Focusing on the spread of non-native plant species in parts of northern Europe, the work examined how exotic plants enter new landscapes. It consists of tiny artificial flowers made from various found objects and materials, such as plastic, rubbish and gold leaf. The project had several manifestations in various countries. In 2005, it was installed at the Botanical Garden in Ljubljana, Slovenia. The installation included a narrative audio guide of real and fictitious escape stories of exotic species. Hundreds of specimens of plastic and wire blue grass, battle grass, ryegrass, poppies and solar sunflowers were installed in experimental plant beds.

The *Diary of Weeds* is an ongoing project that began as a survey of an abandoned train depot in Berlin, the Gleisdreieck, which was due for development. Toland produced photographic signs – or 'portraits' as she calls them – of all the urban weeds found at the site, providing scientific and cultural information about each specimen, such as their origins, flowering times and uses in medicine. She also translated the botanical names of each one into six languages (German, English, French, Polish, Bosnian, Turkish) to reflect the social and biological diversity of the depot. The signs were displayed in gaudy gold frames to highlight the value we place on objects such as works of art or family portraits but not on images of common dandelions, soapworts or ragweeds. Toland also offered guided tours to give visitors a visual and historical overview of the site's vegetation.

Toland continues to identify and document plants in other abandoned urban spaces across Berlin. To date, she has photographed over 250 wild native and non-native plant species growing in the city. These images have been used as visual material for an e-learning project of the Technical University of Berlin's Department of Ecosystem Science and are also documented online.

Tilia tomentosa – heart shaped beauty for the broken heart, from *Diary of Weeds and Gallery of Weeds*, 2009

Vicia cracca – vetch measures, from *Diary of Weeds and Gallery of Weeds*, 2006–8

'The site survey that began at the Gleisdreieck depot grew into a weekend passion and hobby that slightly resembles the romanticized botanical identification and collection fetishes of nineteenth-century amateur naturalists. I don't claim to have rigorously documented which species grow where.... However, based on this project I have come to befriend many wildflowers and grasses, especially the more photogenic ones, and can now greet them by name in construction ditches, historical parks, lakeside shores and surrounding woodlands.'

ALEXANDRA REGAN TOLAND

Galápagos Sulphur, 2009

Galápagos Blue, 2009

ALISON TURNBULL

British, b. 1956

Located in the Pacific Ocean, off the coast of Ecuador and near the Equator, the Galápagos Islands are renowned as places of astonishing biodiversity. Cut off by miles of water, they are home to dozens of species that can be found nowhere else on Earth. Made famous by the discoveries of Charles Darwin, whose visit to the archipelago in 1835 led to his theory of evolution, the Galápagos attract both tourist and scientist alike, keen to see how nature works, how animals and plants can adapt to their environment and coexist in a system of interdependence. But the islands are also a fragile ecosystem facing complex social and environmental challenges.

Between 2007 and 2011, twelve artists visited the islands as part of a residency programme. Each one was free to connect with the place in whatever way was most appropriate to their practice. Alison Turnbull has long been interested in methods of scientific taxonomy, in particular systems of botanical classification. Before her departure to the islands in 2009, she discovered *Werner's Nomenclature of Colours*, a nineteenth-century primer for naturalists (which Darwin took with him on HMS *Beagle*), in which colours are divided into three categories: animal, vegetable and mineral. While on the Galápagos, Turnbull studied various species of butterfly and moth that are found there, both in the field and at the Charles Darwin Research Station, which collects all specimens found on the islands. Her interest in colour had led her to the subject. Butterflies are unusual in that colour plays a part in their taxonomic classification: white and sulphur yellows belong to the Pieridae family, while blue butterflies make up the Lycaenidae family.

Turnbull continued her research back in London during a residency in the Natural History Museum, which contains eight million moths and butterflies. She sourced all 105 specimens of Galápagos butterflies in the museum's collections, recorded their colour characteristics and made an inventory of the data on the specimen labels. Her print *Specimens* translates the information she gathered into an abstract pictorial system that reflects scientific systems of taxonomy. The artist's research in the Pacific thus resulted in a systematic cataloguing of the knowledge held within the museum's archives, but it had another outcome of scientific value too. A week after her return, she was informed that a moth she had found during her stay had been identified as *Ascalapha odorata*, commonly known as the Black Witch, a specimen that is found from Texas to South America, but which had never been seen on the Galápagos before.

Opposite: *Specimens*, 2012

Specimen (6), 2000

MARK FAIRNINGTON

British, b. 1957

Mark Fairnington uses the act of painting as his principal method of research. He creates photorealistic paintings of specimens from zoological collections, in particular those of the Natural History Museum in London, as with his *Mantidae* series of insects. Using high-definition electron microscopes, he photographs the specimen in minute detail, before re-creating the image in paint on eight-foot-high canvases. For the related *Membracidae* series, he worked alongside an entomologist at the Las Cuevas Research Station in Belize to study treehoppers, insects that use mimesis as a form of protection. These creatures adopt strange shapes and structures to mimic thorns, seeds and even other creatures as a way of surviving and protecting themselves from predators. Adult treehoppers can have a large pronotum – a platelike structure on the insect's back – which covers the abdomen and sometimes the entire body. In some species, these extraordinary extensions can take on bizarre forms.

Like an entomologist on a field trip, collecting samples in order to reach a complete understanding of a particular species, Fairnington photographed individual specimens under the microscope. He moved each insect around, shifting the point of focus for each frame. The differences in perspective became an integral part of the finished painting. The super-realistic effect of his canvases suggests at first that we are being given transparent access to an objective truth, but this illusion is shattered by the labour that has evidently gone into fabricating the picture. Indeed, the work highlights the fact that all scientific practice, just like art, involves subjective observation, personal interpretation and individual representation – human choices, in other words.

An entomologist would seek a bug that is most typical of its species and select it as the 'type specimen'. Fairnington, on the other hand, selects those that will generate the most interesting images. The insects are mounted face down in the display drawers; in the paintings, they face the viewer, revealing the pin that holds them to the board – two opposite yet equally valid approaches. Some collections follow certain conventions, such as placing specimens against a background colour or material, in order to present the 'truth'. But the construction of this 'truth' can sometimes verge on falsification – by applying colours to black-and-white scans of specimens to make them more appealing, for example. As the critic Sally O'Reilly writes of Fairnington's work, 'Like the vitrines and bell jars that house these specimens, we are all kept in a perpetual bubble of partial truths and convenient lies. The natural world is like raw footage that the artist can script and reframe into a narrative of his own, using the syntax of the fantasist with as much veracity as that of the scientist.'

Membracidae (1), 2002

Membracidae (Notocera bituberculata), 2002

'At the centre of my research is the idea that observation is never neutral and that the cultural meaning of the images generated by scientific research is often determined by narratives that lie outside the field. I'm interested in how description, its attention to detail, gained through studied and intense observation, becomes a platform for storytelling, speculation and even fantasy.'

MARK FAIRNINGTON

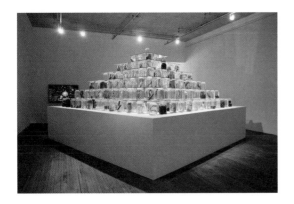

BRANDON BALLENGÉE

American, b. 1974

'My practice has focused on ecological study and sculpting society by implementing increased environmental understanding. A central praxis of this work has been primary biological investigations combined with artistic interpretation of amphibian, bird, fish and insect species. Achieved through participatory field surveys and laboratory research ... art works are created from direct experiences with animals in their natural environment as well as those in artificial conditions. By using diverse mediums such as paintings made from collected pollutants, chemically altered specimens, living plants and animals in installations, I try to re-examine the context of the museum space from a static controlled environment (implying rationality and control) into a more organic structure reflecting the inherent chaos found within evolutionary processes and nature herself.'

BRANDON BALLENGÉE

Brandon Ballengée trained as an artist before becoming a biologist and environmental activist. He creates hybrid works that bridge the fields of art and ecological research and are inspired by his vast field and laboratory experience. A central concern of his investigations both as an artist and as a scientist has been the occurrence of physical deformities and population decline among amphibians, a subject on which he has published papers in scientific journals. Since 2009, he has been a visiting scientist at McGill University in Canada and is a member of Sigma XI, the American Scientific Research Society.

In his first major solo exhibition in New York in 2012, Ballengée presented works that explore the effect of ecological degradation on marine life. He focused on the aftermath of the 2010 BP oil spill in the Gulf of Mexico and its continuing destruction of the local ecosystem. The video piece *Committed* contrasted BP advertisements with scientific data gathered by Ballengée and a team of collaborators. News-style bulletins scrolled across the top and bottom of the screen, refuting the oil company's claims and unmasking its propaganda. Ballengée is nothing if not an assiduous cataloguer and he collates his findings so that they not only inform but also form part of the presentation of his art. To accompany his video, he made available a 435-page appendix of all the scientific evidence that he had accumulated rebutting the corporate rhetoric.

The centrepiece of the exhibition was an installation entitled *Collapse*, a four-sided pyramid, more than sixteen feet high, constructed from glass jars containing 26,162 preserved specimens of fish and other aquatic organisms representing 370 species found in the Gulf of Mexico. Many of these creatures showed some of the strange deformities that have been recorded in the region since the spill: eyeless shrimp, fish with lesions, eyeless baby dolphins. The work resembled a 'trophic pyramid', a representation of an ecosystem food chain, with the simplest life-forms appearing at its base and the more complex life-forms, such as blackfish shark, at the top. Jars at the four corners of the bottom contained the very toxins that caused the devastation: crude oil and Corexit, the solvent used to break up the slick into sub-surface globules, which accelerates the oil's consumption by marine life. Empty jars throughout the levels of the pyramid represented species in decline or those already lost to extinction; their number increased towards the top.

Ballengée is clear that behind both his scientific research and the artistic presentation of his findings is a campaigning zeal. His stated intention with both works was, after raising awareness and gaining the attention of the media, to 'push for governmental reform and [put] real pressure on BP to try better restoration efforts'.

Above and opposite: *Collapse*, 2012

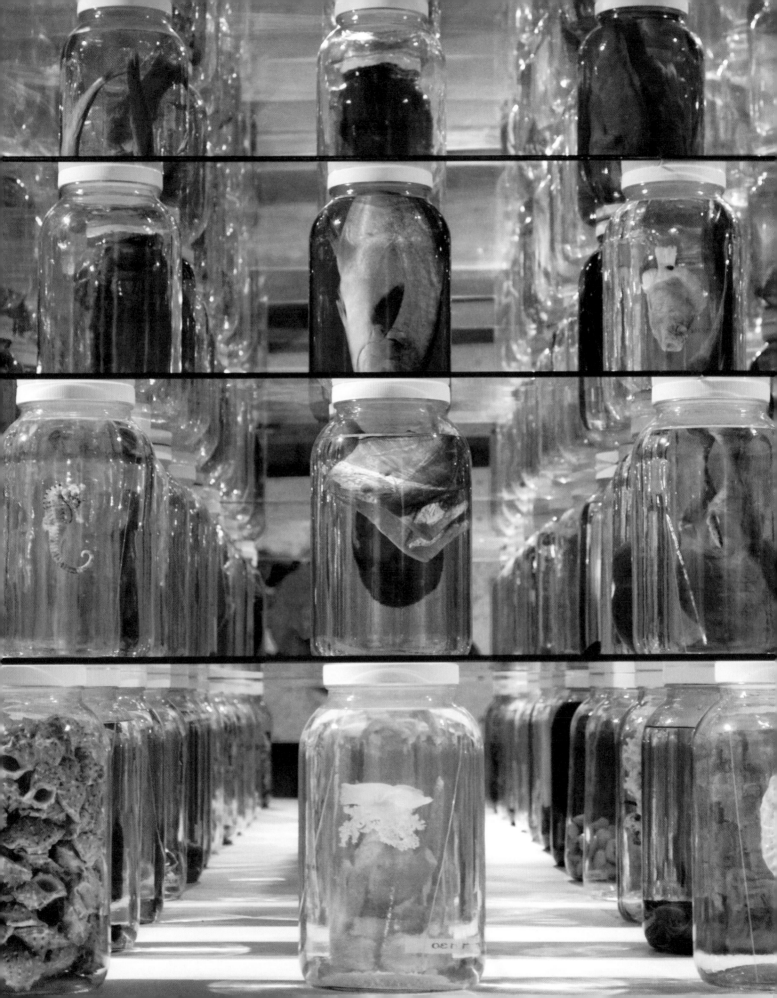

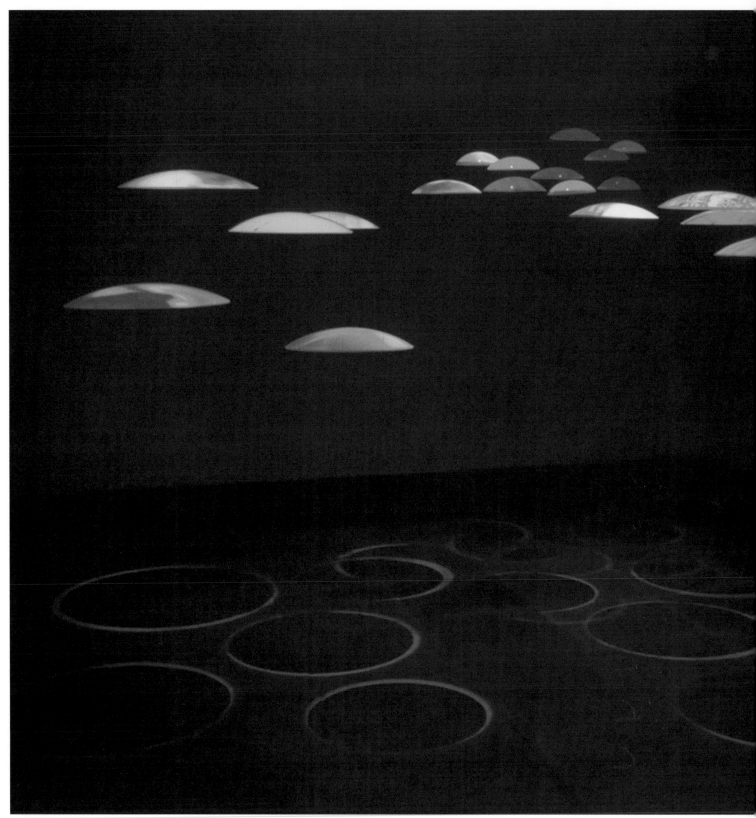

Cascade, 2009–10

JANINE RANDERSON

New Zealander, b. 1974

Janine Randerson works with a range of time-based media, including film, digital audio and video and computer-programmed interactive design. In 2008, she was invited to undertake a residency at the National Environmental Research Institute in Roskilde, Denmark. A key task of the institute is to monitor the effects of climate change on animal and bird behaviour and migration. The scientists create simulations and visualizations from data collected from transmitters on birds such as the arctic tern, Svalbard goose and king eider, and animals such as polar bears, caribou, narwhals and porpoise, to reveal their movement and feeding patterns.

Randerson spent five weeks conducting research alongside (and into) the work of the institute's scientists. She encountered a recurring phrase: 'trophic mismatch'. This condition develops as a consequence of climate change, when the availability of food at certain points of the ecosystem shifts in response to warming temperatures, but the timing of demand for those resources does not keep pace. Scientists describe such a situation, in which there is a mismatch between a food's availability and demand as generating a 'cascade of effects' up or down the food chain. The emotive, yet scientifically applied, word 'cascade', became a motif for Randerson's research.

In her video installation *Cascade*, which is made up of ten circular screens, Randerson uses projected images and sounds extracted from scientific mapping software, as well as footage found on YouTube, including images of Arctic migratory birds recorded on stopovers in Australia and New Zealand and polar bears interacting with eco-tourists in the Arctic Circle. The work thus brings together two spheres that are usually kept apart: data visualizations by professional scientists observing global patterns and amateur videos by enthusiasts filming their own personal experiences. One set of evidence is statistically rigorous and presented formally to the scientific community, while the other is impromptu and shared freely via the web. But by mixing these two forms of knowledge, *Cascade* raises questions about their relative merits. When combined with ordinary peoples' YouTube offerings, the statistical data no longer forms a singular, authoritative version of reality, but becomes just part of one subjective possibility among others.

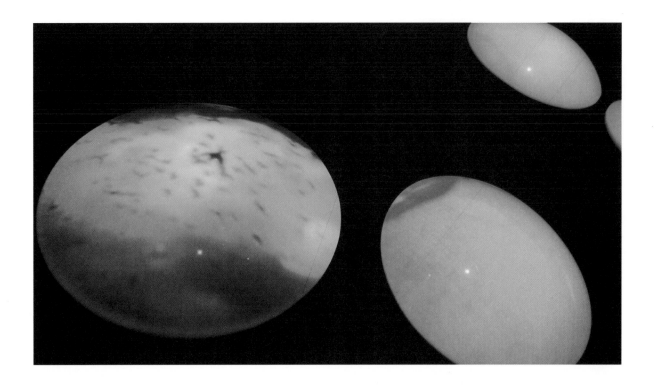

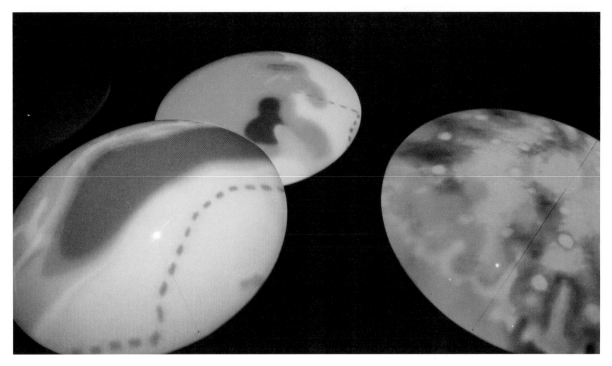

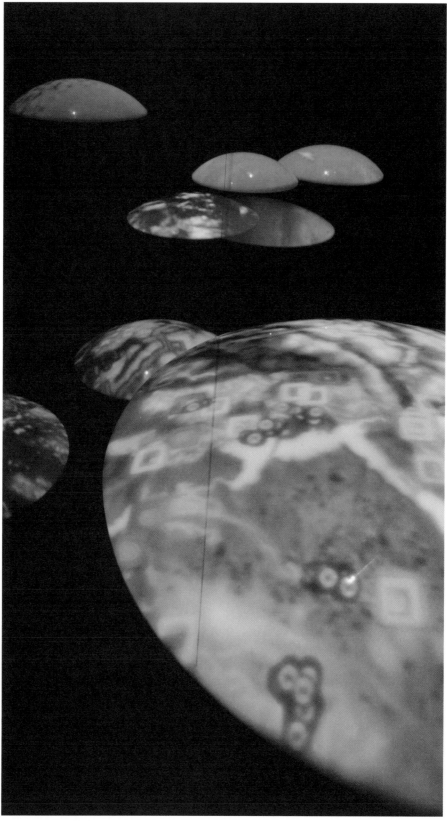

All images *Cascade*, 2009–10

LISE AUTOGENA & JOSHUA PORTWAY

Lise Autogena, Danish, b. 1964
Joshua Portway, British, b. 1967

Lise Autogena and Joshua Portway have collaborated since 1991, producing ambitious and complex multimedia installations that explore the hidden systems, networks, economies and technologies that determine every aspect of our lives. Often beginning from an imaginative, poetic insight but using high-tech methods and equipment, such as the visualization of live data streams, their multi-layered projects seek to pinpoint our position in time and place and reveal different levels of human connectedness and interdependence on a global scale.

Most Blue Skies is a computer-generated work that attempts to find the eponymous 'most blue skies' in the world. It uses an advanced system of real-time data from three satellites and custom-built simulations to measure the passage of light through the atmosphere and to calculate the exact colour of the sky at six million places on Earth. The name of the location of the current bluest sky is projected beneath a square wall illuminated by a specially developed lighting system reproducing the colour of the bluest sky at that precise moment, while ongoing calculations and a global map of sky colours are also displayed.

Autogena and Portway realized *Most Blue Skies* with the aid of a large team of climate, colour and computer scientists from organizations such as the Imperial College Space and Atmospheric Physics Department, the UCL Colour and Vision Research Laboratory, and the Meteorological Office in Britain, and NASA and the Physical National Renewable Energy Laboratory in the United States. The work therefore combines the very latest 'blue-sky thinking' in scientific research and technology with a romantic, almost utopian effort to represent and understand the changing nature of our atmosphere. But it also highlights our complicated and evolving relationship with the natural world, for not only does it point to our faith in and dependence on the protective blue sky above us, it also demonstrates our need to master the environment through knowledge and to project a human vision onto nature itself.

Most Blue Skies II, 2009

'Part of the point of the project is that it is impossible to answer the question, so it's about throwing yourself at this wall of impossibility and pushing on to a ridiculous extent.'

JOSHUA PORTWAY

LAYLA CURTIS

British, b. 1975

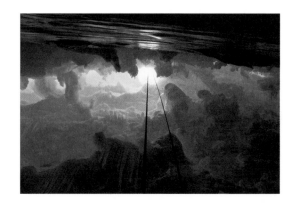

The multi-form work of Layla Curtis explores the ways we perceive, navigate and make use of physical space. In particular, she is concerned with how we map borders and boundaries, both real and metaphorical, to define territories and to establish a sense of 'place'. Maps are one of the most effective visual means we have to express our collective identity, to create a sense of belonging or ambition, and to represent shared affiliations, beliefs and values. But more than just displaying topographical features and political, historical and cultural facts, maps can also serve the exercise of power and authorized knowledge. They can act as a means of control, charting permitted places and routes and areas that are out of bounds.

Not surprisingly, extensive travel and long periods of research have characterized much of Curtis's work. For a number of years, her ongoing investigation into forms of mapping has utilized new technologies in extreme environments. In 2005, she spent three months in Antarctica with the British Antarctic Survey. Unlike other artists and photographers who have ventured to the continent, Curtis did not use the opportunity to record the unique beauty of the frozen landscape. Instead, she was interested in capturing her own movements. The resulting work, *Polar Wandering*, is a web-based psychogeographical exploration of the artist's travels from her home in London to the Antarctic Peninsula, via Madrid, Santiago, the Falkland Islands and remote islands of the Southern Ocean. Throughout the journey, she used a personal GPS transmitter to track her progress across the globe. The longitudinal and latitudinal data generated by the tracking device was constantly streamed to a project website to create a continuous 27,856-mile-long line drawing that charted her passage to and from Antarctica, embedded with photos, videos, sound recordings and texts created at various key points.

All images *Polar Wandering*, 2006 (details)

The drawing shows that when she arrived on land after each stage of the journey, Curtis would walk around the features that she felt defined each place. At first, these were human-made structures such as roads, but then she would wander through natural phenomena, her route dictated by snowdrifts, crevasses, mountains or the perimeters of penguin colonies. She also logged the more mundane movements of daily life, including trips to the canteen: repeated journeys were apparent from the thickness of the red lines against the white backdrop of the Antarctic terrain. As the project progressed, the live GPS drawing developed into a complex data map through which visitors to the website could follow Curtis's field survey of this relatively sparsely mapped continent – the abstract representation of her subjective wanderings charting the reality of this barren land as accurately as any apparently objective map.

'Throughout my practice I have explored and been inspired by the subjectivity inherent in mapping: differing world views, time zones, national and regional identities, the etymology of place names and the notion of travel which interlinks these entities.... Everyone trusts maps on a daily basis, to get from A to B. But when you dissect them, maps are very subjective things and only hold a certain amount of information. I'm interested in playing with that system.'

LAYLA CURTIS

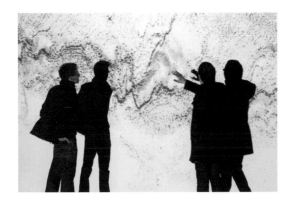

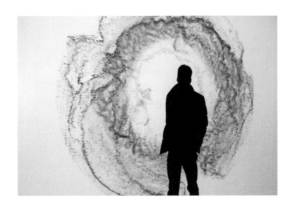

BAILY, CORBY & MACKENZIE

Gavin Baily, British, b. 1971
Tom Corby, British, b. 1966
Jonathan Mackenzie, British, b. 1967

The London-based artists Gavin Baily, Tom Corby and Jonathan Mackenzie work collaboratively using public-domain data, climate models, satellite imagery and the internet. Baily is a freelance developer and software engineer; Corby is deputy director of the Centre for Research and Education in Arts and Media at the University of Westminster; and Mackenzie works in research, with a particular interest in complexity science and algorithms as creative tools. Together, the group pursues projects that overlap art, science, computing and information technology. In particular, they research new ways in which digital information can be used as a creative medium.

In 2009 they began to work with the British Antarctic Survey to explore how the data it collects from its research projects in the Southern Ocean could be shared more widely for a general audience. The project examines how climate modelling has become an important vehicle to communicate environmental change to both specialists and non-specialists. But *The Southern Ocean Studies* digs deeper to explore how climate models can function beyond this original scientific purpose and become art with expressive, conceptual and critical potential.

The installation takes the form of projected data visualizations that show the ocean circulating around Antarctica (at the centre of the projection). Custom-made software tracks currents and maps these real-time movements onto other geophysical data sets to produce flickering constellations showing tidal flows, wind direction and weather patterns. While *The Southern Ocean Studies* thus simplifies the natural processes at play in the Antarctic waters, rendering them in a direct and accessible form that can be easily 'read', it also complicates our reading by demonstrating how the same processes are layered and connected to each other. Rather than isolating any one of them for investigation, the projections reveal how these forces of nature together form a complex ecosystem of cause and effect. As the artists explain: 'While respecting the underlying science, the work seeks to develop a sensibility to the dynamics of ecological complexity as pattern and felt experience rather than quantity and measure. In doing so, we hope to articulate an aesthetic of systemness – a metonym of the interconnected forces operative within the ecosphere to which lived human behaviour contributes and is a part.'

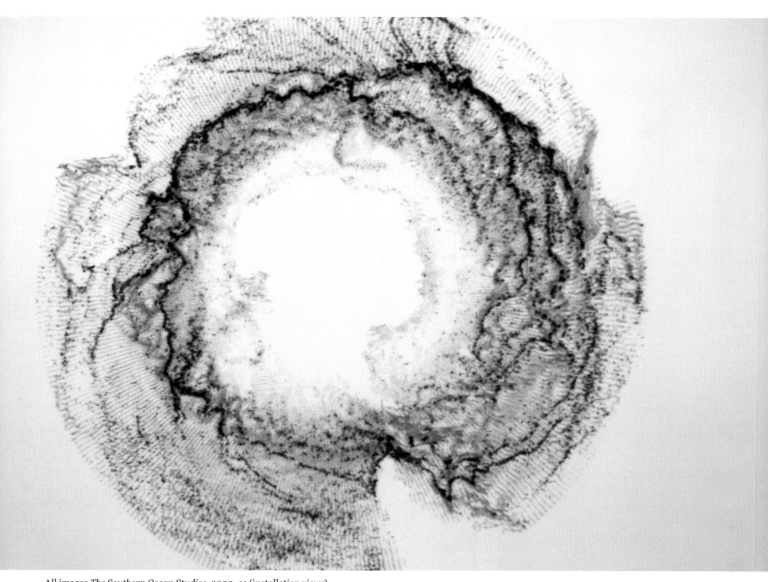

All images *The Southern Ocean Studies*, 2009–11 (installation views)

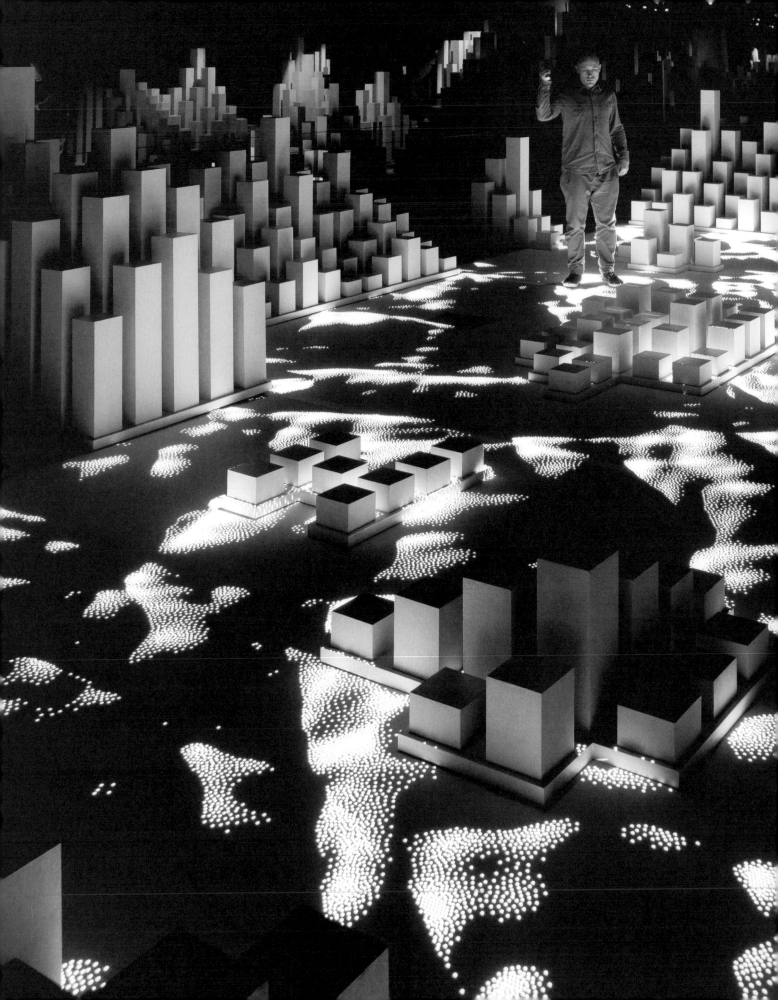

UNITED VISUAL ARTISTS

Founded 2003, British

The award-winning experimental art and design practice United Visual Artists (UVA) produces work that combines sculpture, architecture, communication design, live performance, moving image, digital installation, computer science and engineering. While the group's members come from a variety of backgrounds, its origins in design for live performance mean that many of its projects focus on spectacle and the passive and active role of the spectator.

In 2010, UVA's co-founder and creative director Matthew Clark travelled on a Cape Farewell expedition to the Arctic archipelago of Svalbard, between Norway and the North Pole. Conceived as a response to the spectacular icy sights he encountered on the trip, *High Arctic* is an immersive installation that uses sound, light and sculpture to create a responsive landscape for visitors to explore and interact with.

The work fast-forwards us to the start of the next century, to the year AD 2100, and the Arctic has changed beyond recognition. The highly stylized model of the region combines architectural lighting design, art code, animation, sound design and poetry. The columns of 'ice' represent real glaciers in the Svalbard area and together they form an archipelago of sixty-five islands. An artificial horizon created from a seamless canvas of light surrounds the gallery, and changes in intensity and colour, depending on the participants' movements. Sounds weave throughout the space, including words of poetry and the voices of Arctic explorers across the centuries. Visitors use ultraviolet torches to make their way through the darkness. These flashlights activate projections and unlock hidden elements, constantly shifting patterns of graphics and text that react to anyone approaching. As they navigate a course through the ice islands, participants discover five pools of open space to explore. Using the torches to interact with animations, they are confronted with the three thousand glaciers that will melt over the coming centuries. Like the real glaciers themselves, the projections become increasingly polluted as visitors journey through the five different areas. The more torches in a certain area, the wider the beam of the projection appears.

High Arctic is a monument to the future's past, and a reminder that we can still shape the present's future, but only if we address the impact of human activity on the Arctic environment. 'Walking across those glaciers was the most magical moment for me,' says Clark. 'When I was standing on one of them, one of the scientists said: "In fifty years' time, these won't be here." It is this beauty, scale and fragility – and a sense of loss – that we are trying to embody.'

High Arctic, 2011

All images *High Arctic*, 2011

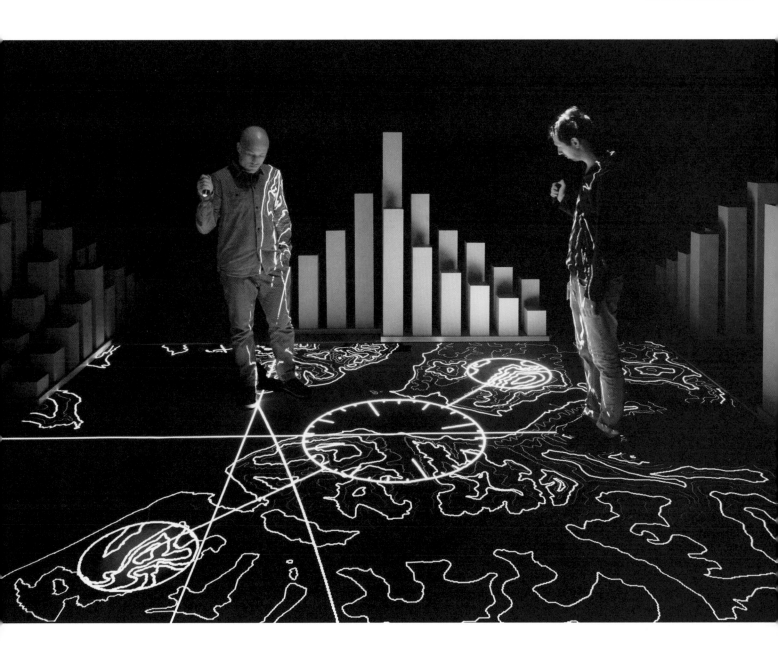

'It is more of a sensory, emotional space ... a playful, musical, visual experience rather than just being a lecture. We want to make you feel something and stimulate your desire to learn stuff. If you are a kid, we want to make you want to find out more and be an explorer.'

UNITED VISUAL ARTISTS

Madre de Dios – Fluvial Intervention Unit, 2010, and installation view of *Perpetual Amazonia*, 2009–10

Pelaeomastodon, 2009–10

LUCY & JORGE ORTA

Lucy Orta, British, b. 1966
Jorge Orta, Argentinian, b. 1953

Lucy and Jorge Orta create art works in a range of mediums, from drawing, sculpture and installation to fashion, photography and performance, and they have long drawn upon sustainability for their inspiration. But they also attempt to solve as well as reflect on ecological and social problems. In 2007, they received the Green Leaf Award for artistic excellence with an environmental message from the United Nations Environment Programme for *OrtaWater*, an intervention that highlighted the scarcity of this vital resource and the problems arising from its pollution and corporate control.

In 2009, the couple joined the Cape Farewell expedition to the Peruvian rainforest, travelling with scientists from the Environmental Change Institute (ECI) at Oxford University, England. They mapped out a two-and-a-half-acre plot at the Manú Biosphere Reserve in the Peruvian Amazon, a UNESCO World Heritage site. Trees and rare plants were marked for data collection and statistics on the types of botanical species were recorded for research programmes. The artists also catalogued and photographed dozens of vulnerable species of flora and fauna. Their experience moved them to create *Perpetual Amazonia*. This two-part art work comprises an ongoing series of stunning close-ups of flower species and a poster that visitors can take home in return for a donation to the conservation efforts in the Amazon. Each photograph is marked with the Universal Transverse Mercator (UTM) coordinates of its exact location in the reserve. Collectors of the original photographs receive a certificate and agree to participate in the research. The aim is to preserve the two-and-a-half acres of rainforest in perpetuity so that it can be dedicated to scientific research for ever.

The project is part of a larger body of work inspired by the Ortas' expedition to the Amazon. They also produced a double-projection video, *Amazonia*, that shows mesmerizing imagery and sounds recorded during the journey. On their return, they commissioned eco-poet Mario Petrucci to create an accompanying poetic narrative. The drawings in the *Amazonia Expedition Sketchbook* reflect the couple's experience of the expedition, while aluminium and porcelain sculptures of bones and fossils covered with drawings of flowers, butterflies and insects encountered on the trip point to the fragile balance between the many thousands of species that live in the Amazon regions and the cycles of life and death.

All images *Perpetual Amazonia (one metre square | S12 48 21.6 W71 24 17.6)*, 2009–10

'We journeyed to the Amazon to experience the immensity and grandeur of such a vulnerable living organism. We found the rainforest to be a beautiful oasis of diversity, in a state of crisis. By gaining an insight, we hope our art works can evoke such feelings so nature can once again invade our minds.... We're concerned with how far the art work can function, activate and be activist, and move important issues forward.... Collaboration with other disciplines is a way to engage with different audiences. Our idea is to spread out as much as possible. Art can help because it has a visual attraction, but there's no way that any artist can do it on their own – we can't get our message across half the time, so we need as much as possible to engage with others. Mario will publish his poetry and do readings, so the work will reach out to another audience, and we plan to send the video off to film festivals. We see it as a team effort. We're all working together for this issue.'

LUCY ORTA

'These people, their travels, their friendships, lovers, the people they encountered at meetings, parties, festivals, the stores they bought their groceries and clothes from, the horses or cars or buses they rode, the artists they met, the theatres they visited and what tea they drank and where it was picked from and who picked it could potentially contribute to the seed bank at Huangui Lu, where a new metro stop was being built and where more seeds and their histories will arrive.'

MARIA THEREZA ALVES

MARIA THEREZA ALVES

Brazilian, b. 1961

The work of Maria Thereza Alves focuses primarily on the move-ment of seeds and plant species around the globe. Alves, co-founder of Brazil's Green Party, is best known for her ongoing project 'Seeds of Change', which explores via the tools and methodologies of archaeology the social history of plant seeds in different port cities throughout the world. In 2012, in Bristol, southwest England, she planted a floating garden on a disused barge using the kinds of foreign seeds that were once mixed up in ships' ballast before being dumped in the river. Her research into old shipping routes revealed that vessels returning from ports around the world would fill their hulls with earth and stones to weigh them down on their journey. This ballast contained the seeds of plants from wherever the ship had sailed. Once back in Britain, the earth was offloaded into the river. Alves discovered that these ballast seeds can lie dormant for hundreds of years, but that by excavating the river bed, it is possible to germinate and grow them into flourishing plants.

For *Wake in Guangzhou*, she took a five-ton sample of earth from Huangui Lu, a street in the former merchants' quarter of the city of Guangzhou (an important port in the Guangdong province of China), and placed it in the courtyard of the Museum of Contempo-rary Art so that the dormant seeds within it were germinated when exposed. Meanwhile, she researched the life of the early Chinese revolutionary Sun Yat-sen (1866–1925), who had a pharmacy not far away from the earth site. She traced the movements of Sun and his family around the world, as well as those of other potential seed transporters. As Alves explains, 'Seeds arrive into the city by the movement of people. Guangzhou's historically important port, which traded with the world, provides countless opportunities for the influx of seeds. Trains, cars, ships and animals also transport seeds. Wind and rain sweep seeds from one place to the other. Birds flying across the continents bring seeds. A botanist once removed a ball of mud from a bird (three years dead) and planted it. Eighty-four plants sprang up.' The plants that grow from the mound of earth thus reflect the centuries-old history of the site. But this is a living history too. Seeds continue to move around the city. Simply by walking, we involve ourselves in their/our histories. The plants that spring up are therefore documents of lives long past as well as witnesses of our own daily existence.

All images (including overleaf) *Wake in Guangzhou: The History of the Earth*, 2008

EMPEROR QIANLONG CONSOLIDATED THE TERRITORY OF XINJIANG WHERE Uyghurs, KAZAKHS, AND THE KYRGYZ live. THE EVENKS IN HEILONGJIANG ALSO BECAME PART OF CHINA ALONG WITH THE MONGOLS. HE INVADED VIETNAM AND BURMA AND BATTLED THE DZUNGARS. THIS IS HIS BIRTHDAY CELEBRATION.

→ LORD GEORGE MACARTNEY OF ENGLAND CAME AND ALMOST MET HIM.

BORN IN IRELAND FROM SCOTS FAMILY, STUDIED IN LONDON, ENVOY TO RUSSIA, GOVERNOR OF BRITISH WEST INDIES, AND GOVERNOR OF MADRAS. HIS VICE-AMBASSADOR IN CHINA WAS SIR STAUNTON WHO BROUGHT BACK A COLLECTION OF 400 CHINESE PLANTS... THEIR SEEDS COULD BE HERE.

DUTCH FACTORY,

ALTERNATIVELY SEEDS FROM MOZAMBIQUE could have arrived via Africans who escaped ENSLAVEMENT BY THE PORTUGUESE, IN MACAO

RUSSIA EXPANDED FURTHER AND FURTHER EAST IN SEARCH OF ANIMALS FOR THEIR FUR. BORDER CONFLICTS BEGAN WITH CHINA ALONG THE AMUR REGION. THERE WAS A SIBERIAN FUR STORE IN SHANGHAI

IN THE PEDLARS C___ there were ___ barbers, sh___

A SEED CAR___

WU BENG OFFICIAL HO___ FOREIGNE___ THE USA H___ AND HIS E___ KWAN LL___ MADE A___ HAD A ___ NEAR ___ GOOD ___

OVER THE YEARS TRIBUTES FROM VIETNAM, BURMA, KOREA, THAILAND, MALAYSIA, FRANCE, NETHERLANDS, JAVA, SUMATRA, AND the MALACCAS (WHERE IN THE 16TH CENTURY, 84 LANGUAGES WERE SPOKEN) AND SRI LANKA, WERE GIVEN.

IN THE SIGNING OF THE TREATY BETWEEN CHINA AND FRANCE LOTS OF PEOPLE PARTICIPATED.

LIVE cattle, CRANES, DEERS, giRAFFES, CLOCKS and PORCELAIN AMONG MANY OTHER THINGS WERE GIVEN AS TRIBUTE.

RICE BOATS FROM VIETNAM, THAILAND, GUANGXI AND HUNAN PROVINCE ARRIVED IN GUANGZHOU

THE RAILROAD IN KENYA WAS BUILT BY INDIAN WORKERS

MACAO WAS A COLONY OF PORTUGAL FOR HUNDREDS OF YEARS. SEEDS COULD HAVE ARRIVED THERE FROM ANY OF ITS COLONIES, LIKE MOZAMBIQUE. FOREIGN MERCHANTS COULD ONLY LIVE IN GUANGZHOU FOR HALF OF THE YEAR, MANY THEN MOVED TO MACAO FOR THE REST OF THE YEAR.

THE DUTCH IN 16__ INDONESIA TRADED SPICES WITH GUANGZHOU, BUT AFRICAN AND ASIAN MERCHANTS WERE TRADING WITH CHINA CENTURIES BEFORE

HORSES AND COWS EAT LOTS OF SEEDS THIS IS DUNG COLLECTION TO KEEP STREETS CLEAN.

Sixty different species of WEEDS GROW IN THE RICE FIELDS OF VIETNAM

EMPEROR QIANLONG'S SOUTHERN INSPECTION TOUR WITH MANY OFFICIALS, SOLDIERS AND HORSES TO HELP SEEDS MOVE ALONG.

PAINTED BY GIUSEPPE CASTIGLIONE, A JESUIT

THIS IS THE CEREMONY WHERE PORTUGAL RETURNED MACAO TO CHINA.

RCHANTS AREA,→
IVES, PASTRY, TEA, CLOTH,
...TAILORS, WEAVERS
...DOCTORS

...WN AS HOWQUA) WAS AN
...ALLOWED TO TRADE WITH
...WITH HONG KONG AND
...LORD MACARTNEY
...SOUTH OF THE RIVER

...KNOWN AS TINGQUA)
...OF WU'S HOUSE. HE
...#16 NEW CHINA STREET,
...MERCHANTS AND THEIR

HEARD (FROM MASSACHUSETTS)
...USSEL & CO. PARTNER) (TRADING IN
...M) COLLECTED TINGQUA'S WORKS.
...THER OF FORMER PRESIDENT FRANKLIN DELANO ROOSEVELT
WAS ALSO A PARTNER TRADING WITH
GUANGZHOU.

A PLAQUE TO COMMEMORATE
MR. WU'S AND PAN'S SALON

TINGQUA'S STUDIO →

MR. BOVET WHO
WAS ESTABLISHING
A LUXURY WATCH
MARKET IN CHINA,
REFUSED TO GIVE A
FELLOW MERCHANT, WHO
RENTED THE WARE HOUSE
WITH HIM, THE KEY TO
OPEN THE LOCK TO LEAVE.
HE THEN ATTACKED MR.
MERWANJEE AND HIS STAFF
WHEN THE MERCHANT TOOK HIS
SWORD AWAY HE RAN AWAY.
HE WAS FROM SWITZERLAND

PAN KHEQUA
WAS ALSO A HONG MERCHANT
WORKING WITH THE BRITISH EAST
INDIA COMPANY, SWEDEN AND DENMARK.
HE HAD STUDIED IN MANILA AND HIS
FAMILY WAS ORIGINALLY FROM FUKIEN.
AT HIS ENTERTAINMENT HOUSE HE MET
WITH AMBASSADORS, GOVERNMENT AND
MILITARY OFFICIALS AND KEPT A
SALON ALONG WITH MR. WU AND INVITED
ZHANG WEI PING, XIONG YING AND
JING ING.
HE HAS 7 SONS,
SOME WERE
MERCHANTS.
ONE HAS A
MEMBER OF
THE MASSACHUSETTS
AGRICULTURAL
SOCIETY

THE FORMER
GERMAN CONSUL
IN SHAMIAN ISLAND→
GERMANY HAD MADE
TANZANIA INTO A COLONY.
THIS IS A CHART OF
WIND DISTRIBUTION IN
EAST AFRICA DURING THE
MONTH OF APRIL. SEEDS
CAN COME FROM MANY
PLACES BY BEING BLOWN.

A WAREHOUSE IN THE LIWAN.

SLAVES AS PERCENT OF
TOTAL POPULATION 1860

TINGQUA'S BROTHER,
LAMQUA WAS HIS DISCIPLE

LU CHI KUANG (KNOWN AS MOWQUA) WAS ALSO A HONG MERCHANT.
HE WAS PAINTED BY GEORGE CHINNERY, WHO WAS BORN IN
LONDON AND WHOSE FATHER WAS A MERCHANT WITH THE BRITISH
EAST INDIA COMPANY. GEORGE TRAVELED TO BRISTOL, DUBLIN AND INDIA.
MOWQUA ALONG WITH HOWQUA BECAME INVOLVED IN AN INCIDENT
INVOLVING CAPTAIN CRAIG, MR. PERCY AND COMMODORE HUGH
LINDSAY WHO FORCED THEIR WAY INTO THE WALLED CITY OF
GUANGZHOU (FORBIDDEN TO FOREIGNERS) IN ORDER TO PETITION THE
SUPERINTENDENT OF MARITIME CUSTOMS WHO MET OFTEN WITH
THE GOVERNOR WHO MIGHT HAVE GONE ICE SKATING WITH THE
EMPEROR
IN THE
FOREST

WHEN HONG
MERCHANTS
VISITED THEIR
FAMILY OR
FRIENDS
GRAVES SEEDS
COULD COME
BACK WITH THEM

WU LIYI WAS AN ARTIST IN THE DISTRICT.
HER GRANDFATHER WAS A MERCHANT TRADING WITH CHILE.

...RE WAS A COMPLAINT
...E BY THE AMERICAN
...AM CLARK CAMPBELL
...NST THE SECRETARY
...HE BRITISH CANTON CLUB,
...MARIA ECA DA SILVA,
PROHIBITING CHINESE FROM

WHEN THE WALL OF THE
CITY WAS TAKEN...

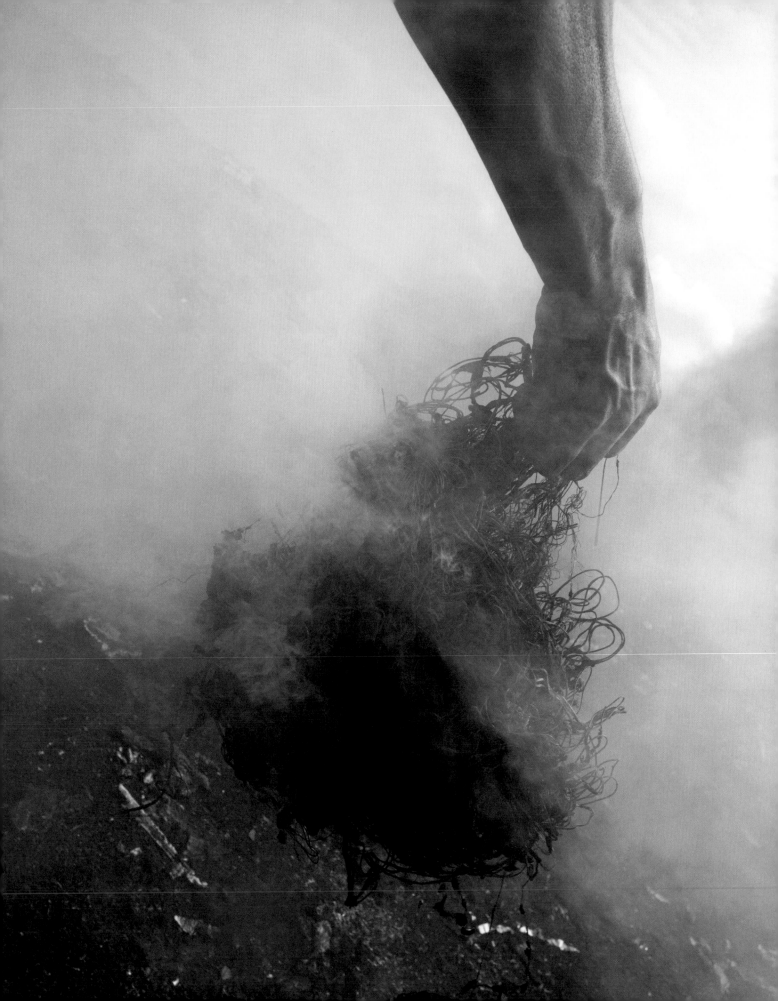

RE / USE

More than any other section, this chapter reflects (and reflects on) the double meaning of its title. First, it presents the work of artists whose primary concern is the way we use and abuse the Earth's resources – not only the processes and materials that are present in the animal and plant kingdoms, but also those we harvest from the planet's atmosphere and weather systems, from on and beneath its surface, and from deep below its oceans. The works examine how we recklessly disturb the precarious equilibrium of the environment by searching for and extracting elements that have driven the march of modernity and are now essential to life in the twenty-first century: oils and fossil fuels, metals and minerals, organic and inorganic substances that build and feed contemporary society. These artists also examine the processes by which we ascribe cultural or financial value to the natural world.

At the same time, some of the projects here respond to our throwaway culture, castigating with subtle suggestion or direct accusation the careless and heartless disposal of consumer detritus and industrial waste that pollutes, chokes and scars the environment and harms humans and animals alike. That many do so by drawing out images of great beauty from scenes of sickening ugliness serves to highlight the striking contrast between our so-called civilized society and the devastating effects of our everyday actions. Politics, both local and global, usually with a commercial imperative, is frequently the backdrop to these instances of pollution that blight the landscape and harm the existence of those who depend on it. These episodes are often stories of the haves exerting their power over the have-nots, controlling access to the land and use of its economic and environmental riches. Small wonder that many commentators believe that this present century's great military conflicts will be fought not over ideology or faith but over possession of dwindling natural resources, not least water and energy.

Of all the chapters in the book, this one provides the most critical and judgmental view of our relationship with the physical world. But it also offers hope of a brighter future, and it is here that we find the second meaning of the chapter's title. For this section begins to imagine an alternative mode of living, one that does not involve the relentless discarding of obsolete products or exhausted matter. It shows how some artists can comment on these issues while offering sustainable solutions, by recycling or reusing human-made or natural objects, or by subverting their original function and diverting them from their intended purpose. They do so conscious of their general obligations as responsible citizens, but also acutely aware of their specific circumstances as professional users and makers of 'stuff', both natural and synthetic. As Simon Draper, founder of 'Habitat for Artists', has said of the group's studios fashioned from discarded materials: 'These intimate work spaces not only ask artists working in them to explore their creative needs, but also act as a metaphor for our own domestic needs. How might we be more creative about our consumption of materials, our use of energy and land? Could we be doing more with less, yet still create a vibrant, relevant society and culture?'

These are questions that motivate many of the artists in the book, and beyond. American sculptor Lisa Corine von Koch expresses the conflict that many environmentally engaged artists feel today as they try to find more eco-friendly ways of practising and creating their art: 'The artwork that I make is a testimony to my search for a point of reconciliation; an attempt to navigate through the paradox of having an environmentalist agenda and still being an object maker and user of materials. My work embodies the tension that I feel from being both a critic and participant in the intersection of nature and culture. As an artist whose primary focus is that of reverence for the natural world, I have recognized the hypocrisy of using materials that contribute to the degradation of the earth. I now primarily use natural materials such as beeswax, pigment and plant material that come from non-indigenous, water-needing flora found in Tempe, Arizona. In addition, I incorporate man-made materials such as used water bottles, paper towels, receipts, junk mail and scraps of canvas that I unravel. These materials testify to the wasteful decadence of our contemporary lifestyle, and can all be repurposed into art material.... It is becoming increasingly more important for me to confront my dependency on a system that causes so much irreversible damage to the planet. I attempt to find ways to implicate myself, and recognize my own weakness for abundant and excessive material use in the studio and in my life. Therefore, I am in the process of seeking out materials and subject matter that are selected with environmental consciousness and awareness. In this way, I seek to both define and to refine my relationship with the environment, and encourage the audience to investigate their own relationship with the planet.'

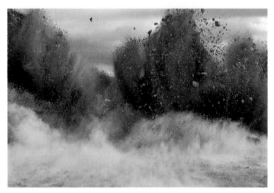

Blast #08316, 1999

A *Bird/Blast #13009A*, 2006

NAOYA HATAKEYAMA

Japanese, b. 1958

One of Japan's most celebrated contemporary photographers, Naoya Hatakeyama is known for his large-scale images that explore the often catastrophic encounters between humans and nature. Drawn to landscapes in transition, he focuses on the methods by which we exploit natural resources for gain and the forces we use to shape the environment to our will. His interest began in the early 1980s, when he started to photograph Japan's limestone mining and processing operations. Limestone, a key ingredient in the production of concrete, steel, glass, plastic and medicine, is one of the few natural resources in which the country is totally self-sufficient. It extracts about 200 million tons each year, and is believed to have an additional 10 billion tons of deposits – enough to last another fifty years.

In 1995, Hatakeyama turned his attention towards the daily detonations to free limestone from the sides of cliffs and mountains, and he has been photographing these explosions ever since. In his *Blast* series, he uses remotely controlled cameras to capture the blasting operations from point-blank range, working with bomb experts to place the camera as close as possible to the heart of the explosion without it getting smashed by flying debris. 'I was moved by the engineers' ability to imagine in their brains how 2,000 tons of rock would break apart and then give me accurate advice,' said the artist. 'From having worked with the rock for so many years, they had gained a vision that I could never imagine. One could say that they were in dialogue with nature in the form of the rocks.'

Hatakeyama's dramatic close-up views of volatile exploding rock provide a unique, awe-inspiring perspective that cannot be seen (or foreseen) by the naked eye, while at the same time displaying the human capacity to destroy. They are overwhelming, almost sublime, as the force of the blasts is frozen in silent, still, meditative images that capture destruction and creativity at the same instant. But unlike the historical sublime, as celebrated in Romantic painting and poetry, these images do not refer to the awesome terror of nature, but to the ferocious power of human-made forces unleashed onto the earth. In one of the photographs, *A Bird/Blast #13009A*, a bird flies through the flying rock and billowing plumes of dust unharmed. Hatakeyama described the moment: 'It felt to me as if "nature" was fleeing. From what? Perhaps from something human.... The enormous power of humans obscures "nature" for an instant, but when the exercise of that power settles down, "nature" reappears as if nothing had happened and goes off to another location.'

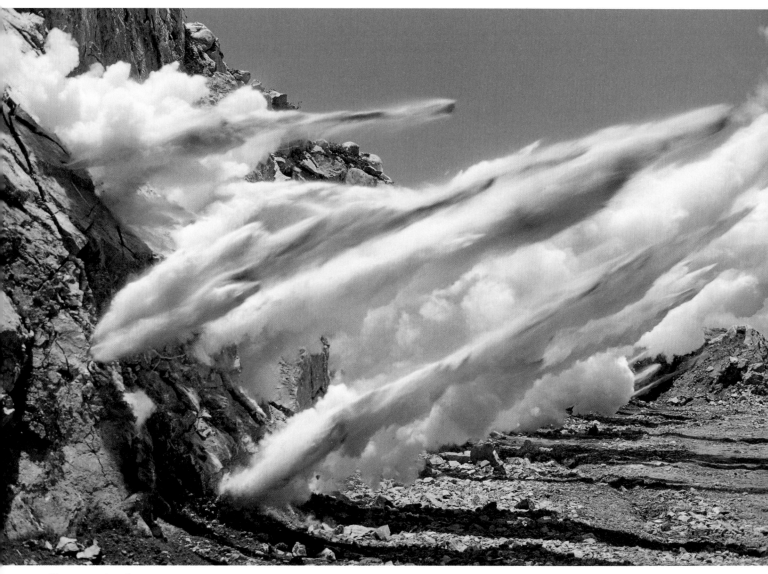

Blast #05707A, 1998

Overleaf: *Blast #08326*, 1999

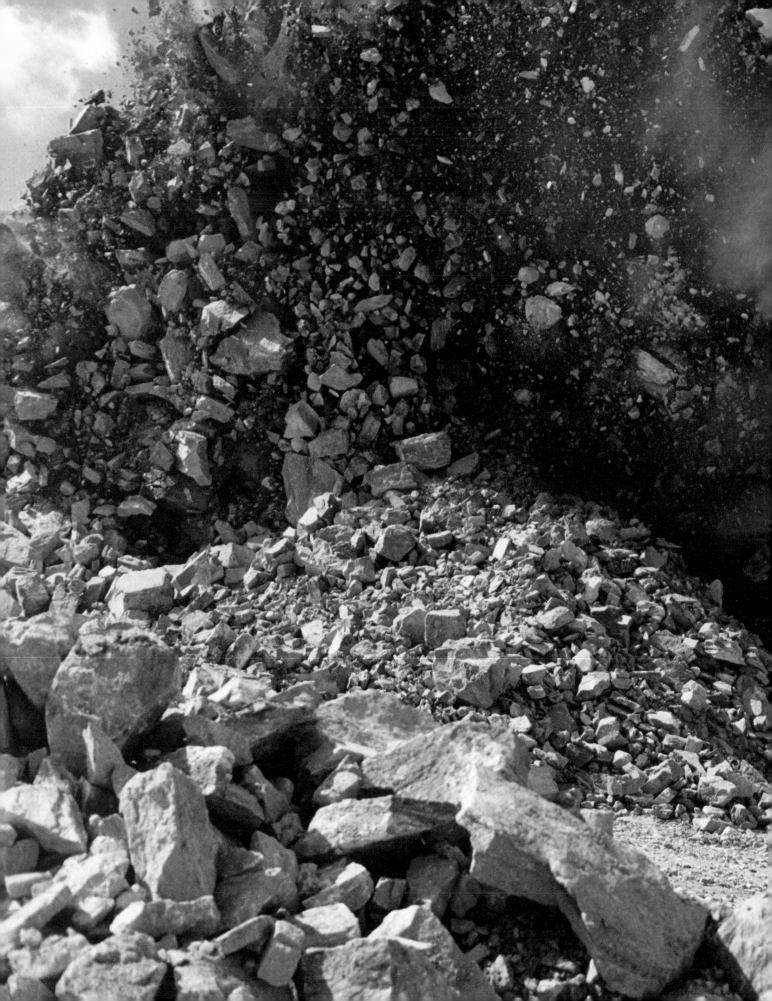

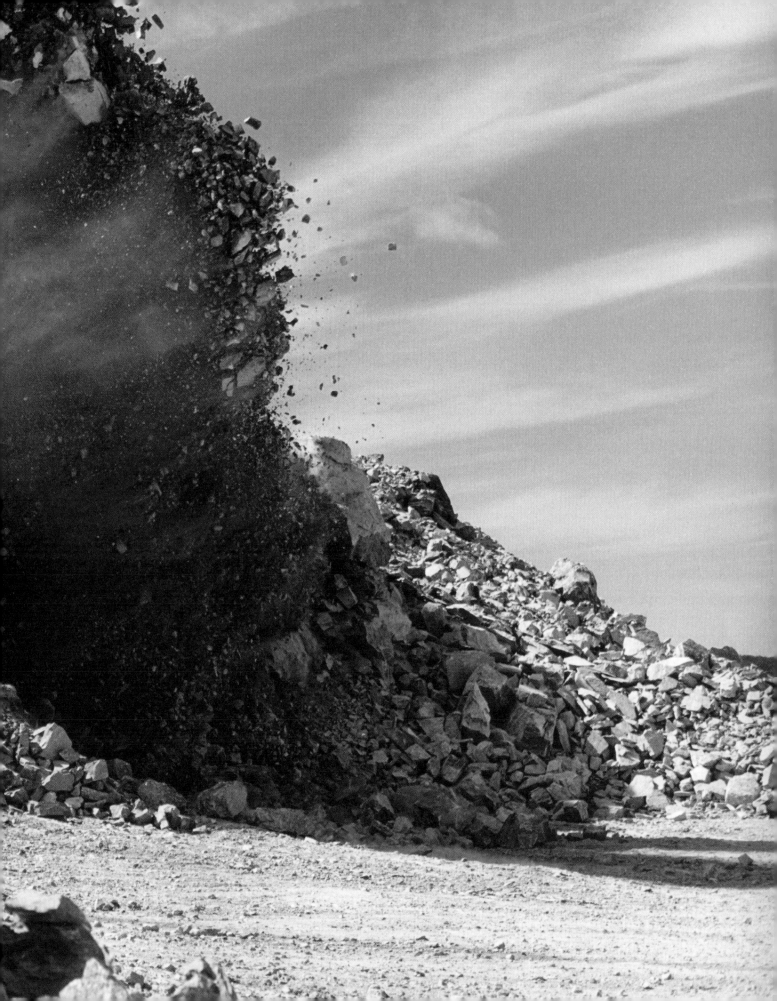

'In some photos you can trace the trajectory of a single person across the photographic frame. In others, there are hundreds of steps taken.... The different physical positions of the footsteps also represent ideological positions: one person's message says this space should be a natural reserve; someone else wants to build a gigantic mall. And then you notice that one footstep, one position or ideology, is being stepped on by another, erasing it. This group wasn't homogeneous; there was an infinity of differences enacted or happening at the same time.... Many of the people who were once marching together in solidarity against the bombing now face the difficult task of democratically debating the future development of this land, and are finding themselves in opposition to each other over these new issues.'

JENNIFER ALLORA & GUILLERMO CALZADILLA

JENNIFER ALLORA & GUILLERMO CALZADILLA

Jennifer Allora, American, b. 1974
Guillermo Calzadilla, Cuban, b. 1971

Jennifer Allora and Guillermo Calzadilla employ sculpture, photography, video and interactive public installation to examine social and political issues. In much of their work, they respond to the diverse but threatened environment of Puerto Rico, where they are based. *Land Mark (Foot Prints)* is one of a series of works by the duo that have involved civil-disobedience groups in Vieques, a small Puerto Rican island that for decades has been used by the US military for naval exercises, bombing practice and the secret testing of biological and chemical weapons.

In Allora and Calzadilla's photographs, the viewer is confronted with a confusing array of footprints etched into golden sand. Such scenes might at first appear as playful holiday snaps taken on the beach. But on closer inspection, the impressions are marked with troubling images and slogans: one declares '*La Marina es muerte*' (The Navy is death); another screams 'We accuse the US Navy of thwarting, for more than a half-century, the healthy development of our economy'. These footprints were left by protestors who had broken into the naval base to disrupt testing exercises. They were wearing rubber shoes designed by the artists and had composed the messages upon them as expressions of their own ideas about Vieques. Some were very direct, saying in effect, 'I disagree with what is happening here', while others were more subtle, imagining different futures for the island. The imprints not only allowed the protestors to communicate their objections to the military, but also enabled them to reclaim the territory by laying down their own 'landmark'.

All images *Land Mark (Foot Prints)*, 2001–2

Long a subject of protest and civil disobedience by the Puerto Rican people, the military base was finally abandoned in 2003. Today the area, although still contaminated and debated, is a wildlife reserve under the protection of the US Fish and Wildlife Service.

All images *Breather*, 2011

ANDREA POLLI

American, b. 1969

Andrea Polli is another artist who works at the intersection of art, environmental science, technology and activism. Her practice spans video and digital media, public interventions, curating and writing, and often involves the gathering of scientific data. She collaborates with urban planners, atmospheric scientists and pollution experts to look at the relationships between humans and climate change. As a member of the steering committee for New York 2050, which imagines the future of New York City over the next four decades, she has worked with planners, scientists, historians and other experts to examine the impact of climate locally and globally. Recent works include spatialized sonifications of meteorological models of storms; sound pieces based on climate patterns in Central Park; the creation of an international network of personal weather stations; and a real-time multi-channel visualization of weather systems in the Arctic.

Two of her environmental installations, *Breather* and *Cloud Car*, attempted to visualize the impact of petrol pollution on the air we breathe. *Breather* began as a project to illustrate the problem of pollution in New Delhi, India, where the air quality in parts of the city is so bad that walking in some areas has a similar effect to smoking fifteen cigarettes a day. It is not surprising that one person dies there every hour from lung disease or breathing complications. To draw attention to the issue, Polli encased a car in a transparent plastic bubble that inflated and deflated at the rate of a human lung. The car she used is one of the most widely owned in India, but has now been discontinued because of its excessive level of pollution. In a later version of the work, installed at the Parco Arte Vivente centre for contemporary art and nature in Turin, Italy, Polli used a now-classic Italian car, the Fiat 500.

Similarly, the ongoing *Cloud Car* visualizes petrol emissions from cars in a spectacular way. Polli fits a car with special-effects equipment and motion sensors, and then leaves the vehicle in the street to produce a cloud of mist that submerges the car, driver and passers-by in a cloud of 'smoke' every time someone walks past. Assistants stationed near the car distribute information about the work, traffic, pollution and its impact on air quality and health, and encourage debates on the subjects.

'I believe it's essential that the public has a greater understanding of science, especially in the case of complex issues like climate change.... Some media figures in the US have been very successful at distorting scientific findings in order to mislead the public, and they can do it because the public doesn't understand the science. People need to understand these issues in order to make informed decisions. But all this wasn't what got me started working with art and science twenty years ago. Then, and now, I found things about science that were very beautiful and poetic. I found that the more I learned, the more profound the beauty. So I started working in this area to share my impressions with others.'

ANDREA POLLI

Cloud Car, 2008–ongoing

Cloud Car, 2008−ongoing

Crushed Cars #2, Tacoma, 2004

From *Midway: Message from the Gyre*, 2009–current

'Exploring around our country's shipping ports and industrial yards, where the accumulated detritus of our consumption is exposed to view like eroded layers in the Grand Canyon, I find evidence of a slow-motion apocalypse in progress. I am appalled by these scenes, and yet also drawn into them with awe and fascination. The immense scale of our consumption can appear desolate, macabre, oddly comical and ironic, and even darkly beautiful; for me its consistent feature is a staggering complexity.'

CHRIS JORDAN

CHRIS JORDAN

American, b. 1963

Chris Jordan's work blurs the line between art and activism. For him, photography is an effective tool to force us to wake up to the realities of climate change and the effects of contemporary consumer culture, and to make us more conscious of our own individual and collective roles in protecting the future of the planet.

Jordan has focused on the impact of mass consumption on the surface of the land, in particular the damage caused by the disposal of waste materials and discarded consumer and industrial products. His photographs intentionally seduce with their superficial beauty of forms and colours while at the same time causing repulsion at the reality of what they depict. The images display a profound awareness of the aesthetic power of colour, composition and framing, as well as a knowledge of art history. Some of the more abstract works in *Intolerable Beauty* resemble canvases by Jackson Pollock and other Abstract Expressionists, while his *Running the Numbers* series includes several reworkings of celebrated paintings that consist of carefully arranged pieces of rubbish: Van Gogh's *Starry Night* made from 50,000 discarded lighters; Botticelli's *Birth of Venus* crafted from 240,000 plastic bags; and Hokusai's *The Wave* fashioned from 2.4 million pieces of plastic recovered from the Pacific Ocean.

The artist actively seeks to change people's perceptions and behaviour with these works. He explains: 'As an American consumer myself, I am in no position to finger wag; but I do know that when we reflect on a difficult question in the absence of an answer, our attention can turn inward, and in that space may exist the possibility of some evolution of thought or action. So my hope is that these photographs can serve as portals to a kind of cultural self-inquiry. It may not be the most comfortable terrain, but I have heard it said that in risking self-awareness, at least we know that we are awake.'

Glass, Seattle, 2004

Circuit Boards, Atlanta, 2004

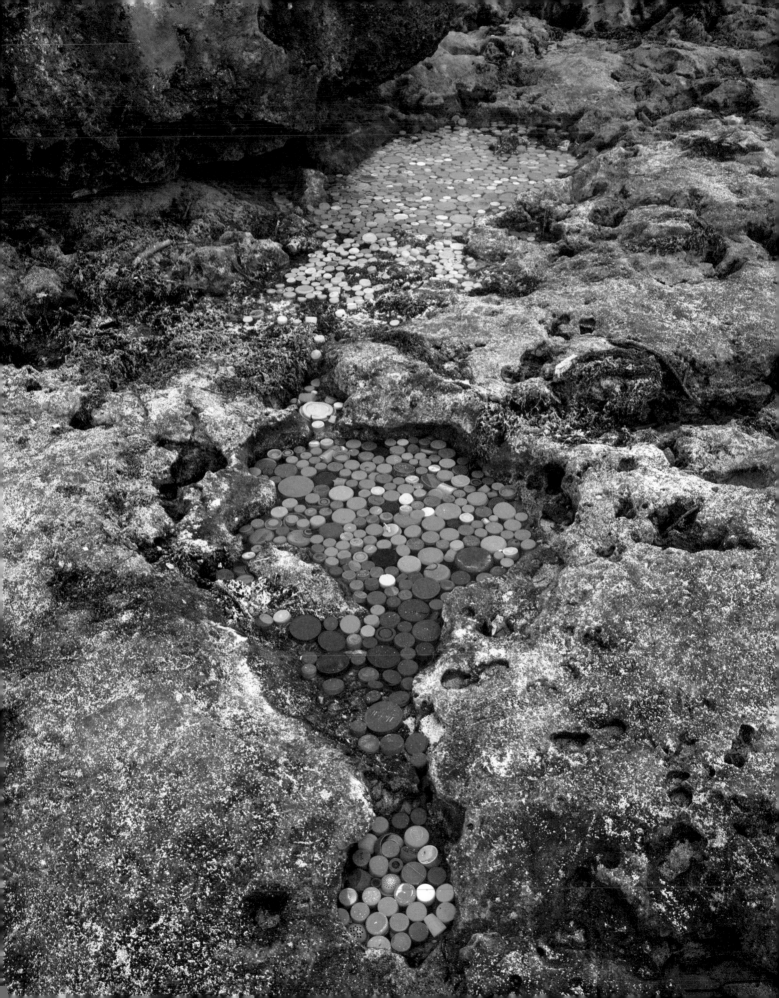

ALEJANDRO DURÁN

Mexican, b. 1974

Nubes, 2011

Alejandro Durán is a New York-based photographer, filmmaker, poet and educator. His photography spans fine art, fashion and nature. *Washed Up* is an ongoing project that addresses the issue of plastic pollution making its way across the ocean and onto the shores of Sian Ka'an, Mexico's largest federally protected reserve and a place of astounding natural beauty. Situated on the eastern side of the Yucatán Peninsula in the state of Quintana Roo, it is one of twenty-three Mayan sites and a UNESCO World Heritage site noted for its 'outstanding universal value'. The reserve is also one of the most bio-diverse regions on Earth. It is home to a wide range of flora and fauna – including jaguars, manatees, crabs, tropical birds and iguanas – and its azure Caribbean waters contain the second largest coastal barrier reef in the world. However, the idyllic Sian Ka'an, Mayan for 'gift from the sky', has also become the unwitting dustbin for the world's waste, which is carried there by ocean currents.

Durán has visited Sian Ka'an several times since February 2010, collecting the plastic waste that has been washed up there. He groups, lists and photographs all found items by size, shape and colour. When possible, he also notes the country of origin: to date he has documented items from around fifty countries on six continents. He then transports this detritus to selected locations along the coast of Sian Ka'an to create colour-based, site-specific sculptures that echo the forms of the surrounding landscape. Sometimes, he carefully arranges this artificial flotsam and jetsam as if it had been deposited by waves or scattered by the wind; at other times, the plastic takes on the life of algae, roots, rivers or fruit, reflecting the flow and growth of plastics into the natural environment. The resulting photographs blend colours, objects and shapes to transform them into organic pieces that seem to have a life of their own: a kaleidoscopic overflow of colourful plastic caps; sea foam formed out of empty, transparent bottles; an endless blood-red river of containers, cartons and crates cascading through lush green forest. Durán uses a mix of natural and artificial light to photograph the sculptures, further blurring the line between existing and constructed realities.

'With the Caribbean shores of the Yucatán Peninsula as studio, and the plastic garbage carried there by ocean currents from all parts of the globe as material, *Washed Up* is my attempt to turn trash into treasure.... Working in response to the landscape and within a highly defined color palette, I sought to create arrangements that look simultaneously natural and artificial. While inspired by the work of Andy Goldsworthy and Robert Smithson, *Washed Up* is intended as something new that speaks to our time and its vast quantity of discarded materials.'

ALEJANDRO DURÁN

Opposite: *Derrame*, 2010

HEATHER & IVAN MORISON

Heather Morison, British, b. 1973
Ivan Morison, British, b. 1974

Heather and Ivan Morison have used nature in their diverse practice for over a decade. At times, they have even used gardening as an art form. In 2001, they acquired an allotment in Birmingham and over many months restored order to the overgrown site. A number of video and conceptual works grew out of their attempts to transform the urban garden. While cultivating the allotment, the latter also developed a fictive alter ego – 'Ivan Morison, the amateur gardener' – who would send out report cards to inform recipients of his progress: 'Ivan Morison is concerned by a powdery mildew that has appeared on his Green Bush marrows.' The following year, he turned his hand to floristry. For two consecutive weekends, he set up a flower stall outside the city's Ikon Gallery, and each day ordered flowers from the Netherlands to sell to passers-by.

Five years later, the couple returned to the international flower trade with their installation *The Land of Cockaigne*, commissioned by Bloomberg SPACE in London. Tens of thousands of flowers were packed into industrial crates, filling the space as though it were a wholesale market. Visitors could experience the flowers by walking between them and among the dense mass and heady scents of the blooms or from a platform above, where the view was a grid of vivid colour. At the end of the show, they were invited to take the flowers away with them for free. This act of largesse was conceived as a moment of conspicuous public consumption in the spirit of the medieval utopia Cockaigne, a land of luxury and abundance, where there were no hardships, restrictions or taboos.

Although superficially intoxicating, the work exposes the implications of mass consumption and unbridled greed. The sheer number of flowers – some 150,000 of them – and mode of presentation highlights the irresponsible processes involved in the flower industry and the demand for year-round production. Intensive horticulture of this kind – an artificial stimulation of nature – requires excessive use of land and water, often in developing countries, where such natural resources are precious; it also relies on carbon-intensive global transportation to reach the international markets it serves. Despite its beauty, then, this complex yet subtle work raises several troubling ecological and ethical issues. It accuses an industry that contributes to global warming and blights the natural world. But it also points a finger at us, the consumers, for it is our unchecked desire that gave rise to and perpetuates this vast, destructive practice.

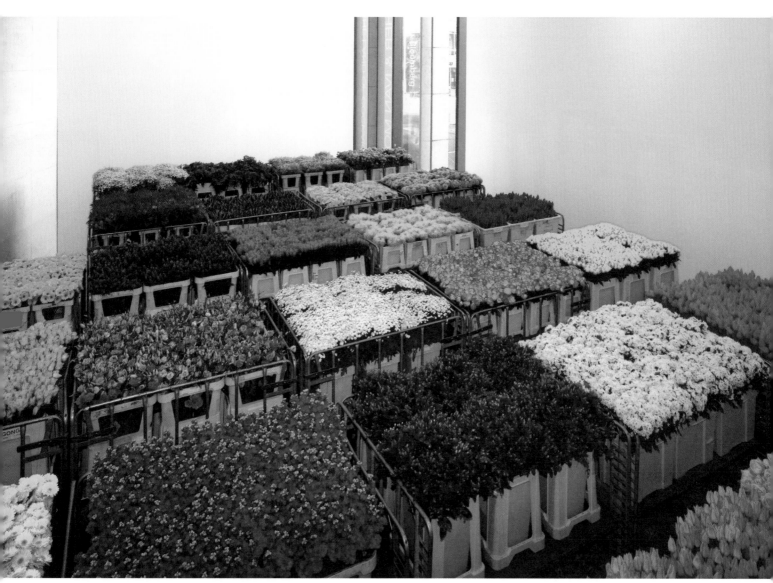

All images *The Land of Cockaigne*, 2007 (installation views)

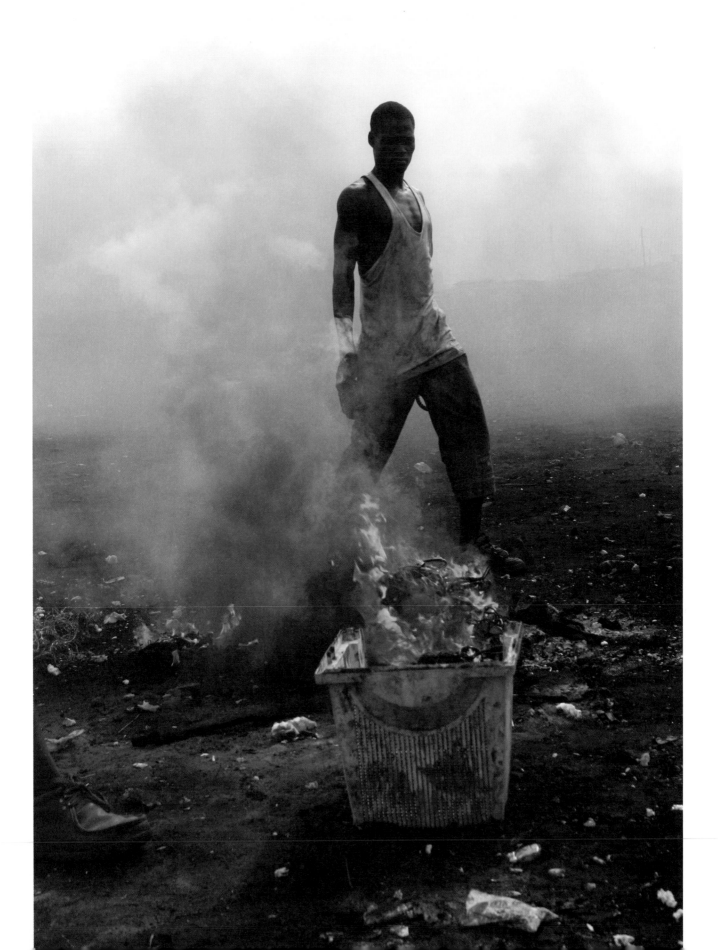

NYABA LEON OUEDRAOGO

Burkinese, b. 1978

Nyaba Leon Ouedraogo was destined for a life as a successful athlete (he was the Burkina Faso champion and Olympic hopeful in the 400 metres) until an injury forced a change of career and he became a photographer. His award-winning work blurs the line between photojournalism and documentary art. In January 2008, while in Accra, the capital of Ghana, to cover the African Cup of Nations football tournament, he was taken to a vast 'cemetery' of abandoned computers on the edge of the city's Agbogbloshie Market. Ghana has become one of the main recipients of the world's electrical waste, which the UN estimates reaches fifty million tons each year. Perhaps unsurprisingly, an illegal but tolerated business has sprung up to deal with this e-waste. Huge amounts of money can be made by stripping the machines down and burning them. Setting them on fire is the easiest way to get the plastic sheathing off the precious copper wiring they contain, which can then be sold on.

All images from *Hell of Copper*, 2008

The dump at the Agbogbloshie Market spreads over six miles and is growing. Every day, all day, young Ghanaians, some only ten years old, scavenge their way through the mountains of redundant hardware. It is exhausting and perilous work. They wear no protective masks or gloves, leaving them exposed to harmful materials such as lead and mercury. The toxic substances that are given off from burning the machines also contaminate the water and the ground, which animals use for pasture. During the eight months that Ouedraogo worked on the site, at least one of the children died. He says, 'I don't know how long it will take, but I want the world to find another way for this work to be done without people getting sick.... Now people must understand the injustices and the sad environmental and human consequences of our global electronic economy.'

'My preoccupation is to see how Africa lives today – with a new regard, with the intention of not sinking in the fatality, the misery, but to shine a light on Africans' daily existence. To show their lives in my way, with my artist's eye. I am not a photojournalist. I make documentary art.... I document a reality, but always with an approach that is both aesthetic and ethical.'

NYABA LEON OUEDRAOGO

Metal Recycling 16, 2010

Metal Recycling 18, 2010

SVETLANA OSTAPOVICI

Moldovan, b. 1967

Svetlana Ostapovici was born in Moldova, part of the former Soviet Union, but in 1999 moved to Italy, where she has lived and worked ever since. Her work examines the destructive side of humanity and focuses on the damage we can cause to the environment as a result of human-made catastrophes such as pollution and fires. She has a particular interest in how we process natural resources: her installations often use recycled materials, while her photographs depict the detritus found in dumps and landfills. She believes that humankind can save itself from auto-destruction only by regenerating everything it consumes, wastes and rejects.

Ostapovici began her career by working in mosaic. Her images retain aspects of that medium: they combine disparate, sometimes dissonant elements in the same work to create a single, thought-provoking composition. In her series *Metal Recycling*, for example, she photographs huge accumulations of consumer and industrial waste that are waiting to be compacted and melted down. But with skilful editing, the artist has inserted celebrated statues from art history into the frame to provide a striking contrast with this dirty and dangerous material: a reclining Buddha, Rodin's *The Thinker*, Romulus and Remus feeding at the wolf's breast. These figurative sculptures, lying at the foot of a mountain of discarded scrap metal, or even perched on top of it, represent the more elevated and noble side of culture (reason, thought, logic) alongside the baser aspects of human life (waste, pollution, decadence), in a vision of civilization that combines beauty and horror.

Even in our age of reuse, reinvention and resampling of motifs, symbols and objects, Ostapovici's photographs are startling. They raise questions about how we value one object over another, even if they are made from similar materials. As she says, 'I'm interested in the ancient bronze sculpture because it is invested with a precious value due to its artistic and historical importance, even though it is made from metal just like garbage. Objects from our daily lives, on the other hand, are thrown away once they have been used. In short, the material may be the same, but the fate is very different.'

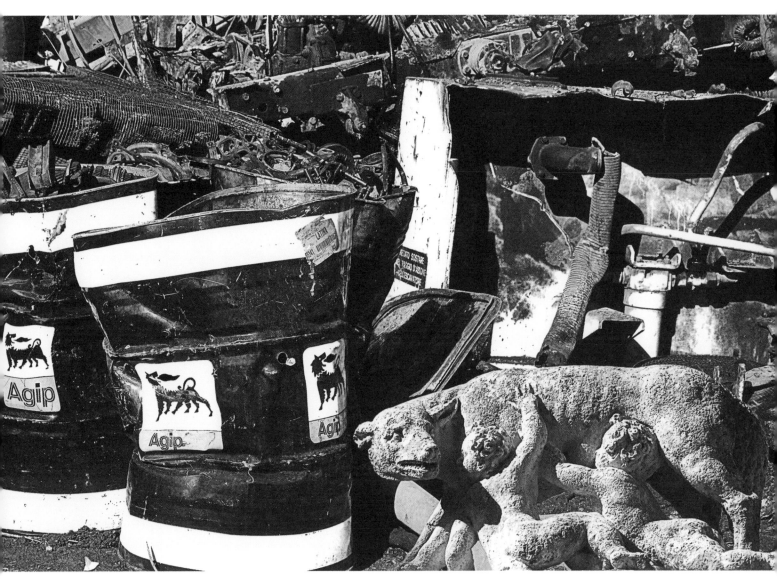

Metal Recycling 28, 2011

'We cannot continue to consume the Earth's resources if we are to survive. We have to recycle everything we use and throw away. Until now, these areas used for collection of recyclable material were seen as unhealthy places to be despised – why? Why not look for the positive things? Why not see these piles of scrap as Dolomite mountains or the Grand Canyon? Why not visit these places like our city streets and squares with monuments, fountains and statues?'

SVETLANA OSTAPOVICI

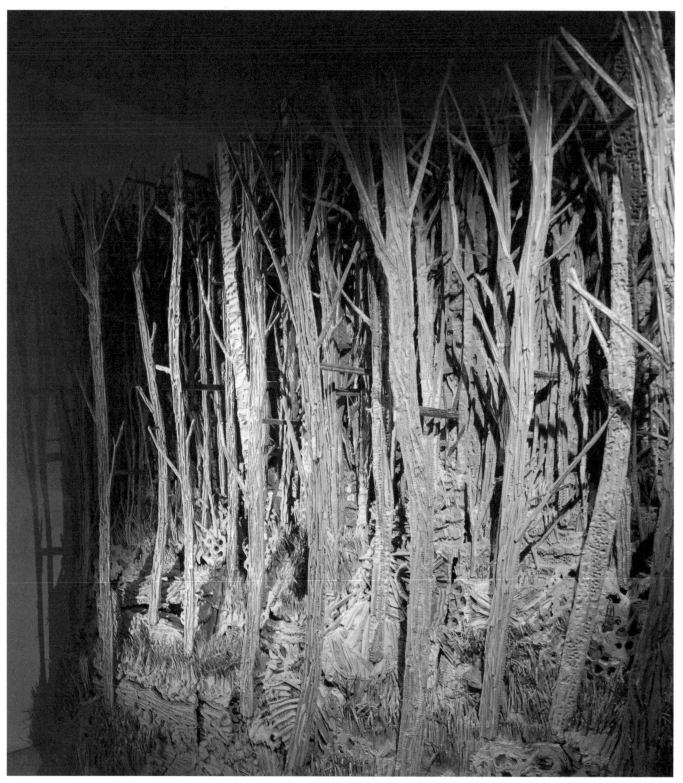

Détails d'une Forêt, 2011 (detail)

EVA JOSPIN

French, b. 1975

Eva Jospin concentrates on the different ways we choose to represent the landscape, not only in art but also in society more generally, and the inherent values implied by our choices. Recently, she has been creating large and detailed forest scenes using an unconventional yet logical medium: cardboard. Although this unlikely material is hard to cut with any precision and is not very malleable, she carves and sculpts it like others handle stone or marble, transforming it into tree trunks, roots and leaves. Her large-scale tableaux, with their illusion of depth and space, fill the gallery and dominate the vision of the spectator. They seem almost to embrace the viewer, whose eyes get lost in the dense strata of branches and undergrowth of these natural labyrinths. Her smaller wall pieces similarly immerse us in a profusion of plants, as if we have plunged our heads inside our own personal herbarium.

By using cardboard to represent trees and vegetation in this way, Jospin is, in a sense, returning the material to its original organic state – a form of creative recycling and reuse, perhaps; but there is an irony in using such fragile and disposable matter to embody the solidity of a trunk and the vast complexities of a forest. Nonetheless, her works demonstrate the lasting significance of trees and woodland as rich poetic forms that resonate through the ages; perennial subjects that will never be discarded.

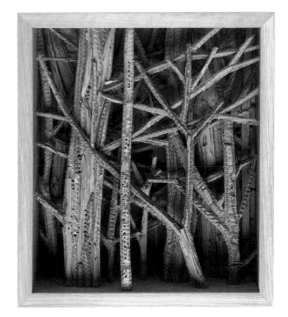

Petit Forêt 8, 2011

'Everyone relates to the forest, because its references lie not only in mythology, but also in gothic architecture and animation. Forests are places where you can lose yourself as if by magic.'

EVA JOSPIN

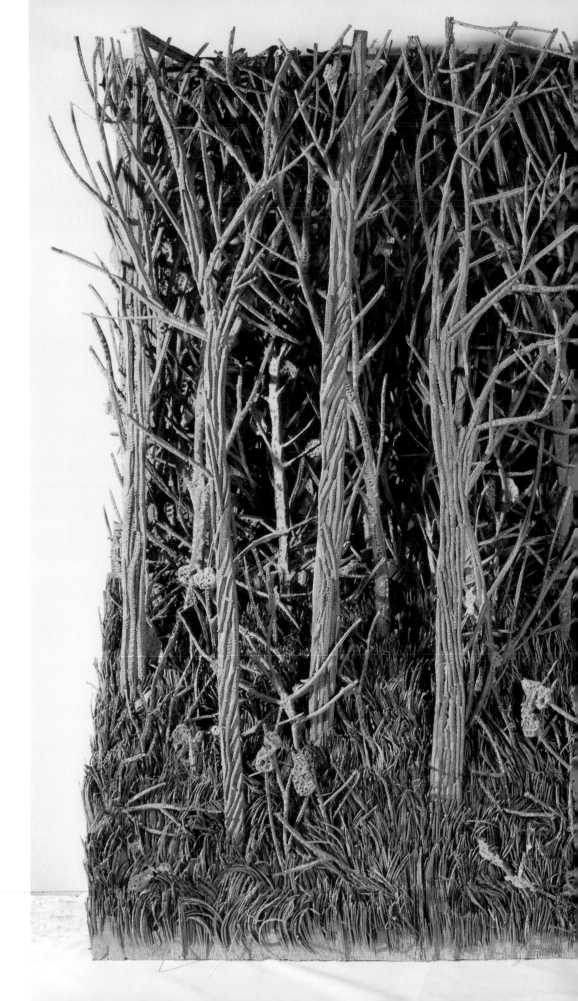

Détails d'une Forêt, 2010

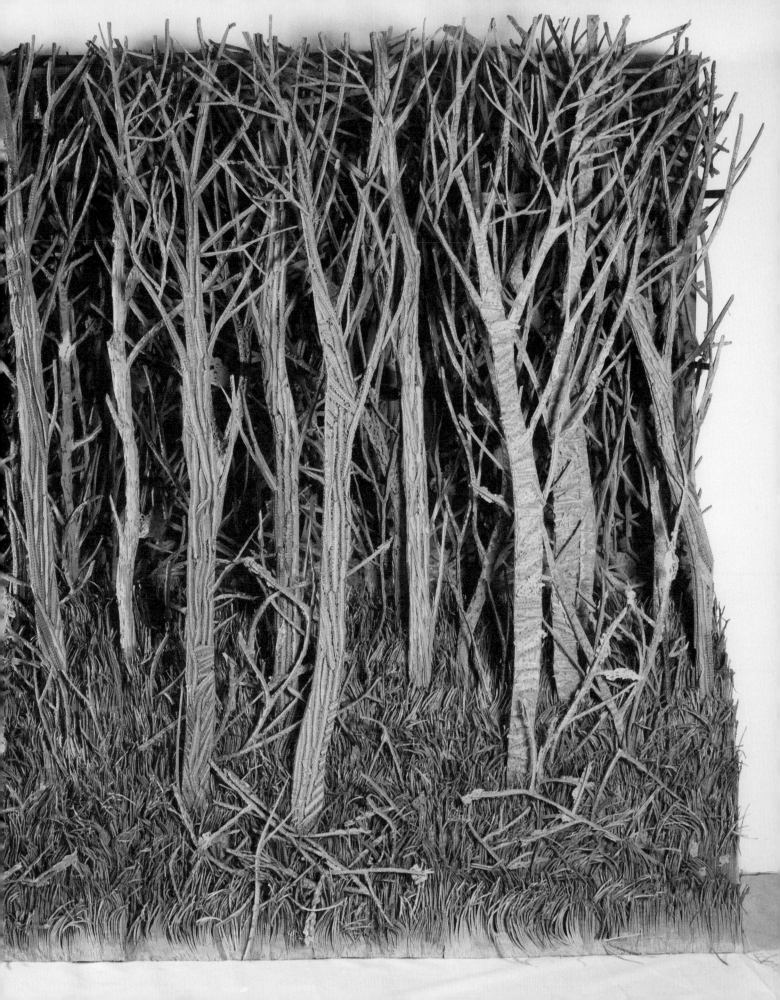

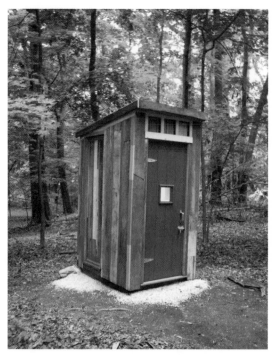

An early studio at Abington Art Center, Jenkintown, Pennsylvania, 2007

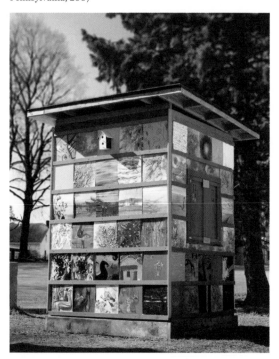

A studio installed on Main Street, New Paltz, New York, 2009

Opposite: Historic Huguenot Street, New Paltz, New York, 2009

SIMON DRAPER

British, b. 1960

Simon Draper moved from Wales to the United States in the 1980s and has lived there ever since. The reuse of materials and objects has been a recurring theme in his work. Recently, he has started to incorporate other artists' works in his own projects and to include older art works in newer pieces in a form of creative recycling.

In 2008, Draper began *Habitat for Artists*, a collective project that uses recycled materials to construct temporary, reusable working artists' studios. These intimate spaces are small – no more than six feet by six feet by nine feet – and are placed in a variety of locations, from shopping streets and car lots to farms and parks. The project invites artists from various communities to work in these sheds and to explore different sustainable practices. The studios are built from reused and reclaimed objects to minimize their carbon footprint. Each artist is encouraged to adapt their shed to suit their own needs, resourcefulness and interests – they are free to customize the fabric of the structure in whatever way they choose, in the knowledge that their alterations may in turn be reused or even destroyed by a future 'resident'. Sustainability is also often incorporated into the art work they produce, with an emphasis on creative reuse. While developing their own practice, the artists also engage with audiences from the area, taking part in discussions about art, sustainability and other topics of relevance to the local community.

Since its creation, *Habitat for Artists* has partnered with schools, universities and art institutions, and has involved more than fifty artists. Many of the project's iterations have been in partnership with ecoartspace, an organization based in New York and California and a leader in unifying art with care and concern for the environment. The group often supports projects that have a strong collaborative and educational component, and highlights topics such as climate change and water- and land-use.

For Draper, *Habitat for Artists* raises questions about the role of artists as pioneers in developing neighbourhoods and their migration from these places for economic reasons. At a time when the price of creative workspaces in the world's major cities is escalating, the project questions how much space an artist needs to create their work. But these workspaces are about more than the creative requirements of artists – they also prompt examination of our own domestic behaviour. As Draper puts it, 'How might we be more creative about our consumption of materials, our use of energy and land? Could we be doing more with less, yet still create a vibrant, relevant society and culture?'

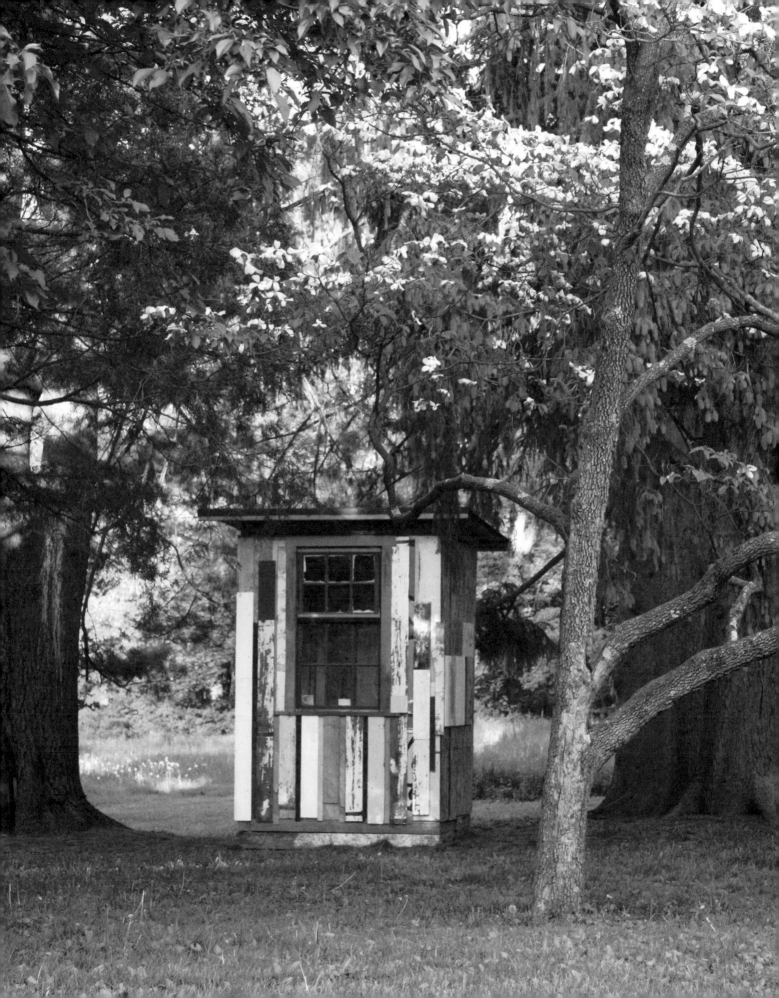

Going down into a recently excavated tunnel, Madrid, 2010, from Wastelands, *2003–ongoing*

'I want to question urban planning through the study of places which escape
a fixed definition of city or of architecture: empty lots, wastelands, demolition
sites – places that due to forgetfulness or lack of interest escape a defined
design and are open to all kinds of possibilities.... Wastelands are important
because they are the only places in the city that remain without definition.
Untouched by design, everything that takes place in them happens by chance
and not according to a plan.... I see great value in this lack of a design, and
that is why I would like to "preserve" these wastelands in my works, if that
is possible and makes sense.'

LARA ALMÁRCEGUI

LARA ALMÁRCEGUI

Spanish, b. 1972

Rotterdam-based Lara Almárcegui combines social and ecological commitment with a conceptual approach. Since the mid-1990s, she has examined inner-city land use and the processes of urban transformation created by political, social and economic change. She is particularly fascinated by places that are in the process of development or have been ignored by architects, planners and developers. She thus concentrates on neglected or undefined spaces that are not usually the focus of attention: wastelands, condemned buildings, allotments, disused plots and marginal sites on the edge of cities.

Describing herself as an 'archaeologist of the present', Almárcegui begins by interviewing various experts and collecting historical, geographic, ecological and sociological data about the sites. She then documents the locations' unique characteristics and features in different ways. In the process, she unearths histories and exposes the potential of forgotten public and private space. The information she gathers is presented in the form of tours, installations, guides, maps and photographs that show the past, present and future of the vacant lots in an objective and matter-of-fact fashion.

Almárcegui claims that while wastelands embody a different pace of change from that of designed space, they are simply the most visible representatives of the living processes to which all urban environments are subject: 'natural processes of decay, transition and entropy – processes which affect all places, but which are hidden in the rest of the city.' Her studies question our concept of wilderness and ask why we perceive some sites to be more 'special' or 'natural' than others – that is, why they are considered places rather than mere spaces. In the spirit of the Situationists undertaking a *dérive* through the city, her tours and guidebooks offer an alternative experience and reading of the urban landscape, shining a light on and celebrating these otherwise unacknowledged landmarks and preserving them through the passage of time and constant change.

Almárcegui's studies also extend to examinations of the invisible elements of a city's fabric, such as construction materials. In a number of locations, she has calculated precisely the quantities of concrete, wood, brick, rubble, sand and other materials needed to construct certain buildings or, in the case of São Paulo, an entire city. For her solo show at Vienna's Secession she took stock of the materials used to build the main hall and heaped up equivalent piles – all products of the recycling process – in the gallery space. In this and similar works, she offers visitors an alternative way of seeing, experiencing and imagining the built environment. At the same time, with her use of natural resources, she looks ahead to the future life of buildings once their materials have been processed and used again.

Digging, Amsterdam, 1998

A Wasteland in Rotterdam Harbour, 2003–2018, 2003

Guide to the Wastelands of São Paulo: A selection of the most interesting empty terrains in the city, 2006

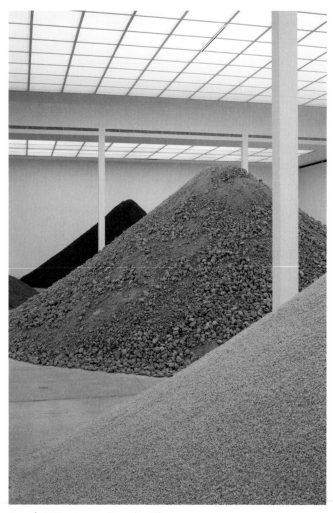

Bauschutt Hauptraum, Secession, Vienna, 2010

*Construction materials of the water tower,
Phalsburg, 2000*

Hidden (Smoke Detector), 2011

MATT COSTELLO

American, b. 1984

Matt Costello is an American artist and designer who studied at the Royal College of Art in London. During his time there, he developed the *Hidden* project, which explores the relatively new concept of virtual water and its influence on industrially produced objects. Virtual water is the amount of water that is used to produce the food we eat and the goods we consume and is a key indicator of the true ecological footprint of our society.

Almost 6,600 gallons of water are used to produce the metal in an average-sized car, for example. This sounds high, until you consider that it takes 3,300 gallons to produce just 35 ounces of beef and a whopping 5,300 gallons to make a large bar of chocolate; 550 gallons are needed to make 18 ounces of cheese and 143 gallons to grow 18 ounces of barley; 44 gallons of water are required to make one glass of milk and almost 30 gallons are used to grow the beans for a single cup of coffee. The average person in the United Kingdom uses around 33 gallons of 'real' water in the home every day – for drinking, cooking, washing, and so on – but around 770 gallons of 'hidden', virtual water embodied in food and goods consumed.

Costello's *Hidden* sets out to communicate the virtual water present in certain manufactured goods and materials. The project has two components. The first is a set of glass vessels designed to give visual form to the different amounts of water required to produce industrial products. The stopper in each of the bottles is made from a different material – steel, aluminium, pine, epoxy, glass and ceramic – and each vessel is sized to contain the amount of water used to make its cap. From this we can instantly visualize the varying amounts of virtual water held within each material. The project's second component involved creating prototypes of two household objects – a smoke detector and an alarm clock – so that they used less water than with conventional mass production. Both items were redesigned in ceramic and cork and used around four gallons less water than their inexpensive plastic and metal counterparts. The clock was also designed to emphasize its physical qualities: the user must flip it over to switch it off, thereby experiencing the tactile pleasure of the ceramic. Costello's two alarms not only demonstrate how it is possible to reduce the amount of water hidden in our everyday goods, but also act as the perfect wake-up call to the potential of improved design led by environmental factors.

'People generally don't think that there is water that goes into the objects that we have and the food that we eat because it's not something that you see. You don't pick up an object and see that 200 litres went into making it. It's not something that is easily known or visualized.... As children we are taught the water cycle will continue for ever. Unfortunately, this does not take into account the increase in urbanization and industrial production that is disrupting the natural cycle. Between large dams, increased irrigation, unregulated pumping, increased deforestation and continued use of pesticides, we are using up the little bit of resource we have available. Couple this with the cultural, political, and economic problems associated with water, and the phrase "water is the new oil" does not seem too far fetched.'

MATT COSTELLO

Hidden (The Virtual Water Embedded in our Goods), 2011

Hidden (Alarm Clock), 2011

RE / CREATE

This chapter develops the search for solutions to environmental problems that we saw emerging in the last section. It highlights the work of artists who propose – not always seriously, it must be said – new ideas, new possibilities and new realities. Here the standards of inventiveness, creativity and experimentation come to the fore, not only in terms of artistic practice, but also in ecological sciences and everyday life. These individuals and collectives employ novel techniques or invent new devices and methods that have yet to be tested, while others suggest alternative visions of the world – indeed, even new worlds altogether – that push the boundaries of accepted science.

Prototypes, experiments, hypotheses and beta tests are among the approaches adopted by the artists in this section. Radical in intent and iconoclastic in method, they seek to challenge the status quo and disrupt conventional habits. They ask why must we accept the received ideas of how we should live. If the 'normal' way of living has led to the climate crisis, why not question the norm? Do we not have a responsibility as artists and as individuals to find alternatives? Why not think differently? Why not act differently? Why not think the unthinkable?

These are questions with which designers and engineers are also wrestling every day, of course, and in the pages that follow it may indeed appear that there is only a fine line between art and design, between the artist and the designer – if there is any line at all. In fact, these projects emphasize the existential difference between the two professions, for the designer's raison d'être is to find an answer to a question, whereas the artist's job is often simply to ask the question … or to pose a different one altogether. Curiosity or fascination with a problem may have been the initial impulse that prompted the artist to act, but she or he has no obligation to find a solution. Asking the question, and asking questions of the viewer-participant, may be quite enough. Complicating rather than clarifying a complex problem is a valid outcome for an artist. The award-winning designer John Maeda made this point in his celebrated book *The Laws of Simplicity*: 'The best art makes your head spin with questions. Perhaps this is the fundamental distinction between pure art and pure design. While great art makes you wonder, great design makes things clear.'

And this essential difference is the reason why, unlike designers (and unlike those in the following section), the artists in this chapter rarely demonstrate any visible missionary zeal to change the world in any meaningful way. Their attitude seems to be 'Oh, there's a problem? Well, here's a potential solution. It's just a suggestion, though. You can take it or leave it. You might want to try it … but you don't have to. It's up to you. It's just an idea.' Consequently, humour and playfulness are characteristics of a number of the projects found here. Many are not entirely serious; some are wholly ridiculous – and yet each one, like every joke, reveals a truth of some

kind. What is more, just because we do not yet know that we need something does not mean that it will not be necessary in the future. Outlandish as they may appear to us now, some of these proposals are destined to be adopted more widely.

But some might reasonably ask where is the art in all of this? The artists in this and the following chapter are pushing the boundaries of what is expected in artistic practice as well as in everyday life. In many respects, they reflect the influence of the emergence of relational aesthetics in the late 1990s and early 2000s, a form of radical, often performative art that was not about creating objects but about establishing new forms of social relations and alternative ways of living.

Relational aesthetics and its offshoots are now accepted and recognized (although sometimes misunderstood and critiqued) forms of practice. Nonetheless, for many artists, there remains a pressure, even from forward-thinking institutions, to produce a high-profile, object-based work, even when something more process-oriented might have longer-lasting impact and be more beneficial to its audience. As Steve Badgett from the collective Simparch says: '[We] get more inquiries because of our reputation for doing big interventions. That's getting harder for me to do, ethically, so something needs to change. I think, okay, combine the two – big intervention and a permanent, valuable project for a community. That takes a lot of maturity, focus and sacrifice – not glamorous. I can see a lot of art institutions not wanting to support that type of project, because the process is long term and may not have a "big wow", though there are signs that art institutions are slowly changing. Now there's always news about problems with water, waste, big agriculture – the failures keep emerging. It could be a new role for the artist to look at the bigger picture, a more systematic approach to see what's not working and then help guide whatever industrial approach toward a more holistic, less destructive method.'

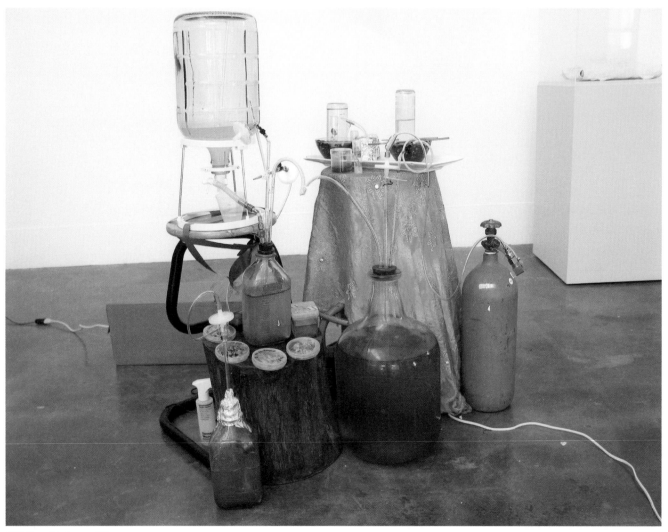

DIY Algae/Hydrogen Kit, 2004

FUTUREFARMERS

Founded 1995, international

Founded by American artist Amy Franceschini, Futurefarmers is an international group of practitioners, including artists, designers, architects and researchers, who collaborate on a range of art and design projects that are motivated by activism. Through innovative product design and public workshops, they seek to tackle a variety of social, cultural and environmental issues, raise awareness and offer radical – and sometimes quirky – solutions. They begin by deconstructing established systems related to the environment, both physical and administrative, such as government health policies, transport infrastructure and farming and food production, to understand how they function. Having taken apart these well-oiled machines and examined their constituent parts, they then reassemble them into different configurations to propose alternative scenarios.

Most of the group's activities are experimental in nature, and often playful in outcome. One early example is *Photosynthesis Robot* from 2003, a prototype (or 'three-dimensional sketch', as they call it) of a possible perpetual-motion machine driven by phototropism – that is, the movement of plants in relation to the sun. The motion of the plants as they turn to face the sun would propel this four-wheeled vehicle slowly over a period of time. *Sunshine Still* from 2010 was a traditional moonshine still that had been re-engineered to produce ethanol (drinkable alcohol) from compost, waste or algae, which would be collected by the *Sun Runner*, a pedal-powered pick-up unit that would gather green waste from homes in exchange for this potent liquid (nicknamed 'Sun Shine' because it is made with the energy of the sun).

DIY Algae/Hydrogen Kit was a collaboration with the National Renewable Energy Laboratory (NREL) in Colorado. It was inspired by research into the process of 'biophotolysis', by which hydrogen is produced as the result of sunlight acting on enzymes in algae. Considerable efforts are being made to develop this method, which is a sustainable and environmentally friendly way of producing clean energy. The Futurefarmers' proposed kit, as its name suggests, is a 'backyard/DIY' model that would allow anyone to produce their own hydrogen at home using off-the-shelf and found supplies. A follow-up project, *Lunchbox Laboratory*, also designed with the scientists at the NREL, would enable schoolchildren to collect local algae strains, culture them and test how much hydrogen they produced in the hope of finding ever more efficient varieties.

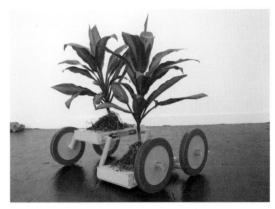

Photosynthesis Robot, 2003

In Search for the Blue-Green Algae from DIY Algae/ Hydrogen Kit, 2004

'We are artists, researchers, designers, farmers, scientists, engineers, illustrators, people who know how to sew, cooks and bus drivers with a common interest in creating work that challenges current social, political and economic systems.... While we collaborate with scientists and are interested in scientific inquiry, we want to ask questions more openly. Science asks questions to find "answers" and seeks to find a methodology to answer the next question, while we ask questions to seek more questions.'

FUTUREFARMERS

Clean Air Machine, 1997

N55

Founded 1994, Danish

The Copenhagen-based art collective N55 has achieved international recognition for its radical and humorous work. After co-founder Ingvil Aarbakke died in 2005, her husband, the artist, activist and self-proclaimed 'closet architect' Ion Sørvin, became responsible for N55's activities, working with others on specific projects. The current core collaborators are Danish architect Anne Romme and German designer, artist and activist Till Wolfer. Together they challenge conventional notions of living, architecture and economic models.

All of the group's projects involve creating prototypes of out-of-the-ordinary yet functional products that subvert the rituals and conventions of everyday life. These objects are also designed to minimize each individual's ecological footprint and maximize their positive impact on society. All of N55's work is freely accessible. Their books, manuals and images can be seen online and are not copyrighted. The group actively encourages others to share, reuse and rework their proposals as open-source material.

Two of the group's earliest proposals were *Clean Air Machine* and *Home Hydroponic Unit*. According to its manual, '*Clean Air Machine* enables people to improve the air quality of their indoor environment by cleaning the air of all known air pollutants.' The *Home Hydroponic Unit* allows users to grow their own supply of toxin-free, nutrient-rich food by using the hydroponics technique. Hydroponics, in which plants are grown in pure water, encourages larger and healthier crops because all the nutrients remain in the system rather than being lost to the environment. The method also consumes far less water than conventional soil-based cultivation. N55's unit generates sufficient produce to provide a daily supplement to a household of three or four persons. It can be easily installed indoors, so that one is not dependent on arable land to grow food.

City Farming Plant Modules also enables the growing of plants outdoors in cities where no native soil is available. The modules are flexible forms that are made from a semi-permeable material containing pockets of soil. They soak up any rainwater that falls on them, or a direct water supply can be introduced via hoses connected to drainpipes on nearby buildings. The modules come in several different sizes, allowing a variety of crops to be produced. They can be placed directly onto the street and used by any passer-by.

However, if you wanted to grow your fruit and vegetables in a more conventional fashion, you may need your own personal supply of soil. N55's *Soil Factory* enables people to produce their own by 'vermicomposting', a simple and cheap way of composting that involves worms and other organisms breaking down organic household waste to produce a highly fertile growing substance.

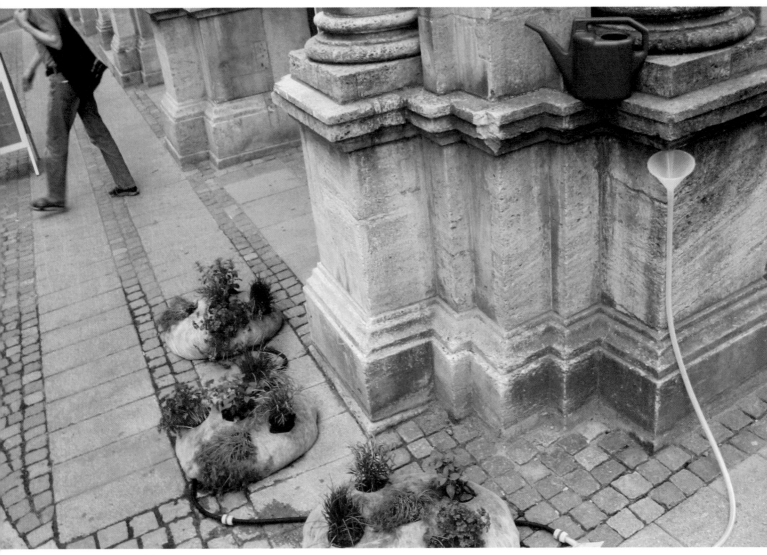

City Farming Plant Modules, 2003

'As artists we work on the edge of the productive field and also on the edge of any well-defined area of knowledge. In a way, we are on the edge of most things. This is in many ways a privileged position. With this privilege follows responsibility, which becomes obvious if you get public attention.... What we are doing in our work is to try to find ways of living with as small concentrations of power as possible.... We try to investigate and create consciousness about things that one otherwise wouldn't notice: which ways of living we don't try out, what houses we don't live in, what technology is not employed, etc. It is a kind of research into forgotten areas or areas outside of commercial or political interest.'

N55

Soil Factory, 1998

Soil Factory, 1998

Opposite: *Home Hydroponic Unit*, 1997

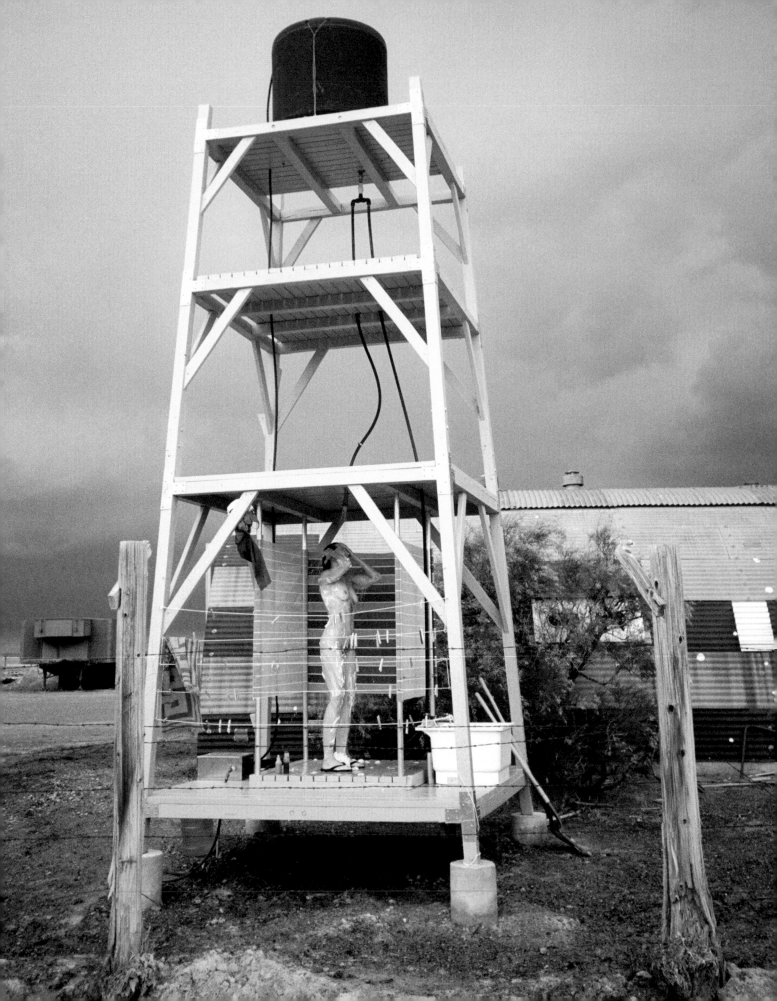

SIMPARCH

Founded 1996, American

The American collective Simparch was founded in New Mexico by the artists Steve Badgett and Matthew Lynch. Its name, a combination of the words 'simple' and 'architecture', reflects the group's interest in sustainable alternatives to conventional building processes and the use of architecture to explore social and environmental concerns. It also points to their practice of producing large-scale, site-specific installations and public works that utilize salvaged or recycled materials brought together in a DIY fashion. Collaborating with other artists, builders, critics, filmmakers, skateboarders and musicians, Simparch creates sites that allow for social interaction as well as experimentation with design and materials. Its work thus hovers somewhere between architecture and popular culture, activism and anarchism, art and non-art.

Built as an experimental yet permanent installation at the Center for Land Use Interpretation's remote research facility in the Utah desert, *Clean Livin'* is an entirely self-contained and self-sustaining living system. The facility allows artists and researchers to live, for several months at a time, in what used to be the ordnance compound of the US Air Force's largest wartime airbase. *Clean Livin'* is a testbed for alternative energies and experimental low-impact, autonomous living. Simparch reinhabited the abandoned location by employing sustainable 'soft' and 'slow' technologies that massively decrease its carbon footprint. Electricity comes from a system of solar panels, making use of the most constant source of renewable energy in this scorched environment. Water, however, has to be hauled in, fifty-five gallons at a time, from six miles away by two people on a four-wheeled bicycle, and stored in a tank at the top of a twenty-foot tower. Waste water is collected and processed using solar distillation to make it drinkable. Organic waste is composted to make fertile soil for growing. A Simparch team revisits the site every year to make repairs and improvements.

The success of *Clean Livin'* led to the *Dirty Water Initiative* in the San Diego-Tijuana region, which straddles the frontier between the United States and Mexico. The work tackled the different levels of available pure water on the two sides of the border, and highlighted the government and private corporate interests that control the provision of clean water. The public exhibit consisted of a supply of contaminated water and a series of solar stills connected in a line to create a temporary purification plant that greeted visitors as they entered Mexico. According to the group, the work 'directly challenged the cliché "don't drink the water"' that many subscribe to when travelling to a foreign land. After the end of the exhibition (part of InSite 05), the stills were donated to Mexican families in the local area.

Dirty Water Initiative (DWI), 2005

'An interest in experimenting with building, engineering and design using commonplace materials has been part of the work from the beginning, but in the past few years it's evolved into making something functional/useable. We are always asking what is worth doing or how can we be generous with a project? Ever since I can remember, I've had a nagging sense of failing policy, failed institutions, so I think that's behind the eco-related projects.... But we are artist-minded more than activist-minded, so need a creative imperative for our projects.... If you are an artist, you have licence to explore issues critically.... Artists play with self-referential systems. To work in a real situation seems more pleasing. To engender a new system in a community that might take root, that's more satisfying.'

STEVE BADGETT

Opposite: *Clean Livin' (shower tower)*, 2003–ongoing

SIMON STARLING

British, b. 1967

'Maybe the obsession with movement and travel and journeys in the work is all about trying to establish a better understanding of a still situation, a static situation, a place.... There's a sense of premonition or something in those places, that they're almost a projection into the future. This struggle in the Tabernas Desert to stop the desert growing, which is happening for climate-change reasons and for bad land-use reasons; the construction of this multi-million-euro solar research place to try and make salt water into fresh water to irrigate the land; then the bizarre mock-Hollywood, mock-Texas Leone thing – it's a sort of tourism mixed with real, hardcore agricultural economics and ecology. For me, it's a really heady mix, and I attempt to distil some of that into my work.'

SIMON STARLING

Simon Starling is an English conceptual artist and the winner of the 2005 Turner Prize. His work mixes installation, film, photography, objects and performance, and deals with issues surrounding the growth of global capitalism and humankind's relationship with the natural world. He is particularly preoccupied with the various narratives that spring from globalization, such as the way natural forms move around the world in increasingly rapid fashion.

Influenced by the history of alchemy, Starling is also fascinated by the processes of transforming one substance into another. He describes his practice as 'the physical manifestation of a thought process', revealing hidden histories and relationships between objects and people, times and places. The idea of efficiency is another theme that informs many of his works, which often involve the artist making pilgrimage-like journeys.

For *Tabernas Desert Run*, he crossed the Tabernas Desert in Andalucia, southern Spain, on an improvised electric bicycle. The region is the only 'true desert' in Europe and is growing in size each year due to climate change and poor land management. Between the 1960s and 1980s, the desert was the location of several popular films such as *Lawrence of Arabia, Conan the Barbarian, Indiana Jones, 2001: A Space Odyssey, The Good, the Bad and the Ugly* and *The Magnificent Seven*, as well as many spaghetti westerns by the filmmaker Sergio Leone. It is now also the home of the Solar Platform of Almeria, a research facility developing the use of solar energy to desalinate seawater, a potential antidote to the area's desertification.

Starling made the forty-one-mile crossing on a bicycle powered by a fuel cell, an early form of generator, which creates electricity by using compressed bottled hydrogen and oxygen drawn from the atmosphere. The only waste product from using this clean energy was one pint of pure water, which Starling collected during the trip. He used the captured liquid to paint a watercolour of an Opuntia cactus, which he later exhibited sealed in a Perspex vitrine in an oblique reference to the closed, symbiotic system in *Condensation Cube* by the German-American artist Hans Haacke. The work makes other connections, too, both backwards and forwards in time. The painting refers to Leone's introduction of the cactus to the region for the production of his film sets, while the journey itself is a homage to Chris Burden's 1977 *Death Valley Run*, in which the performance artist crossed the California desert on a bicycle powered with a small petrol engine. Starling's use of an alternative form of energy is also an allusion to the nascent local industry on which the area's future may depend.

Tabernas Desert Run, 2004

NILS NORMAN

British, b. 1966

Nils Norman's unique mix of art and activism proposes new forms of sustainable living and land use. Driven by a strong commitment to social and environmental issues, he proposes alternative economic and ecological systems, while at the same time critiquing the history and role of public art with humorous, ironic and playful works.

Working rather like a designer, Norman begins by creating digital illustrations and architectural models to explore his ideas. Based on meticulous research, all of his proposals could be realized with existing technology, and several have been developed into fully functional working prototypes. *Geocruiser* is a mobile library, education centre and plant nursery housed in a converted coach. The library contains books on eco-activism, self-sustainability and radical architecture, and offers free photocopying and internet facilities powered by solar energy. The bus also includes a greenhouse of vegetables and herbs, watered by a 'rainwater filtration unit' and by condensation from the windows. A vermicomposting unit uses worms to create rich compost from recycled organic matter. *Geocruiser* runs on biodiesel, although at one point Norman investigated the possibility of converting the engine to run on used cooking oil. Since it was built, the vehicle has toured various public spaces across Europe, including schools, parks, town squares, museums and libraries, inviting different communities to come on board, take away some plants and learn about climate change. In 2004, the *Geocruiser* was decommissioned and bought by a family for a nominal fee. They redesigned parts of the interior to make it more livable. It was last seen driving around Wales.

Similarly utopian in spirit, *Open-Assembly No. 1 Loughborough: Insects, Worms, Mushrooms, Birds and Students* is the prototype for a new form of public outdoor furniture, developed for Loughborough University in central England. It is designed to bring together humans and animals under one roof to create a communal discussion space. In this and all of his proposals, Norman invents an almost absurd situation in order to highlight the shortcomings of reality and to look forward to an alternative existence.

Geocruiser, 2001

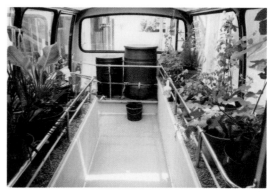

Geocruiser, 2001

'Some see utopia as a dream space, a fantasy future society. That's one part of it. Others see it as a critical tool with which to critique society and the conditions we live in, which is how I use it. Using the idea of utopia as a way of getting to another place, which doesn't need to be a perfect place.... It's a way of moving out of the place we're in to somewhere else. It's a process rather than a goal.'

NILS NORMAN

Opposite: *Open-Assembly No. 1 Loughborough: Insects, Worms, Mushrooms, Birds and Students*, 2010

Butterfly Bridge, 2012 (mock-up of the bridge in use)

Constructing the bridge

Customized road sign

NATALIE JEREMIJENKO

Australian, b. 1966

An early participant in the net.art or internet art movement of the 1990s, Natalie Jeremijenko was one of the pioneer artists to explore the intersection of society, the environment and technology and to harness the transformative potential of new media. Innovative and visionary, her work blends art, engineering, environmentalism, biochemistry, technology and neuroscience to create real-life experiments that enable social change. Her ongoing project *OneTrees*, which began in 1998, was one of the first art works to tackle the issues of genetic engineering and the cloning of nature. She planted a thousand clones of a single walnut tree in sites across San Francisco Bay, USA. Although genetically identical, the individual specimens grew at varying rates and took on a different form and appearance from one another, indicating that it was not the genetic make-up of the trees that was the primary determinant of their development so much as the environmental and social conditions of their site.

Jeremijenko, who describes her work as 'X design' (short for experimental design) and herself as a 'thingker', is director of the Environmental Health Clinic at New York University, where she is also assistant professor of art. Modelled on conventional clinics at other academic institutions, this experimental lab approaches health from the conviction that external factors rather than internal biology are the most important element in an individual's well-being. Students can make an appointment to discuss any environmental health concerns they may have. They leave the consultation with a prescription not for medicines, as they would do at a conventional health clinic, but for actions. They also receive referrals not to medical specialists but to activists, artists' groups and other organizations that either promote or enable improvements in the life and environment of a local community through participation.

One such participatory project was Jeremijenko's *Butterfly Bridge*, a three-month public intervention in Washington, DC, that set out to help butterflies to navigate obstacles in the city such as roads. They were encouraged to bounce along the bridge by the presence of enticing flowering vegetation, which guided them over the busy junction. The bridge benefits more than just the butterflies, however. The existence of different species of butterflies and moths is vital to preserve biodiversity in built-up areas. They are important pollinators and thus ensure the continued survival and ongoing evolution of different forms of plant life. The significance of Jeremijenko's minimal spectacle lies, therefore, not only in the direct practical assistance it offers to these tiny creatures that live alongside us, but also in the model it provides for a reimagined urban infrastructure built for the benefit of all cohabitants, both human and non-human.

The installed bridge

'It's a particularly urban design challenge, to transform our relationship with the ecosystem to become a form of cultivation rather than extraction or damage.... Through these lifestyle experiments – which must be playful, enjoyable, interesting, compelling, wondrous, otherwise people aren't going to do them – people are getting a real empirical sense of how we might improve things.... We can't depend on these traditional, slow and often faulty political processes to address a material and techno-scientific reality. We know that traditional political systems aren't good at doing that. Figuring out what to do is something we all have to be involved in. We have to draw on the greatest renewable resource that we have, which is the creative power of many people to address these issues.... [Only] by drawing on the diverse intelligence, experience and experiments of many different people can we reimagine our relationship to natural systems, and can we redesign and rebuild it.'

NATALIE JEREMIJENKO

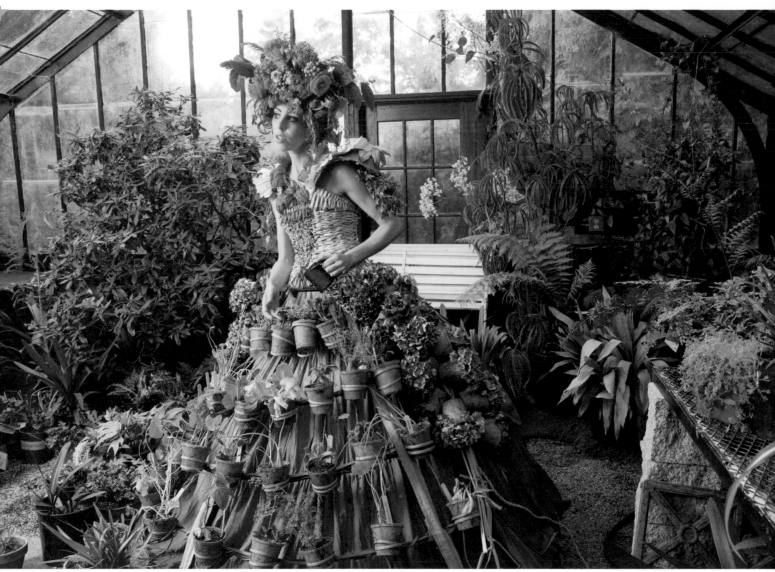

Mobile Garden Dress, 2011

'The decaying aspect of my art is very much part of the process. My art work is about having an authentic experience of nature, one where we are not separate from the natural world and one where there is beauty in all of life's cycles. The modern expectation of humans staying perpetually youthful and fresh is not only unrealistic but the cosmetics and fashion industries are laughing at us all the way to the bank.'

NICOLE DEXTRAS

NICOLE DEXTRAS

Canadian, b. 1956

Nicole Dextras creates ephemeral works inspired by the socially engaged art practice of Joseph Beuys and a commitment to sustainable living. She began her *Weedrobes* series in 2005 as an experiment in making clothes and accessories from plants. Her original concept of clothing as a link between the body and the land has now evolved into an ongoing investigation into consumerism, the fashion industry and our relationship with the built environment.

Each *Weedrobes* project operates in four stages. It begins as a garment made from plant materials, designed with a high degree of craftsmanship and attention to detail to mimic actual clothing; upon closer examination, it becomes apparent that the garment is made from leaves and flowers and is held together with thorns; and each unique piece is created with what is in season at the time and what is available in the artist's garden in Vancouver, in abandoned lots or in compost piles in local parks. In the second stage, the clothing is photographed being worn in urban settings that contrast with the natural materials and origins of the clothes. The third stage involves interventions in shopping areas, where the wearer discusses consumerism and environmental issues with passers-by. In the fourth stage, the garment is returned to nature by being placed in a garden or park setting and allowed to decompose.

A development from the initial *Weedrobes* project, *Urban Foragers* is a series of works that Dextras describes as 'wearable architectures that support a sustainable lifestyle for the new urban nomad'. Each item of clothing can be transformed into a temporary shelter and can also enable the growing of food. The *Mobile Garden Dress*, for example, consists of pots of edible plants and a hoop skirt that converts into a tent.

According to Dextras, the *Weedrobes* philosophy is 'based on being a free thinker, creating one's own sense of style while also raising awareness about the impact of industry on our ecosystem'. As with all of her work, the ephemeral qualities of the piece symbolize the vulnerability and fragility of our ecosystem. Wearing nature not only emphasizes the fundamental link between humans and the natural environment, but also focuses attention on the implications of throwaway consumer goods.

Skunk Cabbage Slippers, 2008

Yucca Prom Dress, 2005

Teardrop Terrarium, 2004

Teardrop Terrarium, 2006 (detail)

PAULA HAYES

American, b. 1958

The daughter of two farmers, sculptor Paula Hayes has been working with and in nature for over two decades, merging her interest in gardening with her career as an artist. Her practice ranges from designing planters and bird feeders from silicone and cast acrylic to landscaping entire gardens. Hayes's art embraces the effects of time and transformation on the environment and examines how ritual and symbolism affect the way we observe, understand and care for our natural surroundings.

As well as being the garden designer of choice for the New York art world, she has received considerable attention for her series of indoor terrariums made from hand-blown glass, which have been installed in leading galleries and institutions such as the Museum of Modern Art, New York. Inside each of these bubble-shaped vessels is a tiny forest of lush vegetation that the artist has planted and arranged over many hours of careful attention and manipulation with surgical tweezers. She cultivates her terrariums for a year before eventually entrusting them to collectors.

These exquisite containers of plant life – which can take the form of teardrops, bubbles or sometimes breasts – are self-contained worlds where weather, light, humidity and temperature can be controlled more easily than in a normal garden. Nonetheless, as art objects, they require an unusual devotion on the part of the collector. For unlike the traditional static work, they are constantly changing and growing. They also require environmental conditions that are antithetical to the preservation of most other forms of art. For that reason, anyone who buys a terrarium is obliged to sign an agreement that is an integral part of the work. Among other things, the document states that: 'The owner is under obligation to maintain the life of the artwork described by seeing to it that the container contains a living landscape'; and 'The owner is responsible for the artwork in as much as the artwork does not exist without the responsibility and commitment to its undertaking.'

Thus Hayes's terrariums do more than simply bring the outdoors inside; they also bring the processes of nature straight into our daily, domestic lives, forcing us to take ownership and responsibility for them, despite the disruption that may cause. For the artist, this enforced stewardship of nature on a small scale will lead us to a better understanding of the fragile state of the environment and a greater awareness of our individual and collective responsibilities.

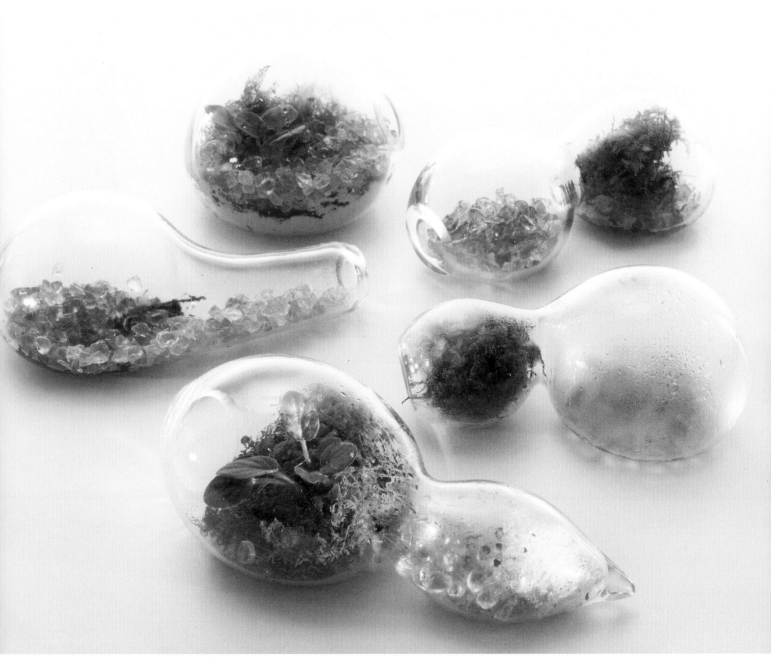

Arrangement of various tiny terrariums

'Living art literally involves the attentive and continuous role of participants and caretakers in all aspects of the continuum of its manifestation and life; this reality is at its core…. It is essential that there be an internal, collaborative maintenance of the life of the work so that it can exist as an artwork. Secondary systems (such as owner, object, value, resale) become irrelevant, while interrelatedness and continuously active and attentive devotion become essential.'

PAULA HAYES

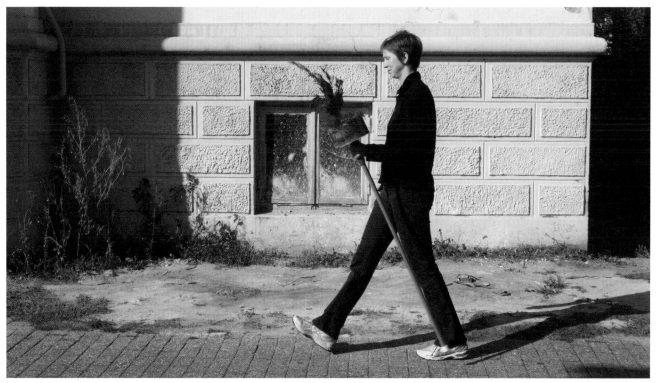

Landscape for Walking, 2009

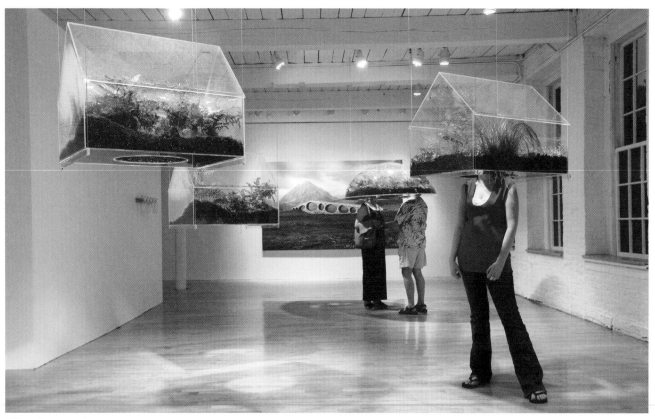

Village Green, 2008

VAUGHN BELL

American, b. 1978

Vaughn Bell is a sculpture, installation, performance and video artist who creates interactive projects and immersive environments that transform our relationship with our immediate surroundings. The daughter of two landscape architects, she was interested in nature and art from an early age, eventually realizing that she could bring the two concerns together.

Her works offer a unique and often hilarious mix of serious environmental issues with a sense of the absurd. For instance, aware that city-dwellers no longer have any real connection with the natural world, she created the *I Ped*, an augmented walking stick that encourages the user to explore and study the landscape. Local community members are invited to borrow one of these 'tools for walking' and to create their own personal record of the environment by documenting their experience and by sharing their observations with the next user. A more primitive version of your GPS digital mobile device, it aids navigation by providing the basic tools for mapping and observing your environment: a pen, a notepad and a compass. The *I Ped* grew out of a similar project, *Landscape for Walking*. This 'walking stick for urban conditions' allows the user to take their own piece of nature with them wherever they go and is part of Bell's *The Portable Environments* series, which she began in 2002 with several gardens, forests and greenhouses that could be transported in shopping trolleys. The series now includes miniature replicas of mountains that can be wheeled around and pocket human-made biospheres – entirely closed ecological systems – just two inches wide. Visitors to her exhibitions can 'adopt' these hand-held terrariums and nurture them by following strict instructions.

Bell's exploration of personal ecologies reaches a highpoint of absurdity with her compact domes filled with greenery that people can wear on their heads, and personal home biospheres for one or two, which are larger domes that hang from the ceiling, allowing the owners to place their heads inside in the comfort of their own homes. The works address our need to both control and care for our environment, a duality of opposing intention that exists in constant tension. They are miniature versions of the public park that developed in the nineteenth century – an attempt to contain and preserve nature artificially within the city. According to the artist, the biospheres have a similar feel to an 'intensive care unit', in which a highly artificial life has been created, 'a kind of crude approximation of the original ecological system,' she says. 'I'm fascinated with all the various and problematic and hopeful ways that we conceive of how we relate to nature and this futuristic, dystopian vision where we're cut off from nature or we have to build this alternate reality for ourselves.'

'With the *Personal Biospheres*, I explore the miniaturization of landscape, the separation of one piece of "land" from the whole, and the relationship of care and control that this embodies. A tiny mountain or a small piece of land is suddenly within the scale of the human body, implying a different relationship than the one of awe, alienation or domination that is present in many encounters with our surroundings. The work is informed by an ever-expanding array of ideas and histories. I am as interested in discussions of sustainability, property rights, public space and ecological function as I am in a range of contemporary art practices.'

VAUGHN BELL

Metropolis, 2012

TATTFOO TAN

Malaysian, b. 1975

'I'm creating a scenario, a place for people to interact. It's about bringing people together to start a conversation. I don't strive for a resolution, like an activist. It's the idea that art happens when people interact, rather than art as an object or commodity that you can trade. I give the idea, I create a situation, but the art work still belongs to the participant.'

TATTFOO TAN

Tattfoo Tan was born in Malaysia and moved to New York City in 2000. A proponent of social sculpture as advocated by Joseph Beuys, he seeks to collapse the categories of 'art' and 'life' into one, and through his work find an immediate, direct and effective way of tackling issues facing society. His practice involves multiple forms of media and various types of presentation, but group participation is a core element, transforming the making of art into a ritualized and shared experience.

S.O.S. Mobile Gardens is part of Tan's 'S.O.S. (Sustainable. Organics. Stewardship.)' initiative. This year-long horticulture and cultivation project engaging with green ethics and aesthetics grew out of multiple concerns. It addressed the fact that society is losing important skills – such as gardening and foraging – and becoming too reliant on an industrial food system that is not sustainable; it also sought to counteract the scarcity of growing space in urban areas; and it attempted to deal with the problem of waste in our cities. Tan's 'mobile gardens' were made from shopping carts, discarded suitcases, abandoned baby strollers, even an unused commode, which have been retrofitted with found materials so that they can grow fruit and vegetables. Tan also provided instructions for others so that they could create and use their own edible gardens. These DIY objects were then pushed around the city and left at strategic points to prompt public debate about socio-economic and environmental issues such as recycling and food justice.

Tan's 'movement' is overflowing with symbolism. The discarded shopping cart, in particular, is a sign of our times. Product of big business and symbol of consumer excess as much as the objects it contains, it is seen being pushed around the streets by the most destitute members of society. The cart is therefore an object that raises many questions about overconsumption, homelessness, urban decay and social neglect. Similarly, the rise of the edible garden and organic farming and the return to local produce are timely responses to a global food industry tainted by harmful practices, one that produces an inferior product at great cost to the environment.

Tan claims that with projects such as *S.O.S. Mobile Gardens* he is raising questions rather than resolving them. He sees himself as a catalyst for change and designs his interventions to generate further actions by others and encourage their input. He hopes that by taking part in these ephemeral and conceptual projects, individuals will become more aware of social and environmental issues and change their own behaviour for the better.

Opposite and above: *S.O.S. Mobile Gardens*, 2009–ongoing

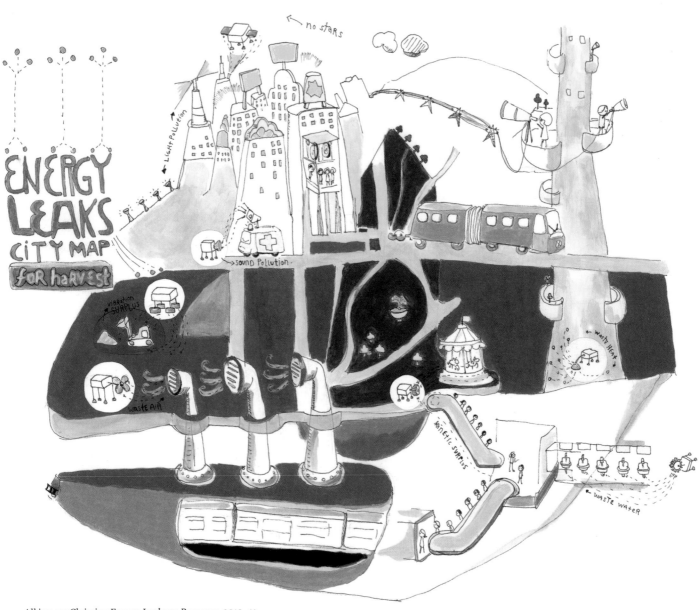

All images *Claiming Energy Leaks as Resource*, 2010–11

NEIGHBOURHOOD SATELLITES

Myriel Milicevic, Italian/German, b. 1974

Myriel Milicevic is an artist, researcher and interaction designer based in Berlin. She set up the Neighbourhood Satellites group initiative to explore the hidden connections between people and their surroundings. The group organizes participatory projects that grow out of discussions and collaborations with other artists, designers and scientists working in the laboratory and in the field.

Energy Harvests was a Neighbourhood Satellites project established with fellow Berlin-based artist Hanspeter Kadel and designed to investigate the phenomenon of energy leakage and the possibilities of reusing waste energy. We are surrounded by potential sources of free energy that are currently being lost: heat waste from poor insulation; light pollution from street lamps, neon signs and illuminated advertising; vibrations and air currents caused by the flow of traffic. In theory, all of these leakages could be collected and transformed into usable energy.

To demonstrate the principle, Milicevic and Kadel placed a system of harvesters in the Neukölln metro station. Small windmills were installed on the platforms and activated by the movement of air from approaching trains. They used the electricity they generated to broadcast short recordings about alternative ways of living. The pair also created a set of portable devices that could collect energy leaks in the form of light, sound, vibrations, water and air, and could use that energy to recharge batteries. As they distributed the prototypes around the city, some interesting practical, theoretical and ethical questions were raised. How would people use this energy if they could harvest it? Would they share the energy they collected or keep it all for themselves? Could local sharing networks that collected and distributed harvested energy be set up on behalf of the community? How would such a system work? What changes to individual and collective behaviour and economic models would such a scheme require? As energy becomes ever more scarce, would free harvested energy be a source of conflict or cohesion among a specific society?

The project examined these and other questions through interviews with thinkers and makers; a free newspaper, *Currents & Stories*; workshops for building light-pollution harvesters and instigating discussion; and DIY kits that provided all the components and instructions to put the devices together so that anyone could make their own energy harvesters to discover, capture and transform sunlight and light pollution.

'Recently we have observed that an interest in environmental awareness and sustainability has gained relevance not only in many art projects but also within business strategies, technology industries and politics. This development is as exciting as it is curious. At the same time, I feel there is a danger in words like "sustainable" becoming popular buzzwords – they inevitably will lose their meaning as people grow tired of them. Artists' intentions may be doubted when they address such topics. It will be an interesting challenge to keep people on their toes.'

MYRIEL MILICEVIC

209

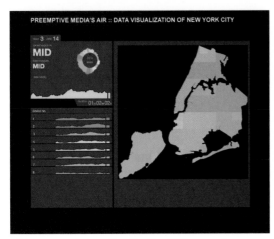

All images *Area's Immediate Reading (AIR)*, 2005–8

PREEMPTIVE MEDIA

Founded 2002, international

Established by the interdisciplinary artists Jamie Schulte, Brooke Singer and Beatriz Noronha da Costa (who died in 2012), Preemptive Media is a group of artists, activists and technologists who develop beta tests, prototypes and experiments based on scientific research. According to the group, 'PM is most interested in emerging policies and technologies because they are contingent and malleable. The criteria and methods of PM programs are different [from] those run by businesses and government, and, therefore, PM gets different results. PM hopes that their enquiries create new opportunities for public discussion and alternative outcomes in the usually remote and closed world of technology-based research and development.'

AIR was a public experiment in which people used Preemptive Media's portable air-monitoring devices to test the atmosphere of their local environments for pollution. The devices were equipped with sensors that detect carbon monoxide, nitrogen oxides and ozone. Participants were able to see pollutant levels in their locations, as well as current readings from the other devices in the network, and through GPS tracking could discover their proximity to known pollution sources. The machines also transmitted live data to the project's website.

The project launched in September 2006, in New York City, and was subsequently conducted in Pittsburgh, Brazil, Australia and California. As with many of the projects in this chapter, it was designed as a small-scale tool with an individual user or small set of users in mind but soon expanded to generate wider debate about larger environmental and ethical issues and the future of the planet. As San Francisco-based curator Jordan Geiger put it, 'With *AIR*, the space in question is air itself; and the revelation of local and remote pollutants as a kind of ownership, a contested area of rights. Who has the right to pollute, and where are they?'

'We share a concern for similar issues such as power/knowledge, social engagement and topics of social injustice. How is behaviour regulated? What motivates people? What are the grey zones in policy? We knew our work needed more than one discipline for it to be effective. While we have similar concerns, we have varied backgrounds in the areas of art, engineering and technology. From this diverse background, we look at extreme aspects of an issue in order to create dialogue and to provide tools to ask questions.... Artists are allowed to have opinions, which isn't always the case in other fields. But our working within the realm of art is balanced by our work as individuals in various fields outside the art world, so as not to stay in a "bubble" and become homogeneous.... We would like people to copy the process and realize that they can do something even if they're not scientists. We want people to ask: who are the experts?'

PREEMPTIVE MEDIA

Supergas/The Land, 2002

'You just have to remember in the morning what hat to put on. It's a little bit confusing sometimes. It's like applied schizophrenia. You try somehow to avoid specialization, which is a global tendency also. Because, for example, if this project was *only* an art project, I think it would have limits. It would probably be commodified and then some kind of art collector would buy it and it would end up in a corner in a ... that kind of limit. We think of our work as tools that can work on different levels at the same time, without opposing each other. Right now we teach at CalArts [California Institute of the Arts]. We've also taught at an agriculture school in Cambodia. In that situation, our background as artists doesn't have any importance at all. It's not a secret ... but in that situation we are agricultural consultants. Again, just remember what hat to wear.'

SUPERFLEX

212

SUPERFLEX

Founded 1993, Danish

The irreverent and humorous collective SUPERFLEX was founded by the Danish artists Jakob Fenger, Rasmus Nielsen and Bjørn-stjerne Christiansen. The group's projects, which it describes as 'tools', take the form of proposals and prototypes that invite people to participate in the development of different models of production – of energy, of objects and of knowledge. Often they collaborate with specialists from other fields, who provide the necessary expertise to realize their imaginative experiments.

One of the group's earliest projects was to work with engineer Jan Mallan to construct a simple, portable biogas unit that could produce sufficient energy for the average African family from organic materials, such as human and animal faeces. Each unit produces around 100 to 140 cubic feet of gas a day from the dung of two or three cattle. This is enough for a family of eight to cook and to run one gas lamp. They also created a modified replica of the celebrated PH5 lamp, a classic of Danish modernist design created in 1958 by Poul Henningsen. SUPERFLEX reengineered one of the lamps to run on biogas. However, they were soon presented with a 'cease-and-desist' letter from Louis Poulsen Lighting A/S, the company that owns the copyright of the original PH5 lamp, demanding that it stop all activities involving the lamp, including the use of certain words.

SUPERFLEX projects, while often proposing a solution to a serious problem, can take absurd form. To coincide with the UN Global Climate Summit in Copenhagen in 2009, the artists organized a group session in which participants were hypnotized so they could experience the effects of climate change from the perspective of a cockroach. The group also planned five sessions to take place in different locations involving different animals: The Eagle, Dhaka, 2012; The Jelly Fish, Rio de Janeiro, 2015; The Polar Bear, Møn, 2020; The Mosquito, Ilulissat, 2025; and The Mammoth, Zanzibar, 2050. These are key years in international environmental agreements, and the places are all in some way connected to climate change. The animals reflect shifts in global weather patterns: they are either extinct, about to disappear, are spreading rapidly or carry dangerous diseases that threaten humankind.

Supergas, Supercopy/Biogas PH5 Lamp, 2002

Supergas/The Land, 2002

THE JELLYFISH

EXPERIENCE CLIMATE CHANGE AS A JELLYFISH

HYPNOSIS GROUP SESSION
Cais Nobre, Marina da Glória
Rio de Janeiro, Brazil
14 January 2015, 06:00
Participants 5
No recording allowed

Experience Climate Change as a Jellyfish, 2009

THE MOSQUITO

EXPERIENCE CLIMATE CHANGE AS A MOSQUITO

HYPNOSIS GROUP SESSION
Noah Mølgaard-ipaqqutaa 9
Ilulissat, Greenland
21 July 2025, 09:00
Participants 5
No recording allowed

Experience Climate Change as a Mosquito, 2009

RE / ACT

The artists in this final section actively set out to transform the world and change it for the better. No longer passive observers or reporters, or even engaged researchers, who leave the task of acting to others, these individuals and groups pursue a determined strategy to improve the natural realm as the very purpose of their art. In some respects, they seem more like eco-activists operating within an art context and using creative means to achieve their environmental goals. They either make radical interventions that have a direct impact on local and global ecosystems, or else enlist others to alter their behaviours and beliefs for the benefit of the planet. In this way, these artists cross the line from suggestion or proposal, which we saw in the previous chapter, into action to leave a lasting legacy that goes far beyond the aesthetic.

Some critics might argue a case for the Enlightenment principle of the autonomy of art – that is, that art is separate from life, and its power comes precisely from being uncontaminated by the mundane concerns and realities of everyday existence. Such a theory also holds that the artist is a solitary genius set apart from the rest of society and operating with disinterested freedom. But these views, commonplace until at least the 1960s and lingering in various forms to this day, have been largely discredited and are now considered untenable by many practitioners and commentators. Leaving aside the numerous philosophical, theoretical or artistic objections to that position, just on the practical level it is evident that as the art establishment has expanded and become more institutionalized in recent decades, it has found itself at the centre of a complex and sometimes murky network of connections and interests – some visible but many not – stretching from the studio, the community group and the local supporter to high finance, arms traders and oil companies. In such circumstances, the idea that art exists in some separate realm cut off from real life seems naive or utopian at best. On the contrary, it is caught in a web of complicity from which it would struggle to disentangle itself.

The interconnected nature of the worlds of art and society reflects the complexities of the environmental agenda. But this in itself offers opportunities and hope for the future. As Birgit Arends, curator of numerous art and ecology projects, has said: 'Conservation efforts are increasingly guided by the value of nature in ways that can be understood by economists, politicians and financial markets – as another way to counteract the accelerated destruction of biodiversity. This means placing a monetary value, thereby a tradable value, on public goods services that our natural environment provides, such as clean air, fresh water, fertile soil, drought and flood prevention, resistance to erosion, provision of nursery grounds and so on. This language of economic currency, advocating the monitoring of nature and ecological modernization, may be another way to prevent the increasing rate of the depreciation of our natural assets or indeed the rapid rate of extinction of species across the globe. Moreover, the relationship between biodiversity loss, climate change and sustainable development for people needs to be transformed into a financial mechanism towards preserving ecosystems. Environment and economy have become intrinsically linked.'

All the artists in this chapter recognize this fact. Several even choose to explore and exploit these links in their work, utilizing the practices and structures of global capitalism and geopolitics to question the status quo. Many of them have been inspired by the practice and teachings of 'social artists' such as Joseph Beuys, who saw no distinction between art and life; early performance artists who similarly blurred the boundaries between the two; and the pioneering eco-artists mentioned in the introduction who cleared a path – in some cases literally – for others to follow. Some are building on the more recent trend for performative 'relational' work that seeks to create new social situations enacted for and by an 'audience'. They produce temporal projects in collaboration with active participants, with varying layers of interaction, ritual, dialogue and education. Many of these works take the form of collective action, even where an individual artist may have conceived the project initially. Often there is a practical imperative for such an approach, for it pools resources, skills and interests that any one person could not have alone, resulting in a richer, more diverse and more effective result. But also sometimes the choice to work collectively has been driven by a desire to reject selfish individualism and to foster instead a sense of shared responsibility in the face of the global issues.

But however committed the artists may be to improving the world, they recognize that their contribution can only ever be a drop in an increasingly polluted ocean. The environmental challenges we face require both individual and collective action on a mass, international scale if they are going to make a difference. As Dominic Eichler, writing about Danish artist Tue Greenfort's eco-related work, emphasizes, 'The real point for Greenfort, as in most of his projects, is proving that there are viable alternatives. He wants to highlight how these alternatives aren't given serious consideration, while the insatiable thirst for oil causes wars, injustice and environmental degradation.... It's not about perfect solutions, or a crusade, or dogmatic insistence. But it doesn't shy away from making a point. For him, environmental issues and art meet like cohorts not contradictions.' But some might reasonably ask why should we look to artists for the answers, and not to eco-campaigners or scientists or politicians? Greenfort himself explains: 'Art has the ability to elaborate and open up discourses without being labelled and categorized as this or that political faction. It can draw on a more complex system of references and interdisciplinarity than a purely politically defined activity.'

Even if the results are relatively small in scale and their effects apparently modest, these artists offer a model for the future. The book opened with a quote from Lucy Lippard. Over many decades, this influential author, activist and critic has done much to champion artists who engage with the most urgent environmental issues of our age, so it is only fitting that she has the last word. 'There is no reason to exaggerate the elusive power of art. Artists cannot change the world – alone. But when they make a concerted effort, they collaborate with life itself.'

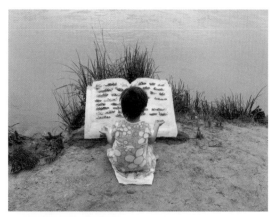

Cleo reading *Tome II*, 2009

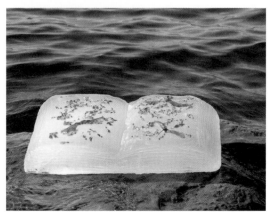

Ottawa River Book III, 2012

'All my work is from the perspective of an artist. I work with scientists a lot but the way that I see the world is the poetic vision of an artist.... Part of it is language: when you are trained in a discipline, you have a language that you study, that you grow up with, so I may be talking with a biologist friend about the same thing but we use different terminology to describe it.... Part of the meaning of the term "eco-artist" is that it is in service to the eco-system. You are trying on some level and in some way, whether large or small, to help the eco-system along, to help it thrive.'

BASIA IRLAND

BASIA IRLAND

American, b. 1946

Basia Irland is an author, artist and activist who has created numerous eco-related books, art works and documentaries over four decades in Africa, Canada, Europe, South America, Southeast Asia and the United States. She is also professor emerita at the University of New Mexico, where she established the respected interdisciplinary Art and Ecology programme. Most of her projects focus on and utilize water, both as a material and as a subject matter. Working with experts from other fields, including scientists, engineers and non-governmental organizations, she has undertaken major river restoration projects and built functioning systems for collecting rainwater, all informed by aesthetic as well as ecological concerns. For her, water is more than just a vital element necessary for survival; it also has an important social and cultural function in connecting disparate communities.

Irland's ongoing project *Receding/Reseeding* is typical of her practice in that it highlights the need for both scientific knowledge and community action to deal with the implications of climate change. Each work consists of releasing huge blocks of floating ice down the rivers from which the water was drawn to make the sculptures. The blocks, which can weigh several hundred pounds, are carved in the forms of books and carry a 'text' written in seeds that come from local, native plants. As these ephemeral books of ice gradually melt into the current, they release the seeds into the water. The resulting plants that grow alongside the river help hold soil in place, restore eroded banks, provide shelter for native animals and sequester carbon dioxide.

In preparation for the sculptures, Irland meets with local botanists, plant specialists and community members to determine the best seeds for each riparian zone – typically from endangered plant species – to include in the ice. 'These seeds are embedded into the books, so the seeds themselves form a kind of text,' she says. 'I think of it as a kind of international ecological language. It is a language of the land, of that particular site.' She calls the project 'receding/reseeding' because it links the receding of the world's glaciers to the use of local seeds to restore nearby waterways and water resources. A temporal, sensual and lyrical response to climate change in the spirit of 1970s' eco-feminism, Irland's ice books bear witness to the global climate crisis while providing a small-scale intervention that actively improves a specific local environment.

Opposite: *Ice Book XXIII*, 2008

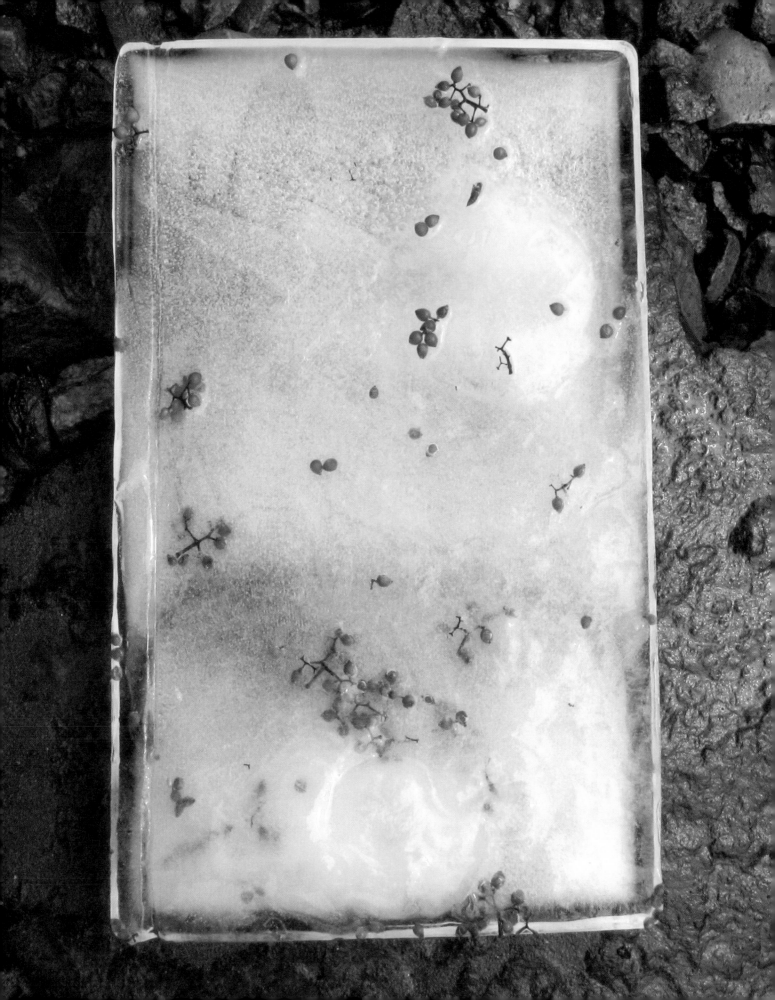

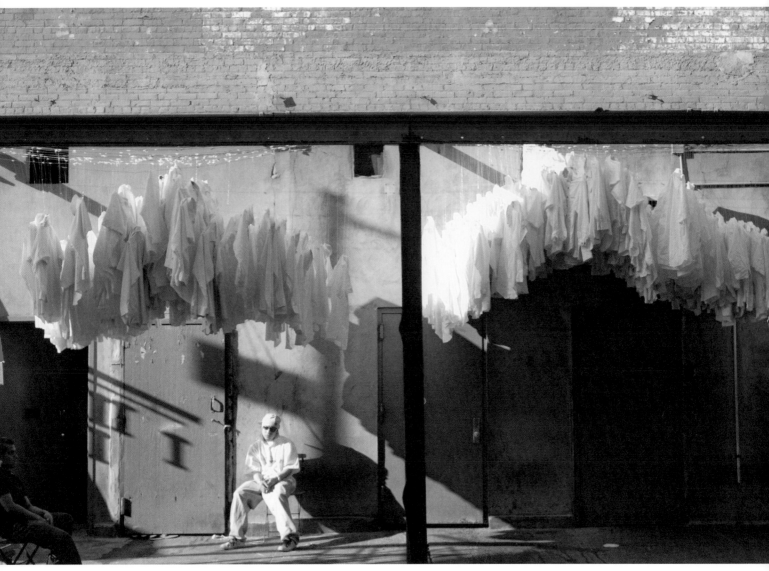

Albedo Cloud on Little West 12th St, 2007

'It is an investigation into latent mythology. The more reflective the Earth, the less sun is absorbed and the cooler it stays. Ice and snow are white. When they melt, the Earth gets less reflective, warmer. More ice melts, and it gets even warmer. We want you to increase the overall reflectivity of the Earth by wearing white.'

THE CANARY PROJECT

THE CANARY PROJECT

Founded 2006, American

Part of the ongoing The Canary Project, established by Susannah Sayler and Edward Morris (see also p. 60), *Increase Your Albedo!* consisted of a number of public interventions that took place across New York City. They were enacted by Annie Murdock, Amy Burrel, Edward Morris, Jussara Lee and Orlando Palacios, and involved sculpture, fashion and performance. Unlike many of The Canary Project initiatives that aim to raise awareness and deepen public understanding of human-induced climate change, *Increase Your Albedo!* set out actively to provide a real solution and to change the environment for the better – albeit temporarily.

Albedo is the measurement of the Earth's reflectivity, its ability to reflect the sun's radiation. Reflecting the sun helps the planet stay cool, just like wearing white clothes on a hot day keeps you cooler than wearing black ones. The Earth as a whole reflects about thirty per cent of incoming solar radiation back into space. Clouds and snow and ice each have an albedo of roughly eighty per cent. They are effectively the planet's thermostats, regulating its temperature. Because of the effects of global warming, the reflective polar ice caps are melting and becoming darker ocean water. Any loss of sea ice of this kind creates more water, which has an albedo of only between three and five per cent. This net reduction of albedo results in further heat absorption at the Earth's surface, causing more sea ice to melt, leading to more warming, and so on. According to scientists at the Scripps Institution of Oceanography in California, 'A three-percent decrease [in albedo] would create a severe heating effect comparable to that caused by a sixfold increase in atmospheric carbon dioxide, far greater than anything projected by today's climate models.'

Everything on the planet affects its albedo. The *Increase Your Albedo!* project enables everyone to do something about climate change by simply wearing white, thereby increasing the Earth's reflectivity and the amount of solar radiation it bounces back into space. The group takes inspiration from Gandhi, himself a well-known wearer of white, who once famously said: 'Be the change you want to see in the world.' The project's series of public performances across the city with all-white costumes were designed to encourage others to take part, while simultaneously actually cooling the planet by increasing its albedo, if only momentarily.

Albedo Cloud on Little West 12th St, 2007

Albedo Pilgrims at the Socrates Sculpture Park (NYC), 2008

HighWaterLine, Manhattan Beach, New York, 2007

HighWaterLine, DUMBO, New York, 2007

EVE MOSHER

American, b. 1969

Eve Mosher is an artist and interventionist based in New York City. She uses this urban setting as her starting point to explore social and environmental issues. *HighWaterLine* was a work that stretched along seventy miles of the New York City waterfront. Mosher walked through the streets, front yards and back alleys of Manhattan and Brooklyn marking a six-inch chalk line ten feet above sea level to indicate the possible extent of increased flooding brought about by global warming. The line represented the point to which scientists, government agencies and insurance companies believe water would rise after a major storm. With climate change, this area could become inundated as frequently as every four years. Mosher worked for six months on her drawing, meeting hundreds of workers, homeowners and pedestrians along the way. The process was documented in photography and a seven-minute film.

While the work clearly has similarities with Haubitz+Zoche's *waterknowsnowalls* (see p. 52), the difference is that Mosher set out with the intention to effect actual change rather than just highlight an issue. As she created the work, she handed out information on climate change and explained to locals its potential impacts. Indeed, Mosher's stated objective in undertaking the project was to have one-on-one conversations with people about the subject. She also developed an open-source learning guide and tools (with collaborators Patricia Watts, founder of ecoartspace, and community organizer Heidi Quante) to provide the resources for any community to build awareness of the risks of flooding and to create scalable methods to respond to the threat. The *HighWaterLine* project's website also had a section that exhorted visitors to 'Take Action', with advice about what real differences, big and small, they could make at home, at work or school, in the community, or in the political sphere. With Quante, similar interventions were planned for Miami, Philadelphia and London.

HighWaterLine, Canarsie, New York, 2007

'I'm not a lobbyist, I'm not a scientist, but I am an artist, I am a creative person so I wanted to create something that brings awareness to this very difficult issue and I wanted to make it really simple so that people can understand it within our timeline, within our generation. So it was all about distilling this big issue down.... That's what I as an artist seek to do – distill down big issues and provide tools that people can utilize themselves, tools that can be owned and used by communities to create the change themselves.'

EVE MOSHER

Above and opposite: *indestructible language*, Pulaski Skyway, Jersey City, New Jersey, 2007

MARY ELLEN CARROLL

American, b. 1961

Mary Ellen Carroll is a conceptual artist based in New York City and Houston who has consistently addressed issues relating to our use of the environment and natural resources. One of her most noteworthy projects in this respect was *prototype 180*, which explored land-use zoning policies and involved rotating a plot of land in Houston containing a dilapidated family home by 180 degrees.

indestructible language was the debut project for the Precipice Alliance, established by the artist Joel Sternfeld and art publisher Donna Wingate. Their mission was to raise awareness of climate change by commissioning 'high-profile, innovative public artworks that address this urgent matter, while simultaneously functioning as an educational and informational forum'. Together they found the ideal site for their inaugural work: a disused factory in New Jersey situated alongside a major route. Carroll installed an enormous illuminated nine-word text piece on the site that stretched across nine hundred feet and five buildings, with the final three words rounding the corner of the fifth building. The red neon sign – a colour that suggests danger but also intense heat – could be seen from up to four miles away by commuters in cars and trains, and by passengers flying into the nearby Newark International Airport. Carroll selected the phrase used in the piece – 'IT IS GREEN THINKS NATURE EVEN IN THE DARK' – from more than two hundred that she generated at random in spreadsheets. This seemingly cryptic series of words is designed to be entered and read at any point as a continuous loop. According to Carroll, it was inspired by the media's basic assumption that 'global warming is a moral issue not a scientific fact'.

But what sets the work apart from others in this book that merely comment on environmental issues is that it also attempted to alleviate the effects of its own production – it set out to remedy the harm it had caused to the environment by conserving energy and reducing greenhouse gas emissions. The installation used the very latest technology to ensure that it was entirely carbon neutral. Low-wattage neon bulbs, solar power, energy-efficient transformers and lead-free glass were all utilized. Meanwhile, an environmental charitable foundation donated carbon credits to offset any non-renewable energy used. While the work's direct impact on climate change was therefore entirely neutral – neither ameliorating nor damaging the environment – its long-term benefits could be substantial if it influences other artists to limit or eradicate the carbon footprint of their own creations. As green design consultant and writer Jill Fehrenbacher remarked about the work, if other artists took Carroll's lead, 'the world would certainly be a cooler place'.

Public Smog billboards in the Ndokoti quarter of Douala, Cameroon, 2009

AMY BALKIN

American, b. 1967

The work of Amy Balkin regularly involves the artist taking direct action to effect change, often by employing current international legal, political and financial protocols. For *This is the Public Domain* (2003–ongoing) she purchased a parcel of Californian desert in an effort to create a permanent common that is free to everyone in perpetuity. The project also included research into the various legal processes needed in order to hand over all rights associated with ownership to the global public. Similarly, *Public Smog* was a series of attempts to establish a 'clean-air' park in the Earth's atmosphere open to public use. The project consisted of the artist buying and withdrawing carbon-gas offset credits from emissions trading markets, made possible by the Kyoto Treaty, thereby making these unavailable to polluting industries, and an as-yet-unsuccessful attempt to submit an application to qualify the entire atmosphere as a UNESCO World Heritage site, with a full paper trail recording her efforts.

Public Smog was, in fact, made up of two parts – a Lower Park and an Upper Park – each of which addressed a particular environmental challenge to the health of the atmosphere: smog in the troposphere and increasing greenhouse gas concentrations in the stratosphere. The Upper Park opened in the stratosphere over the European Union from the autumn of 2006 with the purchase of fifty-one tons of carbon dioxide emission allowances (EUAs) in the European Union Emissions Trading Scheme (EU-ETS) and remained open to the public until the expiration of the offsets at the end of 2007. It reopened from April to August 2010 over the United States with the purchase of the right to emit 500t/CO2 (Chicago Climate Exchange Carbon Financial Instruments). The Lower Park opened briefly to the public in June 2004 over California's South Coast Air Quality Management District's Coastal Zone. Creation of the park was made possible through the purchase of a small amount of nitrogen oxides offsets.

According to Balkin, 'In the process of attempting to create the park, the project intersects the geopolitics of the atmosphere, and political and economic efforts to monetize and control this system through markets, international law, treaties, and police power. As the politics of the atmosphere and the atmospherics of politics are currently so intertwined, it's important to consider the air as a political construct, legally and financially manipulated by polluting entities and nation-states, who continue to sabotage attempts to ameliorate climate change.' Balkin also installed a series of thirty billboards, which featured slogans in French and English, across Douala in Cameroon, prefiguring the possible opening of a similar clean-air park over Africa.

'The domain of art risks not only being a tolerated exception, but an active site for recuperation of political activity. Like a "public park" within a totalized system of property, the domain of art could be argued to act as a built-in pressure valve that displaces political action from real recuperation to self-limited, and so tolerated, symbolized recuperation instead. But socially engaged work doesn't exist in a vacuum, and is presented in a social and political context. And the domain of art has always been a vital place for the creation of critical counter-narratives in the context of political engagement.'

AMY BALKIN

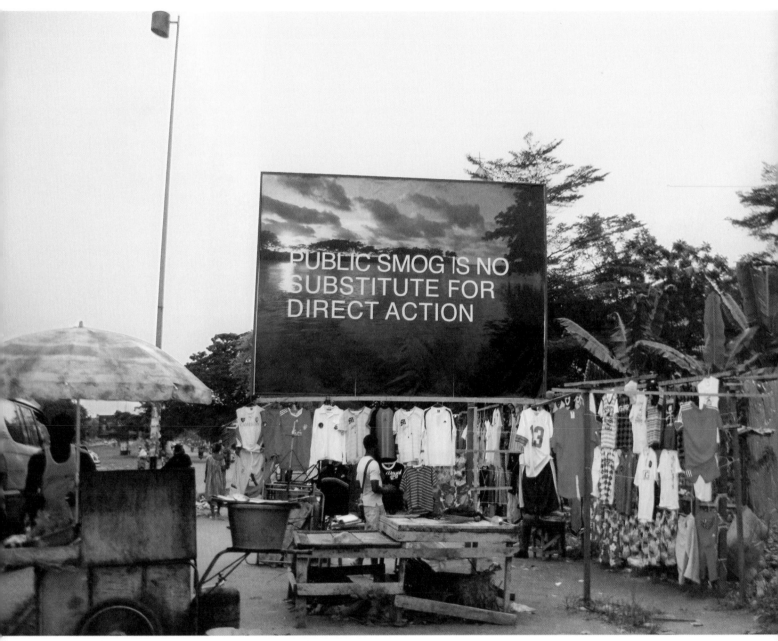

Public Smog billboards in the Bonamoussadi quarter of Douala, Cameroon, 2009

The Lower Park opened over California's South Coast Air Quality
Management District's Coastal Zone in June 2004.

The Upper Park was open in the stratosphere over the
European Union from Autumn 2006 until 2007.

View of *myforestfarm*, 2008

DIRK FLEISCHMANN

German, b. 1974

Artist-entrepreneur Dirk Fleischmann uses business models as a strategy to explore economic forms. He has set up a series of experimental micro-businesses to operate alongside multinational corporations, playfully yet critically challenging and subverting the logic, practices and structures of global capitalism. His past ventures have included a small retail outlet selling chocolate, a trailer-rental company, a game show, a fashion label, a solar-energy producer, an egg merchant and an estate agency.

myforestfarm is one of Fleischmann's most ambitious projects to date. It is a voluntary carbon-offset programme in the form of a reforestation scheme located in the mountains near Antipolo City in the Philippines. In 2008, he began the process of planting the first of 1,838 trees across some four acres of land with the aid of workers from the local community. He aspires to take an ethical approach to the running of the entire operation, from the working conditions to the social and ecological impact of the forest. As a result, the plantation is completely organic and has a zero carbon footprint.

The project started in response to the booming carbon-offset market and was driven by Fleischmann's dissatisfaction with the way many offset businesses simplify the issues of climate change by pretending that the problem of emissions can be solved simply by purchasing offsets. *myforestfarm* counters this myth by revealing all the complexities and costs of carbon-dioxide sequestration. Reforestation projects are popular with the voluntary carbon-offset programmes because they transform the carbon-dioxide sequestration of the trees into tradable carbon credits, which can then be sold on the open market. Although *myforestfarm* does result in the offsetting of carbon dioxide, none of the carbon credits it generates is for sale. Instead, Fleischmann offers art rather than credits, 'thought instead of speculation', he says.

Each of the 1,838 trees has been photographed and its image transferred to an individual CD, with its precise GPS location recorded on the disk. The resulting photographic works – *mycarbon-credits* – are exhibited in gallery shows and sold via the project website for ten euros each, with the earnings going directly into a fund to support the project. This commodification process draws attention through symbolic means to the way the carbon credit itself is a financial invention of the commodity markets. Fleischmann expects *myforestfarm* to be self-sustainable within ten years, supported by the sale of fruit harvested from the trees.

Position of the tree 'Chico 07' as seen on Google Maps

Screenshot of the myforestfarm.com website, 2013

Photo of tree 'Chico 07', 2009

mycarboncredits (Chico-07), 2010 (detail of CD)

myforestfarm (1838 trees), 2010 (installation shot)

F.R.U.I.T., 2005 (detail, wrapped fruit)

F.R.U.I.T., 2005 (detail, poster showing food miles)

FREE SOIL

Founded 2004, international

Free Soil is an international group of artists, activists, researchers and radical gardeners with a shared interest in the environmental impact of urban development and globalization. It has created a range of multimedia projects that incorporate sculpture, installation, public projects, gardens, workshops and websites. Produced for the 'Beyond Green: Toward a Sustainable Art' exhibition held at the Smart Museum of Art, University of Chicago, USA, in 2005, *F.R.U.I.T.* highlights the social, economic and environmental costs of transporting food from rural areas to urban populations – an issue that has since become the focus of growing consumer alarm across the developed world.

Focusing on the orange, the group undertook research to trace the fruit's route to market and documented the impact of its journey. The gallery component of the project included a replica of a market stall filled with fake oranges wrapped with information sheets about Free Soil's 'The Right to Know!' campaign. Visitors were invited to take one of these sheets and wrap it around real fruit in their own local shop or market and leave it for others to pick up. The project not only encouraged people to learn about where their food comes from and to support local farmers, but also made use of existing local networks to spread information more widely and encourage a shift in consumer behaviour.

'*F.R.U.I.T.* takes up the challenge of elevating the ecological knowledge of consumers and encouraging a way of life that is friendly to the environment. We want consumers to be conscious of the entire life of a product, from production to utilization, and not just what they see in the stores. Consumers must be aware that every phase of a product's life influences the environment and ourselves.'

FREE SOIL

F.R.U.I.T., 2005 (detail, printed wrapper to wrap fruit)

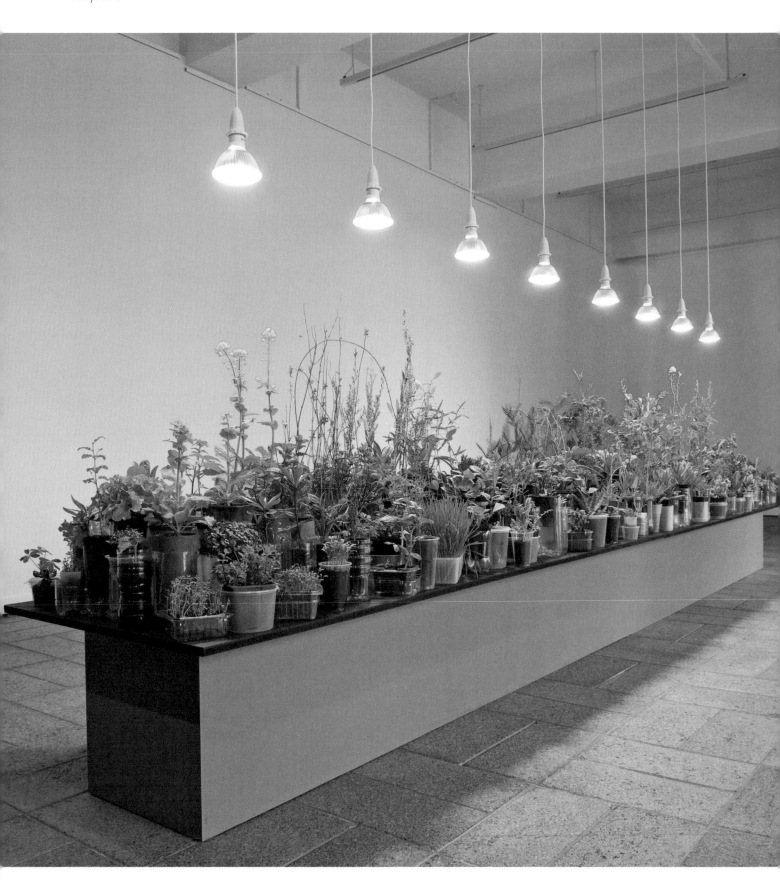

LAUREN BERKOWITZ

Australian, b. 1965

Lauren Berkowitz works with living and ephemeral materials to evoke the passage of time and the cycles of life and death. She also often makes use of found or recycled objects to address the degradation of the natural environment caused by human activity, frequently utilizing some of the vast quantity of plastic bottles, pots and packaging that we generate and dispose of every day. In her view, this huge excess of human-made waste is just one of the ways we have lost touch with nature and any sense of where and how our food is produced.

Manna and *Sustenance* are two related works that comprise dozens of edible plants arranged within, between and upon numerous retrieved plastic cartons that fill long, low tables. For both installations, Berkowitz transforms the gallery space into a temporary greenhouse, modifying the lighting and atmosphere to provide the right environmental conditions to promote plant growth. Her regular intervention is required to maintain the art works.

According to curator Alana O'Brien, with these works Berkowitz is questioning the sustainability of intensive agricultural practices and the introduction of non-native species 'that have been destroying the fragile Australian continent since colonization. At the same time, she proposes indigenous and succulent plants as a way of broadening our choices to include more sustainable food sources.'

Beyond merely raising awareness about these issues, however, the works also seek to make a small yet tangible difference to the natural environment. Berkowitz draws on the mystical Jewish concept of Tikkun Olam, which can be loosely translated as 'healing or repairing the shattered world'. At the conclusion of the exhibitions, the food and medicinal plants were dispersed to various gardens in Melbourne and Sydney, representing a small contribution towards the regeneration and renewal of the local ecosystem. This modest gesture demonstrates that even simple, practical steps undertaken by each individual can contribute to the health of the planet.

Opposite: *Manna*, 2009

Overleaf: *Sustenance*, 2010

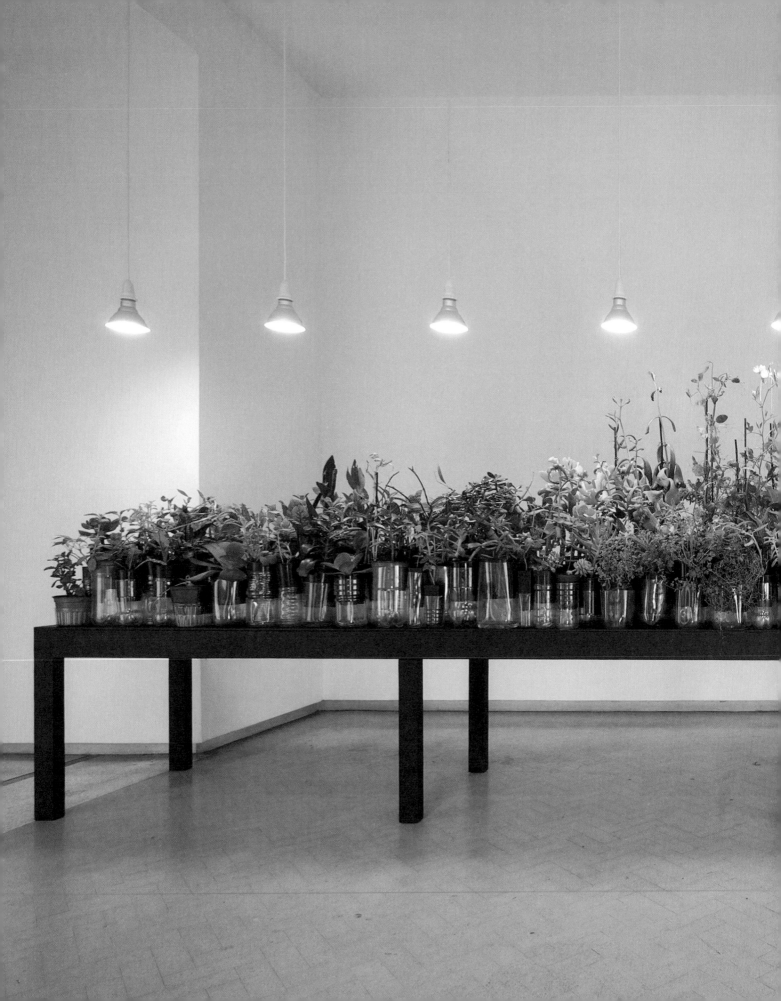

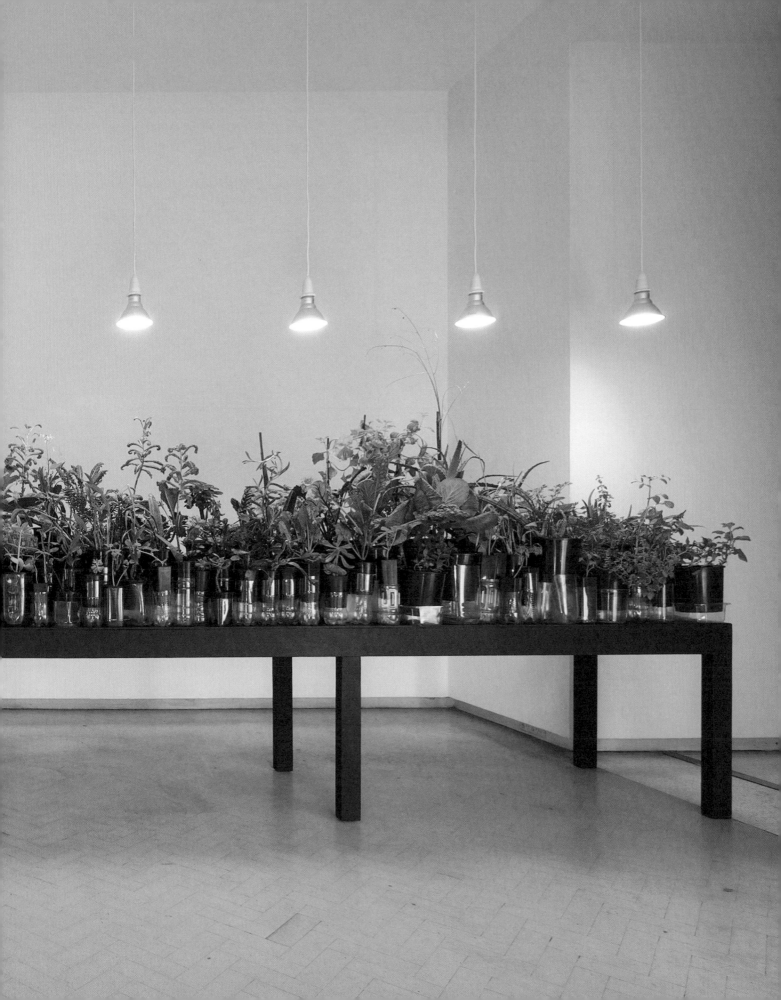

Planting *Food Forest*, 2010

Preliminary plan of the site, 2010

ARTIST AS FAMILY

Founded 2009, Australian

As the name suggests, Artist as Family is a group of artists made up of a family of four, including two children, living in rural Australia: Meg, Patrick, Zephyr and Woody Jones. Together they have created a number of living and edible projects that explore and utilize local food economies and energy resources.

For the 'In the Balance: Art for a Changing World' exhibition at the Museum of Contemporary Art in Sydney in 2010, the family created *Food Forest*, a permaculture garden of edible plants on the lawn of the Anglican church of St Michael's in the Surry Hills suburb. Designed to provide food for a nearby soup kitchen during the course of the exhibition and to decrease the community's dependency on supermarkets, the 'forest' contains fruit trees and vegetable plots. According to the artists, the work 'champions biodiversity and demonstrates that art can be generative; that it can be a resource, rather than just an extractor or exploiter of resources.... This work attempts to blur the line between art and nature. *Food Forest* is a biological system that is in part self-maintaining. It utilizes a combination of applied ecology (mimicking a forest system) and what Artist as Family call 'social warming' (art that makes relationships).' The project also has a clear social benefit, as it gives homeless people the opportunity to feed themselves. The garden is now maintained as a community asset and managed by church volunteers, thereby providing a long-term and sustainable source of free food for local residents.

'It's a poetic space; a garden that supplies uncapitalized food for a soup kitchen and the nearby community; a physical poem set on publicly accessible church ground; a home to marginalized urban dwellers, wildlife and bourgeois organisms. It is a space to inhabit, to garden, to find solace. Its politic makes a clear departure from typical expressions of nihilistic contemporary art. The work is informed by permaculture utopianism, which has in turn been informed by how traditional communities function as non-polluting custodians of land. The food produced by the work forms part of a local gift economy.'

ARTIST AS FAMILY

Food Forest two years on, 2012

'By attacking the front lawn, an essential icon of the American Dream, my hope is to ignite a chain reaction of thoughts that question other antiquated conventions of home, street, neighborhood, city, and global networks that we take for granted. If we see that our neighbor's typical lawn instead can be a beautiful food garden, perhaps we begin to look at the city around us with new eyes. The seemingly inevitable urban structures begin to unravel as we recognize that we have a choice about how we want to live and what we want to do with the places we have inherited from previous generations. No matter what has been handed to us, each of us should be given license to be an active part in the creation of the cities that we share, and in the process, our private land can be a public model for the world in which we would like to live.'

FRITZ HAEG

FRITZ HAEG

American, b. 1969

Fritz Haeg is an artist, designer and architect based in Los Angeles. His diverse work has included public dances, educational environments, domestic gatherings, urban parades, temporary encampments, documentary videos, publications, exhibitions, websites, animal architecture and buildings for people.

Edible Estates is an ongoing project to create regional prototype gardens for families and communities to grow their own food in otherwise unused spaces, such as front lawns. The first garden was created in 2005 in Salina, Kansas, the geographic centre of the United States. Since then, Haeg has established sixteen gardens in cities across the world, including in Britain, Italy, Turkey, Israel, Denmark and Sweden. Each of the gardens is different, responding to the specific character and history of the site and the needs of its owner, and developed with the assistance of local horticultural or community gardening groups. Many of them have been commissioned by art institutions – a sign not only of the art establishment's growing interest in participatory, 'relational' projects, but also, perhaps, of a greater awareness of its social responsibility to its local community. Usually the garden is planted in spring or early summer. The story of its creation and evolution is presented in an accompanying exhibition, which also provides information, workshops, local planting calendars and other gardening resources.

Haeg says that his priority is not to produce pretty gardens that fulfil some preconceived idea of good design – his main focus is on 'people and their relationship to each other and to their environment'. As he explains, 'These simple, low-cost gardens and their stories are meant to inspire others, demonstrating what is possible for anyone with the will to grow food and some unused land between the house and the street. Unlike the unattainable images of perfection seen in design and gardening magazines, anyone should be able to look at these gardens and imagine doing something similar at home. These are real-life gardens, tended by typical families in a variety of common living situations, from homes in the outer suburbs to inner-city apartments. With the modest gesture of reconsidering the use of our small plots of land, the *Edible Estates* project invites us to reconsider our relationships with our neighbors, the sources of our food, and our connections to the natural environment immediately outside our front doors.'

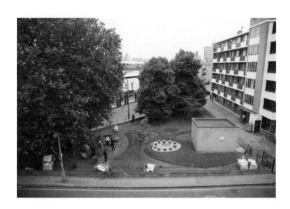

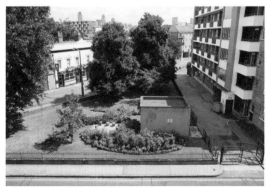

All images: *Edible Estate Regional Prototype Garden #4: London*, 2007

245

REDUCE
ART
FLIGHTS

FREIBURG
BASEL
MULHOUSE

13.06.2013
WWW.REDUCEARTFLIGHTS.LTTDS.ORG

GUSTAV METZGER

German, b. 1926

RAF/Reduce Art Flights is a campaign initiated by German-born Gustav Metzger, creator of the concept of auto-destructive art and one of the key figures of British postwar art. Unknown to many, Metzger has long been concerned with environmental issues. Indeed, he was one of the very first artists to link art with pollution, having developed plans for a number of projects going back to the 1960s that involved the use of car exhaust fumes. In 2007, he was invited by the Sharjah Biennial, a major cultural event in the oil-producing United Arab Emirates, to reconstruct a version of one of the projects first proposed in the 1970s. Metzger lined up several cars and fixed their exhausts so that they would pump into a clear plastic structure that clouded up during the course of the exhibition.

The *RAF/Reduce Art Flights* project began in 2007, when Metzger was invited to take part in the Münster Sculpture Project in Germany. He decided to produce five thousand leaflets, based on a British wartime poster, urging his art-world colleagues to limit their use of air travel during the course of their work. The campaign came at a time that coincided with an explosion in the number and frequency of international biennials, exhibitions and art fairs. As a result, many artists, curators and critics found – and still do – that they were constantly on the move, apparently having swapped the studio, gallery or office for the airport departure lounge as the place in which they spent most of their working hours.

The 'RAF' acronym clearly echoes the name of the Royal Air Force, but also that of the far-left West German organization the Red Army Faction, active in the 1970s. The campaign therefore links the wartime destruction of Münster by British air raids with Metzger's 'ongoing and endless opposition to capitalism and objection to the massive commercial growth of the art industry'. In keeping with his history of creating auto-destructive art over which he had little or no control, he claims no ownership whatsoever over the *RAF/Reduce Art Flights* initiative. For the exhibition 'Greenwashing: Environment, Perils, Promises and Perplexities' at the Fondazione Sandretto Re Rebaudengo in Turin, in 2008, he allowed the curators to produce an 'RAF Torino' leaflet entirely autonomously, which was made available in the galleries and inserted into international mailings in connection with the exhibition.

Metzger fully recognizes that, even if the art world were to dramatically reduce its dependence on air travel, it would be only 'a drop in the ocean'. Nonetheless, he hopes that others will take the inspiration from the RAF 'manifesto' and refuse to participate in the mobility that is increasingly required by the globalized art system, so that 'maybe it will have a bit of an effect somewhere'.

Opposite: *Reduce Art Flights*, 2007/2013

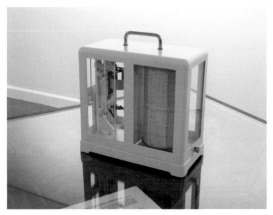

Exceeding 2 Degrees, 2007

TUE GREENFORT

Danish, b. 1973

Tue Greenfort addresses a host of environmental issues in emi-nently practical, mildly impractical and downright absurd fashion with his subtle, almost imperceptible, but hard-hitting works. For the Sharjah Biennial 2007, he persuaded the Sharjah Art Museum to adjust its air-conditioning so that the building was two degrees celsius warmer than usual. He chose that increment because of the 2006 Stern Review into climate change, which concluded that if no action is taken on carbon emissions global temperatures were likely to rise by that amount over the next fifty years. As a result, the museum used less energy and saved money, which it donated, according to the artist's wishes, to Nepenthes, an environmental organization. In the same year, for a group exhibition at the Frank-furter Kunstverein, the artist installed a similar work that sought to make a difference, however slight, to Frankfurt's energy consump-tion. *Untitled (Switch)* was a street lamp modified with the epony-mous switch so that anyone could turn it off when not needed.

The final work in this book is Greenfort's *From Grey to Green*, in which the artist attempted to persuade the Witte de With Center for Contemporary Art in Rotterdam to change to an environmen-tally friendly 'green' electricity provider for the duration of his solo exhibition there in 2006. After much discussion with the energy company ENECO, it proved to be impossible to switch the institu-tion to green energy for the six weeks of the exhibition. Instead, the company offered to make the switch the following year, and then only for a minimum contractual period of twelve months, and to reimburse Witte de With for some of the extra cost. In response, Greenfort left one of the galleries completely empty except for all the back-and-forth email correspondence between the museum and ENECO showing how difficult it was to make the switch from grey to green. Even the best will in the world finds its limits when faced with a fixed-price tariff. Greenfort's eco-switch had to wait until 2007, when the contract expired and the project could be realized as a coda to the show, remaining invisible but present, altering almost imper-ceptibly both the day-to-day running of the institution and visitors' experience of its exhibitions, now bathed in 'green' light.

Greenfort's intention was that the work would make a genuine contribution to the health of the planet, not with some spectacular installation, but with the slightest of imaginative acts. It is a reminder that the most ecologically effective gesture that an artist can make is not to fill the gallery with stuff but to empty it of all clutter so that we can see the essential message more clearly. And the message of Greenfort's intervention is that through their actions artists can change the world step by step, little by little – just like any one of us.

Opposite: *Untitled (Switch)*, 2002–7

From Grey to Green, installation view from 'Photosynthesis', Witte de With, Rotterdam, 2006

FURTHER READING

Artist and project websites
Heather Ackroyd & Dan Harvey: ackroydandharvey.com
Ravi Agarwal: raviagarwal.com
Benoit Aquin: benoitaquin.com
Artist as Family: theartistsfamily.blogspot.com
Lise Autogena & Joshua Portway: autogena.org
Amy Balkin: tomorrowmorning.net; invisible5.org/
 index.php?page=directions; publicsmog.org;
 thisisthepublicdomain.org
Vaughn Bell: vaughnbell.net
Daniel Beltrá: danielbeltra.com
Lauren Berkowitz: laurenberkowitz.com.au/index.html
Suky Best: sukybest.com
Erika Blumenfeld: erikablumenfeld.com
Liu Bolin: liubolinart.com
David Buckland: bucklandart.com
The Canary Project: canary-project.org
Cape Farewell: capefarewell.com
Mary Ellen Carroll: mecarroll.com
Brian D. Collier: briandcollier.com
Matt Costello: matt-costello.com
Layla Curtis: laylacurtis.com
Agnes Denes: agnesdenesstudio.com
Susan Derges: susanderges.com
Nicole Dextras: nicoledextras.com
Marjolijn Dijkman: marjolijndijkman.com
Simon Faithfull, *Habitat for Artists*: habitatforartists.org
Chris Drury: chrisdrury.co.uk
Alejandro Durán: washed-up-project.com
Bright Ugochukwu Eke: u-bright.blogspot.co.uk
Mitch Epstein, *American Power*: whatisamericanpower.com
Mark Fairnington: markfairnington.com
Dirk Fleischmann: dirkfleischmann.net; myforestfarm.com
Free Soil: free-soil.org/index.php
Futurefarmers: futurefarmers.com
Tue Greenfort: tuegreenfort.net
Fritz Haeg: fritzhaeg.com
Helen Mayer Harrison & Newton Harrison:
 theharrisonstudio.net
Haubitz+Zoche: haubitz-zoche.de
Paula Hayes: paulahayes.com
HeHe: hehe.org.free.fr
Katie Holten, *Tree Museum*: treemuseum.org
Basia Irland: basiairland.com
Natalie Jeremijenko, Environmental Health Clinic:
 environmentalhealthclinic.net; *Butterfly Bridge*:
 flickr.com/photos/93786711@N00/sets/
 72157630425661884
Luke Jerram: lukejerram.com
Patricia Johanson: patriciajohanson.com
Chris Jordan: chrisjordan.com
Tim Knowles: timknowles.co.uk
Chiara Lecca: chiaralecca.com
David Maisel: davidmaisel.com
Tea Mäkipää: tea-makipaa.eu
Edgar Martins: edgarmartins.com
Kathryn Miller: kathrynamiller.com
Heather & Ivan Morison: morison.info
Eve Mosher: evemosher.com; highwaterline.org
N55: n55.dk
Neighbourhood Satellites: neighbourhoodsatellites.com
Nils Norman: dismalgarden.com
Lucy & Jorge Orta: studio-orta.com
Svetlana Ostapovici: svetlanaostapovici.it
Katie Paterson: katiepaterson.org
Andrea Polli: andreapolli.com
Preemptive Media, *AIR*: pm-air.net
Sabrina Raaf: raaf.org
Janine Randerson: janineranderson.com
Rúrí: ruri.is
Susannah Sayler & Edward Morris: history-of-the-future.com
Wilhelm Scheruebl: scheruebl.at
Simparch: simparch.org
Buster Simpson: bustersimpson.net
Berndnaut Smilde: berndnaut.nl
Alan Sonfist: alansonfist.com
SUPERFLEX: superflex.net
Tattfoo Tan: tattfoo.com
Leonid Tishkov: leonid-tishkov.blogspot.co.uk
Alexandra Regan Toland: artoland.wordpress.com
United Visual Artists: uva.co.uk
Nicolás García Uriburu: nicolasuriburu.com.ar
herman de vries: hermandevries.org
Klaus Weber: k-weber.com

Exhibition catalogues, surveys and theoretical texts
Andrews, Max (ed.), *Land, Art: A Cultural Ecology
 Handbook* (RSA, 2006)
Beardsley, John, *Earthworks and Beyond: Contemporary
 Art in the Landscape* (Abbeville Press, 2006)

Boetzkes, Amanda, *The Ethics of Earth Art* (University of
 Minnesota Press, 2010)
Carlson, Allen, and R. Cembalest, 'Ecological Art Explosion',
 Art News, 90 (6), Summer 1991
Cheetham, Mark, 'Ecological Art: What Do We Do Now?',
 nonsite.org, 21 March 2013; nonsite.org/feature/
 ecological-art-what-do-we-do-now
Demos, T. J., 'Art after Nature', *Artforum*, Vol. 50, No. 8
 (April 2012)
Felshin, Nina (ed.), *But Is It Art? The Spirit of Art as
 Activism* (Bay Press, 1995)
Gooding, Mel, and William Furlong, *Song of the Earth:
 European Artists and the Landscape* (Thames & Hudson,
 2002)
Grande, John K., *Art Nature Dialogues: Interviews with
 Environmental Artists* (State University of New York
 Press, 2004)
——, *Balance: Art and Nature*, rev. ed. (Black Rose Books,
 2003)
Hanson, Jo, 'My Adventures as an Eco Artist', landviews.
 org/la2003/adventures-jh.html, accessed 19 November
 2013, originally published in *Landscape & Art*, Summer
 2003
Kagan, Sacha, *Art and Sustainability: Connecting Patterns
 for a Culture of Complexity* (Transcript Verlag, 2010)
Kastner, Jeffrey, *Nature* (MIT Press, 2012)
——, and Brian Wallis, *Land and Environmental Art*
 (Phaidon, 1998)
Kester, Grant H., *Conversation Pieces: Community and
 Communication in Modern Art* (University of California
 Press, 2013)
——, *The One and the Many: Contemporary Collaborative
 Art in a Global Context* (Duke University Press, 2011)
—— (ed.), *Art, Activism, and Oppositionality: Essays from
 Afterimage* (Duke University Press, 1998)
Kwon, Miwon, *One Place after Another: Site-Specific Art
 and Locational Identity* (MIT Press, 2004)
Lailach, Michael, *Land Art* (Taschen, 2007)
'Land Use in Contemporary Art: A Forum', *Art Journal*,
 Vol. 69, No. 4 (Winter 2010)
Lippard, Lucy, et al, *Weather Report: Art and Climate
 Change* (Boulder Museum of Contemporary Art, 2007)
Markonish, Denise (ed.), *Badlands: New Horizons in
 Landscape* (MassMOCA, 2008)
Matilsky, Barbara C., *Fragile Ecologies: Contemporary
 Artists' Interpretations and Solutions* (Rizzoli, 1992)
Michel, Karen, *Green Guide for Artists: Nontoxic Recipes,
 Green Art Ideas, & Resources for the Eco-Conscious
 Artist* (Quarry Books, 2009)
Natural World Museum, *Art in Action: Nature, Creativity,
 and Our Collective Future* (Earth Aware Editions, 2007)
Oakes, Baile (ed.), *Sculpting with the Environment:
 A Natural Dialogue* (Van Nostrand Reinhold, 1995)
Schultz, Sarah, and Sarah Peters (eds), *Open Field:
 Conversations on the Commons* (Walker Art Center,
 2012)
Smith, Stephanie (ed.), *Beyond Green: Toward a
 Sustainable Art* (Smart Museum of Art, Chicago, 2005)
Spaid, Sue, *Ecovention: Current Art to Transform Ecologies*
 (Contemporary Arts Center, Cincinnati, 2002)
Strewlow, Heike, et al, *Ecological Aesthetics: Art in
 Environmental Design – Theory and Practice*
 (Birkhäuser, 2004)
Thompson, Nato, *Living as Form: Socially Engaged Art
 from 1991–2011* (MIT Press, 2012)
Watts, Patricia, 'Ecoartists: Engaging Communities in a New
 Metaphor', Land Views, undated; landviews.org/articles/
 metaphor-pw.html
——, 'Performative Public Art Ecology'; weadartists.org/
 ecoart-as-performance
Weintraub, Linda, *To Life! Eco Art in Pursuit of a
 Sustainable Planet* (University of California Press, 2012)
Weintraub, Linda, and Skip Schuckmann, *Cycle-Logical Art:
 Recycling Matters for Eco-Art* (Artnow Publications,
 2007)
——, *ECOcentric Topics: Pioneering Themes for Eco-Art*
 (Artnow Publications, 2006)
——, *EnvironMentalities: Twenty-Two Approaches to Eco-
 Art* (Artnow Publications, 2007)
Willoquet-Maricondi, Paula, *Framing the World:
 Explorations in Ecocriticism and Film* (University of
 Virginia Press, 2010)
Wilson, Stephen, 'Art as Research' (1996); sfsu.edu/swilson/
 papers/artist.researcher.html
Wolfe, Ann M., et al, *The Altered Landscape: Photographs
 of a Changing Environment* (Skira Rizzoli, 2011)

Institution, organization and exhibition websites
Art & Ecology, University of New Mexico: socialmedia.hpc.
 unm.edu/ae/?page_id=2

Art Works for Change: artworksforchange.org
Artists Visit Galápagos: artistsvisitgalapagos.com/about.
 aspx
The Arts Catalyst: artscatalyst.org
Asia-Europe Dialogue on Arts, Culture & Climate Change:
 artandclimatechange.culture360.org/about-2
'Beyond Green: Toward a Sustainable Art' (Smart Museum
 of Art, Chicago, 2005–6): smartmuseum.uchicago.
 eduexhibitions/beyond-green-toward-a-sustainable-art
Center for Art + Environment, Nevada Museum of Art:
 nevadaart.org/ae/index
Center for Artistic Activism: artisticactivism.org/about
Center for Land Use Interpretation: clui.org
Centre for Contemporary Art and Nature: ccanw.co.uk
COAL: Coalition pour l'art et le développement durable:
 projetcoal.org/coal/coal
'Earth: Art of a Changing World' (Royal Academy of Arts,
 London, 2009): royalacademy.org.uk/exhibitions/
 gsk-contemporary-season-2009/exhibition
'Earth Matters' (Heckscher Museum, Huntington,
 NY, 2011): heckscher.org/pages.php?which_
 page=exhibition_detail&which_exhibition=83
ecoartspace: ecoartspace.org
'Ends of the Earth: Land Art to 1974' (Museum of
 Contemporary Art, Los Angeles, 2012): moca.org/landart
'Environmental Dialogues' (Edinburgh, 2011):
 environmentaldialogues.wordpress.com
Five by Five: the5x5project.com
'Greenwashing: Environment – Perils, Promises and
 Perplexities' (Fondazione Sandretto Re Rebaudengo,
 Turin, 2008): lttds.org/projects/greenwashing
Guapamacátaro Center for Art and Ecology:
 guapamacataro.org
'Human Nature: Artists Respond to a Changing Planet'
 (Museum of Contemporary Art, San Diego and UC
 Berkeley Art Museum and Pacific Film Archive, 2008–9):
 artistsrespond.org/about
'Hybrid Fields' (Sonoma County Museum, 2006):
 hybridfields.blogspot.co.uk
Intercreate Research Centre: Art, Science, Technology and
 Cultural Bridging: intercreate.org
Invisible Dust: invisibledust.com
Photography and Eco-Art Centre: eco-art.co.il/home.
 asp?CL=ENG
Prix Pictet: The global award in photography and
 sustainability: prixpictet.com
RANE: Research in Art, Nature & Environment:
 rane-research.org
Sitka Center for Art and Ecology: sitkacenter.org
'Streams of Consciousness: The Histories, Mythologies,
 and Ecologies of Water' (Salina Art Center, Santa
 Fe, 2011–12): salinaartcenter.org/exhibitions/view/
 streams_of_consciousness_the_histories_mythologies_
 and_ecologies_of_water
Stroom Den Haag, Edible Park: stroom.nl/paginas/pagina.
 php?pa_id=8063523
'Surface Tension: The Future of Water' (Trinity College
 Dublin and Eyebeam, New York, 2011–12): dublin.
 sciencegallery.com/surfacetension

Blogs, online journals and other eco-art resources
Art & Research: A Journal of Ideas, Contexts and Methods:
 artandresearch.org.uk
Artists in Nature International Network: artinnature.org
Arts and Healing Network: artheals.org/home.html
Arts and the Environment Network: ciwem.org/knowledge-
 networks/networks/arts--the-environment.aspx
Bioephemera: Art and Science blog: bioephemera.com
EcoArt Network: ecoartnetwork.org/wordpress
EcoArt South Florida: ecoartsofla.org
*Ecozon@: European Journal of Literature, Culture and
 Environment*: ecozona.eu/index.php/journal/index
Green Art Guide: greenart.info/guide
Green Arts Web: greenarts.org
greenmuseum.org: greenmuseum.org
Lake: A Journal of Arts and Environment: lakejournal.ca/
 index.html
Land Views: Online Journal of Landscape, Art and Design:
 landviews.org
Landscape and Arts Network: landartnet.org
Mammut (online magazine on nature, landscape and
 environmentalism): mammutmagazine.org
New Climates: newclimates.com
Resurgence & Ecologist: resurgence.org
TreeHugger: treehugger.com
We-make-money-not-art.com (blog about art, science and
 social issues): we-make-money-not-art.com
Women Environmental Artists Directory: weadartists.org
Wunderkammer: A Journal of Environmental Art:
 environmentalartblog.com/2008_10_01_archive.html

PICTURE CREDITS

a = above, b = below, c = centre, l = left, r = right

Front endpapers: C-print, 100 × 150 cm. © 1998 Naoya Hatakeyama. Courtesy Taka Ishii Gallery, Tokyo; reverse front endpaper–p. 1 & pp. 2–3 Each: suite of 8 digital pigment prints housed in an embossed handmade portfolio box. Edition of 20. Paper size: 55.9 × 43.2 cm each; image size: 34.3 × 22.9 cm. © 2009 Erika Blumenfeld. Courtesy the artist and James Kelly Contemporary; pp. 4–5 C-print, 120 × 150 cm. © 2006 Edgar Martins (www.edgarmartins.com). Courtesy Edgar Martins and The Moth House; p. 6 a Single-channel video display; 4 × 4 configuration of 16 flat-screen LCD monitors. Approximate installed dimensions: 365.8 × 548.6 cm. Photo Pablo Mason. Courtesy David Zwirner, New York/London; p. 6 b Grass, clay, hessian, 600 × 800 cm, image imprinted through controlled production of chlorophyll. Installation shot from 'Terre Vulnerabili', HangarBicocca, Milan; p. 7 a Colour photograph of mobile outdoor installation 'Private Moon' by Leonid Tishkov. Photo Leonid Tishkov. Courtesy of the artist; p. 7 c Stainless steel, neon tube, 234 × 223 × 223 cm. Photo Agostino Osio. Courtesy Fondazione Querini Stampalia, Venice; p. 7 b Courtesy the artist. © 2007 Nicole Dextras; p. 9 a Oil on canvas, 83 × 73 cm. Gallerie dell'Accademia, Venice; p. 9 b Oil on canvas, 68 × 54 cm. Nationalmuseum, Stockholm; p. 10 a Oil on canvas, 94.8 × 74.8 cm. Kunsthalle Hamburg; p. 10 c Oil on canvas, 91.4 × 127 cm. Metropolitan Museum of Art, New York; p. 10 b Mammoth-plate albumen print, printed 1878–81, 38.8 × 53.3 cm; p. 11 a 3/4 mile by 4 mile schemata of a vortex (whirlpool), traced in the sky using standard white smoke discharged by an aircraft over El Mirage Dry Lake. © 1973 Dennis Oppenheim. Photo: Dennis Oppenheim studio; p. 11 c 240,000-ton displacement in rhyolite and sandstone. 18,000 × 600 × 360 cm. Mormon Mesa, Overton, Nevada. Museum of Contemporary Art, Los Angeles. Gift of Virginia Dwan; p. 11 b Mud, precipitated salt crystals, rocks, water, coil, 45,720 × 482.6 cm. Great Salt Lake, Utah. © Estate of Robert Smithson/VAGA, New York/Dacs, London, 2013; p. 12 a & c Four concrete tunnels, each 548 cm long, 282 cm diameter. Overall length: 2,621 cm. Courtesy the artist; p. 12 b ['Skin of leaves – sight to the sky'], bronze, 364 × 265 × 120 cm. Art work © 2005 Giuseppe Penone. Photo © 2005 Archivio Penone; p. 13 a Commissioned by New York City Department of Transportation. 1,219 × 7,620 × 1,371.6 cm. Courtesy the artist; p. 13 c Colour photograph and map, 101 × 60.5 cm. Museo de Arte Moderno de Buenos Aires Collection. Courtesy Museo de Arte Moderno de Buenos Aires Collection. © 1970 Fundación Nicolás García Uriburu; p. 13 b Installation, Hayward Gallery, London. Courtesy the artists; p. 14 a 'Handshake ritual' with workers of New York City Department of Sanitation. Colour photograph, 152.4 × 228.6 cm. Courtesy Ronald Feldman Fine Arts, New York; p. 14 c Two acres of wheat planted and harvested by the artist on a landfill in Manhattan's financial district, a block from Wall Street and the World Trade Center, Summer 1982. Commissioned by Public Art Fund, New York City. © 1982 Agnes Denes. Photograph by John McGrail. Courtesy Leslie Tonkonow Artworks + Projects, New York; p. 14 b *Melica uniflora* mounted on paper, 50 × 100 cm. © 2005 herman de vries. Courtesy the artist; p. 15 a Gunite, wetlands plants, reptiles and fish, five city blocks. © 2013 Patricia Johanson; p. 15 c Plants, industrial fencing on a hazardous waste landfill. Courtesy: Mel Chin and Thomas Hinkle Gallery, Cologne; p. 15 b Soil and seeds. Photo by Michael Honer. © 1992 Kathryn Miller; p. 16 Susannah Sayler and Edward Morris, *Disrupted Ecosystems XXI: Monte Verde Cloud Forest, Costa Rica*, 2006 from *A History of the Future*, 2005–ongoing. Courtesy the artists. © 2006 Sayler/Morris for the Canary Project; pp. 20 & 21 ['Shepherd in Wuwei, Gansu, China', 'Storm in Hongsibao, Ningxia, China'; 'Man in Red on the Highway, Inner Mongolia, China'; 'Storm in Hongsibao No. 1, Ningxia, China'], pigment prints on archival paper, 101.6 × 152.4 cm. © 2006 Benoit Aquin. Courtesy Stephen Bulger Gallery; p. 22 C-type print, A: 120 × 360 cm, B: 60 × 180 cm, edition A: 6, B: 8. © 2008 Yao Lu. Courtesy the artist; p. 23 C-type print, A: 120 × 120 cm, B: 80 × 80 cm, edition A: 8, B: 10. © 2008 Yao Lu. Courtesy the artist; pp. 24–5 Chromogenic colour print, 122.5 × 149 cm. © 2007 Nadav Kander. Courtesy the artist; p. 26 a Chromogenic colour print, 122.5 × 149 cm. © 2006 Nadav Kander. Courtesy the artist; p. 27 a Chromogenic colour print, 122.5 × 149 cm. © 2006 Nadav Kander. Courtesy the artist; p. 27 b Chromogenic colour print, 122.5 × 149 cm. © 2006 Nadav Kander. Courtesy the artist; pp. 29, 30 & 31 Chromogenic colour prints. © 2010 Daniel Beltrá. Courtesy the artist; pp. 32–3 Water, carbon, cellophane bags, thread, dimensions variable. © 2009 Bright Ugochukwu Eke. Courtesy the artist; pp. 34 & 35 ['Ozone Fields'], mixed-media installation, commissioned by the Centre Georges

Pompidou for the exhibition 'Air de Paris'. Realized with the participation of Airparif. © 2007 HeHe. Courtesy of the artists; p. 36 Photographic images, each 61 × 91.4 cm. © 2011 Ravi Agarwal. Courtesy The Guild Art Gallery, Mumbai; pp. 38 & 39 C-prints, 120 × 150 cm. © 2006 Edgar Martins (www.edgarmartins.com). Courtesy Edgar Martins and The Moth House; pp. 40–41 Photograph/lightbox, dimensions variable. © 2001 Marjolijn Dijkman. Courtesy the artist; p. 43 Public artwork, Grand Concourse, Bronx, New York. Photos Katie Holten. Courtesy the artist; p. 44 a Giclée print, 57 × 76 cm. Commissioned by Film and Video Umbrella. © Suky Best. Courtesy the artist; pp. 44 b, 45 a & 45 b Lysonic inkjet prints, 13 × 17.3 cm. Commissioned by Film and Video Umbrella. © Suky Best. Courtesy the artist; pp. 46 & 47 © 1997 Andrej Zdravič. Courtesy the artist; pp. 48 & 49 Each: suite of 8 digital pigment prints housed in an embossed handmade portfolio box. Edition of 20. Paper size: 55.9 × 43.2 cm each; image size: 34.3 × 22.9 cm. © 2009 Erika Blumenfeld. Courtesy the artist and James Kelly Contemporary; pp. 50 & 51 Interactive installation, steel, glass, transparent photo positives, audio system, computer controls, series of framed photographs. Archival structure height 234 cm, length 516 cm, depth 160 cm (closed), 260 cm (extended). Shown in the Iceland Pavilion at the 50th Venice Biennale, 2003, curated by Laufey Helgadóttir. © 2003 Rúrí. Courtesy the artist; p. 52 Project in public space commissioned by Nikolaj Copenhagen Contemporary Art Center, Copenhagen, 2009. Photographs by Haubitz+Zoche. Courtesy Galerie Nusser & Baumgart, Munich; p. 53 Spotlight 2500 watt, digital steering, scaffolding, nautical map. Commissioned by Nikolaj Copenhagen Contemporary Art Center for the exhibition 'Rethink Kakotopia: Contemporary Art & Climate Change', 2009. Photograph by Haubitz + Zoche. Courtesy Galerie Nusser & Baumgart, Munich; pp. 54 a, 54 c & 55 Outdoor installations for sea/lake/pond, etc. Ground area 450 × 450 cm, height approx. 500 cm. © 2007 Tea Mäkipää and Halldór Úlfarsson. Courtesy Tea Mäkipää; p. 54 b Two installations and soundtrack for indoor or outdoor use, large Mercedes, dimensions variable. Soundtrack: 'Motocalypso' by Tony Ikonen. © 2008 Tea Mäkipää. Courtesy the artist; pp. 56, 57, 58 & 59 Archival pigment prints, each 121.9 × 121.9 cm. © 2002 David Maisel www.davidmaisel.com. Courtesy the artist and Haines Gallery, San Francisco; pp. 60 a & 60 c Archival pigment prints from *A History of the Future*, 2005–ongoing. Courtesy the artists. © 2008 Sayler/Morris for the Canary Project; p. 60 b Archival pigment print from *A History of the Future*, 2005–ongoing. Courtesy the artists. © 2010 Sayler/Morris for the Canary Project; p. 61 al Archival pigment print from *A History of the Future*, 2005–ongoing. Courtesy the artists. © 2006 Sayler/Morris for the Canary Project; p. 61 ar Archival pigment print from *A History of the Future*, 2005–ongoing. Courtesy the artists. © 2007 Sayler/Morris for the Canary Project; p. 61 bl Archival pigment print from *A History of the Future*, 2005–ongoing. Courtesy the artists. © 2010 Sayler/Morris for The Canary Project; p. 61 br Archival pigment print from *A History of the Future*, 2005–ongoing. Courtesy the artists. © 2005 Sayler/Morris for the Canary Project; p. 62 Woven taquara, banana trunk fibres, feathers, wire, fishing line, caxeta wood and paint on walls, 152.4 × 348 × 152.4 cm, dimensions variable. Image © Pablo Mason. Courtesy Berardo Collection Museum; p. 63 Taquara, wire, styrofoam, plywood, banana trunk fibers, feathers, sisal, mud, water, lights, MP3 players, speakers and paint on walls, 101.6 × 965.2 × 62.2 cm, dimensions variable. Image © David Rato. Courtesy Berardo Collection Museum; pp. 64–5 Chromogenic print, 178 × 228 cm. © 2004 Black River Productions Ltd/Mitch Epstein. Courtesy of Sikkema Jenkins & Co, New York. All rights reserved; p. 66 a Chromogenic print, 178 × 228 cm. © 2005 Black River Productions Ltd/Mitch Epstein. Courtesy of Sikkema Jenkins & Co, New York. Used with permission. All rights reserved; p. 66 b Chromogenic print, 178 × 228 cm. © 2007 Black River Productions Ltd/Mitch Epstein. Courtesy of Sikkema Jenkins & Co, New York. Used with permission. All rights reserved; p. 67 Chromogenic print, 178 × 228 cm. © 2005 Black River Productions Ltd/Mitch Epstein. Courtesy of Sikkema Jenkins & Co, New York. Used with permission. All rights reserved; pp. 68 & 69 Fifteen pigment prints, each 41 × 61.6 cm (image size), 43.2 × 63.8 cm (paper size). Full size 359.7 × 175.3 cm. © 2006 Joel Sternfeld. Courtesy the artist and Luhring Augustine, New York; p. 70 Chiara Lecca, *Black Still Life*, 2010 (detail). Taxidermy, PVC, ceramics, small wooden table, 200 × 70 × 70 cm. Photo by Ezio Manciucca. Courtesy Galleria Fumagalli, Milan; p. 75 Beetle-killed logs and coal, 12m diameter. © 2011 Chris Drury; p. 76 Digital photograph bonded to glass, 101.6 × 76.2 cm. David Buckland/Cape Farewell; p. 77 a & b Digital photographs

bonded to glass, each 76.2 × 76.2 cm. David Buckland/Cape Farewell; p. 78 a Film still, three digital films, 1h 57m. Photo © Katie Paterson, 2007. Courtesy of the artist; pp. 78 c & b Hydrophone, mobile phone, amplifier, neon. Installation view, Iceland, 2008. Photos © Katie Paterson, 2008. Courtesy of the artist; p. 79 Hydrophone, mobile phone, amplifier, neon. Installation view, Iceland, 2007. Photo © Katie Paterson, 2007. Courtesy of the artist; p. 80 l Gelatin silver print, 169 × 61 cm. © 1998 Susan Derges. Courtesy the artist and Purdy Hicks Gallery, London; p. 80 r Unique dye destruction print, 168 × 61 cm. © 1997 Susan Derges. Courtesy the artist and Purdy Hicks Gallery, London; p. 81 Unique dye destruction print, 168 × 61 cm. © 1998 Susan Derges. Courtesy the artist and Purdy Hicks Gallery, London; pp. 82 & 83 Stainless-steel irrigation, basalt, old growth log, 518.2 × 914.4 × 2,743.2 cm. Collection of Oregon State Convention Centre and administered by Regional Arts & Culture Council, Portland, Oregon. Courtesy the artist; p. 84 a Collage on paper. Courtesy the artist, Andrew Kreps Gallery NY and Herald St Gallery, London; p. 84 b Installation, 1:2 model of an architectural draft, wood, plastic foil, Angel Trumpet trees, living bumble bees. Photo Klaus Weber. Courtesy the artist, Andrew Kreps Gallery NY and Herald St Gallery, London; p. 85 a Photo Klaus Weber. Courtesy the artist, Andrew Kreps Gallery NY and Herald St Gallery, London; p. 85 b Wood, paint, 6 bumble-bee populations, mirror. Photo Klaus Weber. Courtesy the artist, Andrew Kreps Gallery NY and Herald St Gallery, London; pp. 86 & 87 Ink on paper and C-type prints in 11 framed parts, 800 × 300 × 30 cm. © 2012 Tim Knowles. Courtesy the artist; p. 88 Stainless steel, 600 cm tall, 900 cm long. Photo by Andy Spain. Courtesy the artist; p. 89 Photo by Richard Deane. Courtesy the artist; p. 90 Photo by Luke Jerram. Courtesy the artist; p. 91 Mock-up of art work on water by Luke Jerram. Courtesy the artist; pp. 92 & 93 Acrylic paint on road maps, wood, each 35.9 × 35.9 cm. © 2008 Rivane Neuenschwander. Photo by Steve White. Courtesy the artist, Fortes Vilaça Gallery, São Paulo; Stephen Friedman Gallery, London; Tanya Bonakdar Gallery, New York; pp. 94 & 95 Bird-seed installation, dimensions variable. Courtesy the artist; p. 96 a, 96 b & 97 Installation views, 'A Forest Divided', Lunds Konsthall, Lund, 2012. Photos Terje Östling. Courtesy the artist, The Modern Institute/Toby Webster Ltd, Glasgow and Galleria Franco Noero, Turin; p. 96 c Stuffed starlings, iron, nylon thread, approx. 250 × 330 cm. Photo Terje Östling. Courtesy the artist, The Modern Institute/Toby Webster Ltd, Glasgow and Galleria Franco Noero, Turin; pp. 98 & 99 Custom robotics and fabrication, sensors, and ink drawing, 61 × 518.2 cm. Photos courtesy the artist. © 2006 Sabrina Raaf. This project was made possible through grants from the Creative Capital Foundation, New York City, and Columbia College, Chicago; p. 100 a & c Taxidermy, PVC, ceramics, small wooden table, 200 × 70 × 70 cm. Photos by Ezio Manciucca. © 2010 Chiara Lecca. Courtesy Galleria Fumagalli, Milan; p. 100 b Taxidermy, PVC, ceramics, wooden table, ornamental cloth. 180 × 120 × 120cm. © 2007 Chiara Lecca. Courtesy Galleria Fumagalli, Milan; p. 101 Still Life, taxidermy, PVC, ceramics, wooden table, ornamental cloth. 180 × 120 × 120cm; Domestic Economy, taxidermy, PVC, glass, canvas, metal, dimensions variable. © 2007 Chiara Lecca. Courtesy Galleria Fumagalli, Milan and private collection, Italy; pp. 102–3 Photograph, 118 × 150cm. © 2010 Liu Bolin. Courtesy Eli Klein Fine Art; p. 104 Lambda print on Dibond, 75 × 112 cm. Probe, Arnhem, Netherlands. Courtesy the artist, www.berndnaut.nl; p. 105 a Lambda print on Dibond, 75 × 112 cm/125 × 186 cm. Hotel Maria Kapel, Hoorn, Netherlands. Photo Cassander Eeftinck Schattenkerk. Collection Saatchi Gallery, London. Courtesy the artist, www.berndnaut.nl; p. 105 b Lambda print on Dibond, 75 × 110 cm/125 × 184 cm. Castle of D'Aspremont-Lynden Rekem, Belgium. Photo Cassander Eeftinck Schattenkerk. Courtesy the artist, www.berndnaut.nl; p. 106 Heather Ackroyd and Dan Harvey, *Beuys's Acorns (sapling roots)*, 2007. © 2007 Ackroyd and Harvey. Courtesy the artists; p. 110 Installation view, 'Environment 2 Degrees', Futuresonic, CUBE, Manchester, 2009. © 2009 Ackroyd and Harvey. Courtesy the artists; p. 111 © 2007 Ackroyd and Harvey. Courtesy the artists; p. 112 a Poster, dimensions variable. Photo of BD Collier by Kristin A. Dykstra. Poster design by Brian D. Collier, 2007. Courtesy Brian D. Collier; p. 112 c Poster, dimensions variable. Courtesy Brian D. Collier; p. 112 b Archival digital print, preserved plant specimen, monofilament, 40.6 × 27.9 cm. Courtesy Brian D. Collier; p. 113 Archival digital print, 15.2 × 20.3 cm. Courtesy Brian D. Collier. The complete project, including The Highway Traveller Native Seed Dispersal Program, consists of the following components: custom-built lightbox map table (wood, duratrans print), 27 handmade trip journals (cloth and board covers, archival digital prints), 3 roadside

habitat dioramas (wood, preserved plants, earth, wax, light, audio recorded from collection site, archival digital print), 15 framed botanical specimens (archival digital prints, dried plant specimens, monofilament), single-channel video, project website http://highwayexpedition.net; p. 114 a & b Installation views of botanical sculptures in the Botanical Garden Göttingen, mixed-media, variable dimensions. Courtesy the artist; p. 115 a Digital portraits and colour-change observations of six street trees over four seasons. Courtesy the artist; p. 115 b Digital photographs and installation views of photo portraits of common urban weeds with historical, ecological or medicinal significance. Courtesy the artist; p. 116 a & b Photos Alison Turnbull. Courtesy the artist and Matt's Gallery, London; p. 117 Unique archival pigment print, 170 × 110 cm. Courtesy the artist and Matt's Gallery, London; p. 118 Oil on canvas, 203 × 214 cm. Courtesy Mark Fairnington and Galerie Peter Zimmerman; p. 119 a Oil on canvas, 41 × 56 cm. Courtesy Mark Fairnington and Galerie Peter Zimmerman; p. 119 b Oil on canvas, 41 × 56 cm. Courtesy Mark Fairnington and Galerie Peter Zimmerman; pp. 120 & 121 Mixed-media installation, including 26,162 preserved specimens representing 370 species, glass, Preffer and Carosafe preservative solutions, 365.8 × 457.2 × 457.2 cm. Created by Brandon Ballengée with Todd Gardner, Jack Rudloe, Brian Schiering and Peter Warny. Photo Varvara Mikushkina. Courtesy Ronald Feldman Fine Arts, New York; pp. 122–23 Installation view from the exhibition 'ReThink', Moesgaard Museum, Denmark, 30 October 2009–10 January 2010. Four video projections for twenty opaque Perspex screens (15–50 cm diameter) and surround sound (sound design Jason Johnston). Courtesy Moesgaard Museum, Aarhus, Denmark; pp. 124 & 125 Installation views, Waikato Museum, Hamilton, New Zealand. Four video projections for twelve opaque Perspex screens (15–50 cm diameter) and surround sound (sound design Jason Johnston). Courtesy the artist; pp. 126–27 Computer-generated installation, exhibited at 'Convivialité, écologie et vie pratique' at Domaine de Chamarande, Paris, May 2012. Photo credit Laurence Godart; pp. 128 & 129 Internet-based interactive drawing with embedded photographs, www.polarwandering.co.uk. © 2006 Layla Curtis. Courtesy of the artist. Layla Curtis was awarded an Arts Council England International Fellowship to Antarctica jointly sponsored by the British Antarctic Survey. Polar Wandering was developed in collaboration with Locus+; pp. 130 & 131 Dimensions variable, software, climate data, digital projection. Photo courtesy Sarah Bagshaw; pp. 132–33, 134 & 135 Interactive installation, commissioned by the National Maritime Museum, London, in collaboration with Cape Farewell. Poetry: Nick Drake. Sound design: Max Eastley and Henrik Ekeus. Programmer: Luke Malcolm. Photography: John Adrian. Video: James Medcraft. Courtesy the artists; p. 136 a Dug-out pirogue, mirror, lacquered glass, steel frame, reconditioned wood, life rings, toy animals, 160 × 150 × 550 cm. From the 'Amazonia' exhibit at the Natural History Museum. Photo Thierry Bal. Courtesy the artists; p. 136 b Part of Collection: Aepyornis, Gallimimus, Allosaurus, Pelaeomastodon, one of seven Royal Limoges porcelain sculptures, enamel drawings, steel, lacquered glass. Table plinth: 200 × 100 × 110 cm. Photo Thierry Bal. Courtesy the artists and Galleria Continua San Gimignano/Le Moulin; p. 137 Lambda photographs backed on Dibond, framed 128 × 128 × 5 cm each. Courtesy the artists; pp. 138, 139 & 140–41 Mixed-media installation, dimensions variable. Courtesy Galerie Michel Rein, Paris; p. 142 Nyaba Leon Ouedraogo, from Hell of Copper, 2008. C-print, 160 × 120 cm. Courtesy La Galerie Particulière, Paris; p. 146 a C-print, 100 × 150 cm. © 1999 Naoya Hatakeyama. Courtesy Taka Ishii Gallery, Tokyo; p. 146 b C-print, 100 × 150 cm. © 2006 Naoya Hatakeyama. Courtesy Taka Ishii Gallery, Tokyo; p. 147 C-print, 100 × 150 cm. © 1998 Naoya Hatakeyama. Courtesy Taka Ishii Gallery, Tokyo; pp. 148–49 C-print, 100 × 150 cm. © 1998 Naoya Hatakeyama. Courtesy Taka Ishii Gallery, Tokyo; pp. 150 & 151 Twelve colour photographs, each 50.8 × 61 cm. Courtesy Allora & Calzadilla and Lisson Gallery; pp. 152 & 153 Fiat 500 car, plastic bags, dimensions variable. Installation shots from 'Breathless: Andrea Polli', Parco Arte Vivente, Turin, 28 October 2011–26 February 2012. Courtesy the artist; pp. 154 & 155 Car, mist system, dimensions variable. Collaboration with Chuck Varga. Courtesy the artist; p. 156 a Epson inkjet print, 111.8 × 162.6 cm. © 2004 Chris Jordan. Courtesy the artist; p. 156 b Epson inkjet print, 48.3 × 63.5 cm. © 2009 Chris Jordan. Courtesy the artist; p. 157 Epson inkjet print, 111.8 × 142.2 cm. © 2004 Chris Jordan. Courtesy the artist; pp. 158–9 Epson inkjet print, 111.8 × 162.6 cm. © 2004 Chris Jordan. Courtesy the artist; p. 160 ['Spillover'], archival pigment print, 132 × 101.6 cm. © 2010 Alejandro Durán. Courtesy the artist; p. 161 ['Clouds'], archival pigment print, 101.6 ×

132 cm. © 2011 Alejandro Durán. Courtesy the artist; pp. 162 & 163 Commercial cut flowers, wagons, buckets. Commissioned by Bloomberg Space, London. Photos Wig Worland and Peter Abrahams. Courtesy the artists; pp. 164– & 165 C-prints, each 160 × 120 cm. Courtesy La Galerie Particulière, Paris; p. 166 a Lambda on aluminium and Plexiglas, 100 × 150 cm. © 2010 Svetlana Ostapovici. Courtesy the artist; p. 166 b Inkjet on cotton paper, 100 × 133 cm. © 2010 Svetlana Ostapovici. Courtesy the artist; p. 167 Inkjet on cotton paper, 32 × 47 cm. © 2011 Svetlana Ostapovici. Courtesy the artist; p. 168 ['Details of a Forest', 2011], cardboard, glue and wood, 242 × 300 × 56 cm. © 2011 Eva Jospin. Courtesy Galerie Pièce Unique, Paris; p. 169 ['Small Forest'], cardboard and glue in ink box, 40 × 35.5 × 12 cm. © 2011 Eva Jospin. Courtesy Galerie Pièce Unique, Paris; pp. 170–1 ['Details of a Forest', 2010], cardboard, glue and wood, 250 × 360 × 50 cm. © 2010 Eva Jospin. Courtesy Galerie Pièce Unique, Paris; p. 172 a Courtesy the artist. © 2007 Habitat for Artists and Simon Draper; p. 172 b & 173 Courtesy the artist. © 2009 Habitat for Artists and Simon Draper; pp. 174 & 175 Courtesy the artist; p. 176 Installation. Photo © 2010 Wolfgang Thaler Photography. Courtesy the artist/Ellen de Bruijne Projects/Secession, Vienna; pp. 176–7 Courtesy the artist; pp. 178 & 179 Photos Matt Costello. Courtesy the artist; p. 180 Tattfoo Tan, S.O.S. Mobile Garden, 2009–ongoing. Social sculpture, dimensions variable. © 2009 Tattfoo Tan. Courtesy the artist; p. 184 Water, algae, oxygen, photosynthesis, 426.7 × 152.4 × 152.4 cm. Created by Futurefarmers: Amy Franceschini, Michael Swaine, Dan Allende and Stijn Schiffelers in collaboration with Jonathan Meuser and Noah Murphy-Reinhertz. © 2004 Futurefarmers. Courtesy the artists; p. 185 a Paper, wood, foam, plants, thread, 66 × 71.1 × 33 cm. Created by Futurefarmers: Amy Franceschini, Michael Swaine, Dan Allende and Stijn Schiffelers. © 2003 Futurefarmers. Courtesy the artists; p. 185 b Video still. Created by Futurefarmers: Amy Franceschini, Michael Swaine, Dan Allende and Stijn Schiffelers in collaboration with Jonathan Meuser and Noah Murphy-Reinhertz. © 2004 Futurefarmers. Courtesy the artists; pp. 186, 187, 188 & 189 Mixed media. Images courtesy N55; p. 190 Water tower/shower, Wendover, Utah. World War II Quonset hut and support structures. Courtesy the artists; p. 191 Solar distillation units: stainless steel, glass, plastic containers. Tijuana, Mexico for inSITE 05. Courtesy the artists; p. 193 Fuel cell powered bicycle, vitrine, watercolour on paper, 170 × 224 × 62 cm. Production photographs by Simon Starling, the Tabernas Desert, Almeria, Spain. Courtesy the artist and The Modern Institute/Toby Webster Ltd, Glasgow; p. 194 Loughborough University Library, commissioned by Radar, Loughborough, United Kingdom. Photo Phil Wilson. Courtesy the artist; p. 195 a & b Courtesy the artist. © 2012 Natalie Jeremijenko and Gyorgyi Galik; p. 196 c Courtesy the artist. © 2012 Natalie Jeremijenko and Gyorgyi Galik; p. 196 b Courtesy the artist. © 2012 Natalie Jeremijenko and Gyorgyi Galik; p. 197 Courtesy the artist. © 2012 Natalie Jeremijenko; p. 198 Archival inkjet print, 47 × 81.3 cm. Garment made from potted edible plants, wood, willow, organic flax, rush plants, cattail leaves, chilli peppers, corn husks, organic cotton, hydrangea flowers, fresh herbs and rubber casters. Photo Nicole Dextras. Courtesy the artist; p. 199 a Archival inkjet print, 20.3 × 20.3 cm. Garment made from skunk cabbage leaves and thorns. Photo Nicole Dextras. Courtesy the artist; p. 199 b Archival inkjet print, 91.4 × 91.4 cm. Garment made from yucca leaves, flowers and thorns. Photo Nicole Dextras. Courtesy the artist; p. 200 a Hand-blown glass, miniature living plants, organic substrate, 29.2 × 78.7 × 45.7 cm. Ficus pumila and moss. Photo Sherry Griffin. Courtesy the artist; p. 200 b Hand-blown glass, miniature living plants, organic substrate, 27.9 × 71.2 × 33 cm. Moss, fern, recycled glass, gravel. Photo Sherry Griffin. Courtesy the artist; p. 201 Hand-blown glass, miniature living plants, organic substrate. Photo Eva Heyd. Courtesy the artist; p. 202 a Performance with acrylic walking stick containing soil and plants. Documentation of the performance and an invitation to visitors to take the walking sticks for a walk located in the gallery. Commissioned by Edith Russ Site for New Media Art, Oldenburg, Germany. Photo Franz Wauehof. Courtesy the artist; p. 202 b Acrylic, hardware, plants native to the area, soil, organic matter, water, and water sprayers, dimensions variable. Five 'personal biospheres', commissioned for the 'Badlands' exhibition, MassMOCA, North Adams, Massachusetts. Photo Kevin Kennefick. Courtesy the artist; pp. 204–5 Acrylic, aluminium, hardware and rigging, soil, water, native plants and mosses of the Pacific Northwest forests, footstools. Installation at Seattle Center as part of 'Next Fifty'. Commissioned by the Seattle Center Foundation. Photo Spike Mafford. Courtesy the artist; pp. 206 & 207 Social sculptures, dimensions variable.

© 2009 Tattfoo Tan. Courtesy the artist; pp. 208 & 209 Courtesy Hanspeter Kadel and Myriel Milicevic http://energyharvests.org, http://neighbourhoodsatellites.com; pp. 210–11 Electronics and data visualization. Courtesy Preemptive Media (Beatriz da Costa, Jamie Schulte and Brooke Singer); p. 212 Installation photo from The Land in Chiang Mai, Thailand. Photo Superflex. Courtesy the artists; p. 213 a Metal, paint, gas container, glass, cardboard box, 101.6 × 127 × 127 cm. Photo Superflex. Courtesy the artists; p. 213 b Installation photo from The Land in Chiang Mai, Thailand. Photo Superflex. Courtesy the artists; p. 214 & 215 Graphic designs by Rasmus Koch Studio. Photos Superflex. Courtesy the artists; p. 216 Fritz Haeg, Edible Estate Regional Prototype Garden #4: London, 2007. Commissioned by Tate Modern. Photo Jane Sebire. Courtesy the artist; p. 220 a Cottonwood seeds (Populus wislizeni), 300 pounds of hand-carved ice. Rio Grande, New Mexico. Photo Clair Long. Courtesy the artist; p. 220 b Maple keys and white elm (Ulmus glabra) nutlets. Ottawa, Ontario, Canada. Courtesy the artist; p. 221 Red elderberry (Sambucus racemosa), 38.1 × 21.6 × 2.5 cm. Nisqually River, Washington State. Courtesy the artist; pp. 222 & 223 a 550 recycled white dress shirts, monofilament, dimensions variable. Artists: Jussara Lee, Orlando Palacios, Edward Morris. Photo Susannah Sayle. Courtesy the artists; p. 223 b Dresses made from recycled white dress shirts, performance dimensions variable. Artists: Jussara Lee, Edward Morris and Annie Murdock. Photo Curtis Hamilton. Courtesy the artists; p. 224 & 225 Red neon sign, silkscreened print, 243.8 × 27,432 × 121.9 cm. Production: Brand X, Michael Isabell, Chester Jenkins, Lite Brite Neon, Jessica Mein, The Precipice Alliance, Juan Recamán, Technolux, Kenny Trice, Village Typographers, Donna Wingate; pp. 228 & 229 Photos Benoît Mangin. Courtesy the artist; pp. 230 & 231 Courtesy the artist; p. 232 Archival photograph. Photo Dirk Fleischmann. Courtesy the artist; p. 233 a Google Maps imagery © 2013 Aerometrex, DigitalGlobe. Courtesy the artist; p. 233 c Photo Dirk Fleischmann photograph, 31.7 × 47.5 cm. Photo Rodolfo Ferrer. Courtesy the artist; p. 233 b Archival photograph, 31.7 × 47.5 cm. Photo Dirk Fleischmann. Courtesy Hyejin Kim Collection; p. 235 Installation shot, Bielefelder Kunstverein, Bielefeld, Germany. Photo Philipp Ottendörfer, Töpferstr. 26, 8045 Zürich, +41794025633, mail@ottendoerfer.com, www. ottendoerfer.com. Courtesy the artist; p. 236 a Sculpture, installation, prints, website, dimensions variable. Created by Free Soil: Amy Franceschini, Myriel Milicevic and Nis Rømer. Courtesy the artists; p. 236 b Sculpture, installation, prints, website, dimensions variable. Created by Free Soil: Amy Franceschini, Myriel Milicevic and Nis Rømer. Courtesy the artists; p. 237 Sculpture, installation, prints, website, dimensions variable. Created by Free Soil: Amy Franceschini, Myriel Milicevic and Nis Rømer. Courtesy the artists; p. 238 Medicinal and edible food plants, light globes, table, 40 × 70 × 460 cm. Installation view, 'Three Degrees of Change', La Trobe University Museum of Art Melbourne. Courtesy the artist and La Trobe University, Melbourne. © 2010 Lauren Berkowitz. Lauren Berkowitz is represented by Utopian Slumps, Melbourne; pp. 240–41 Medicinal and edible food plants, light globes, 60 × 480 × 60 cm. Installation view, 'In the Balance, Art for a Changing World', Museum of Contemporary Art, Sydney. Photo Ian Hobbs. Courtesy the artist. © 2010 Lauren Berkowitz. Lauren Berkowitz is represented by Utopian Slumps, Melbourne; pp. 242 & 243 Courtesy the artists. © 2010 and 2012 Artist as Family. p. 244 Commissioned by Tate Modern. Photo Fritz Haeg. Courtesy the artist; p. 245 Commissioned by Tate Modern. Photos Heiko Prigge. Courtesy the artist; p. 246 Poster. Courtesy the artist; p. 248 Thermo hydrograph (meteorological instrument), coffee table, Malaysian rubber wood, glass, human hair, plastic membrane, Stern Report quotes, A4 photocopy, photograph, climate diagram, certificate, image, dimensions variable. Exhibition view, 'Still Life: Art, Ecology and the Politics of Change', 8th Sharjah Biennial, Sharjah Art Museum, Sharjah, 2007. Photo Tue Greenfort. Courtesy Johann König, Berlin; p. 249 Site-specific installation: light switch, format variable. Installation view, 'Fresh and Upcoming', Frankfurter Kunstverein, Frankfurt-am-Main, 2002; pp. 250–51 Photo © 2006 Bob Goedewaagen. Courtesy of Witte de With, Rotterdam; reverse back endpaper: ['Clouds'], archival pigment print, 101.6 × 132 cm. © 2011 Alejandro Durán. Courtesy the artist; back endpapers: outdoor installation for sea/lake/pond, etc. Ground area 450 × 450 cm, height approximately 500 cm. © 2007 Tea Mäkipää and Halldór Úlfarsson. Courtesy Tea Mäkipää.

INDEX

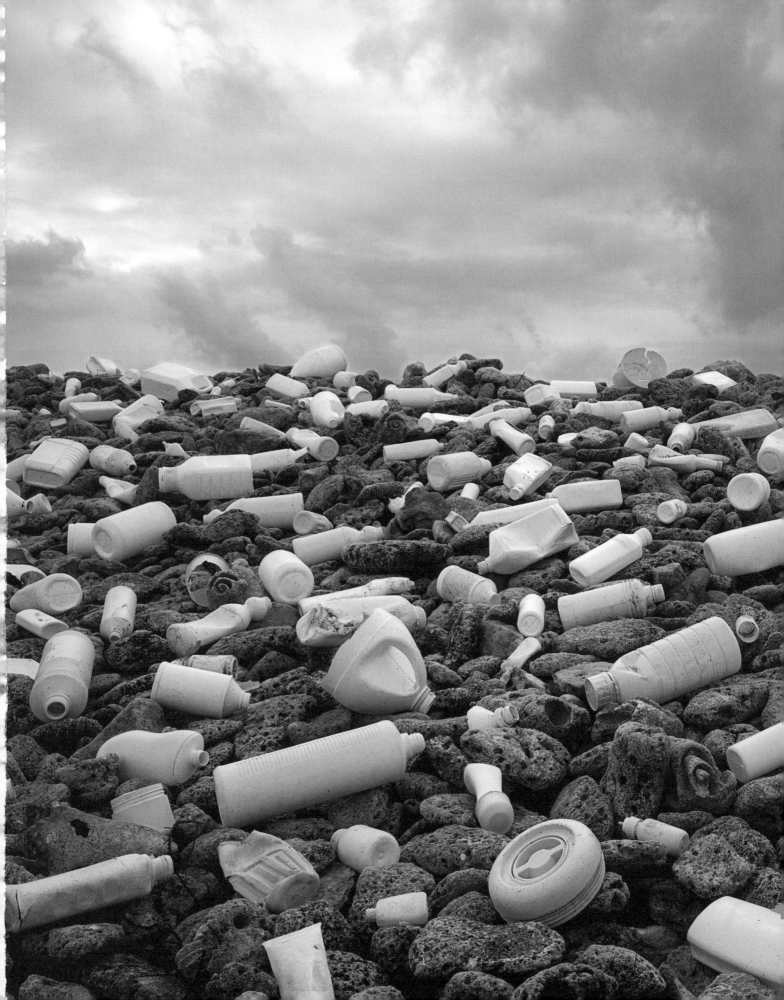